WEDDING PHOTOGRAPHY

Art, Business & Style

Second Edition

WEDDING PHOTOGRAPHY

Art, Business & Style

Second Edition

Steve Sint

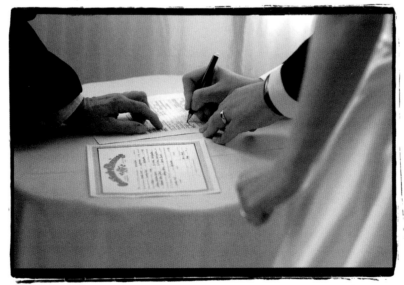

© Frank Rosenstein

LARK BOOKS

A Division of Sterling Publishing Co., Inc.
New York

Book Design and Layout: Springhouse Studio
Cover Design: Dan Lipe, Springhouse Studio
Front cover photo © Freed Photography
Illustrations: Chris McAdoo, Springhouse Studio
Editorial Assistance: Delores Gosnell

Library of Congress Cataloging-in-Publication Data
Sint, Steve, 1947-
 Wedding photography : art, business & style / Steve Sint.-- 2nd ed.
 p. cm.
 Includes index.
 ISBN 1-57990-546-3 (pbk.)
 1. Wedding photography--Handbooks, manuals, etc. I. Title.
TR819.S56 2005
778.9'93925--dc22

 2004010679

10 9 8 7 6 5 4 3 2 1

First Edition

Published by Lark Books, A Division of
Sterling Publishing Co., Inc.
387 Park Avenue South, New York, N.Y. 10016

© 2005, Steve Sint
Photography © Steve Sint unless otherwise specified

Distributed in Canada by Sterling Publishing,
c/o Canadian Manda Group, 165 Dufferin Street
Toronto, Ontario, Canada M6K 3H6

Distributed in the U.K. by Guild of Master Craftsman Publications Ltd.,
Castle Place, 166 High Street, Lewes, East Sussex, England BN7 1XU
Tel: (+ 44) 1273 477374, Fax: (+ 44) 1273 478606,
Email: pubs@thegmcgroup.com; Web: www.gmcpublications.com

Distributed in Australia by Capricorn Link (Australia) Pty Ltd.,
P.O. Box 704, Windsor, NSW 2756 Australia

If you have questions or comments about this book, please contact:
Lark Books
67 Broadway
Asheville, NC 28801
(828) 253-0467

Manufactured in China

ISBN 1-57990-546-3

For information about custom editions, special sales, premium and corporate purchases, please contact Sterling Special
Sales Department at 800-805-5489 or specialsales@sterlingpub.com.

Dedication

For three Js and an M

Acknowledgments

Thank you to the photographers who contributed their work to this book:

PHIL CANTOR PHOTOGRAPHY
www.philcantor.com, (973) 783-1065

FRANKLIN SQUARE PHOTOGRAPHERS
www.fsphoto.com, (516) 437-1055

FREED PHOTOGRAPHY
www.freedphoto.com, (301) 652-5452

GLENMAR PHOTOGRAPHERS
www.glenmarphotographers.com, (973) 546-3636

IN-SYNC PHOTOGRAPHY, LTD.
www.insyncphotography.com, (908) 522-1801

MARCIA MAUSKOPF
www.marciaphoto.com, (805) 688-4033

JOSEPH MEEHAN
www.josephmeehan.com

JERRY MEYER STUDIO
www.jerrymeyerstudio.com, (718) 591-7722

THE PHOTOGRAPHER'S GALLERY
Len, Davide, and Jacqui DePas
www.thephotographersgallery.net
(202) 362-8111

PHOTOGRAPHY ELITE, INC.
www.photoeliteinc.com, (718) 491-4655

JAN PRESS PHOTOMEDIA
www.janpress.com, (973) 992-8812

MARK ROMINE PHOTOGRAPHY
www.romineweddings.com, (309) 662-4258

FRANK ROSENSTEIN PHOTOGRAPHY
www.rosensteinphoto.com, (206) 706-0462

SALZMAN & ASHLEY PHOTOGRAPHY
www.salzmanashley.com, (516) 349-9500

THREE STAR PHOTOGRAPHY
(718) 376-1922

GEORGE WEIR PHOTOGRAPHY
www.georgeweir.com, (717) 538-0635

MICHAEL ZIDE PHOTOGRAPHY
www.michaelzide.com, (413) 256-0779

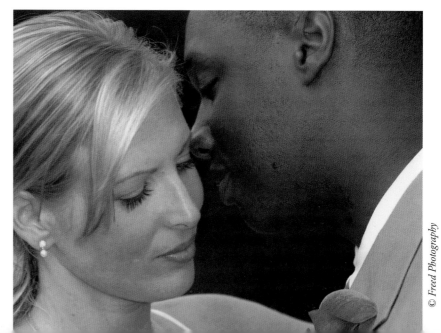

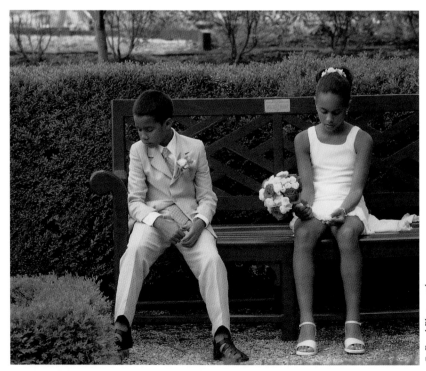

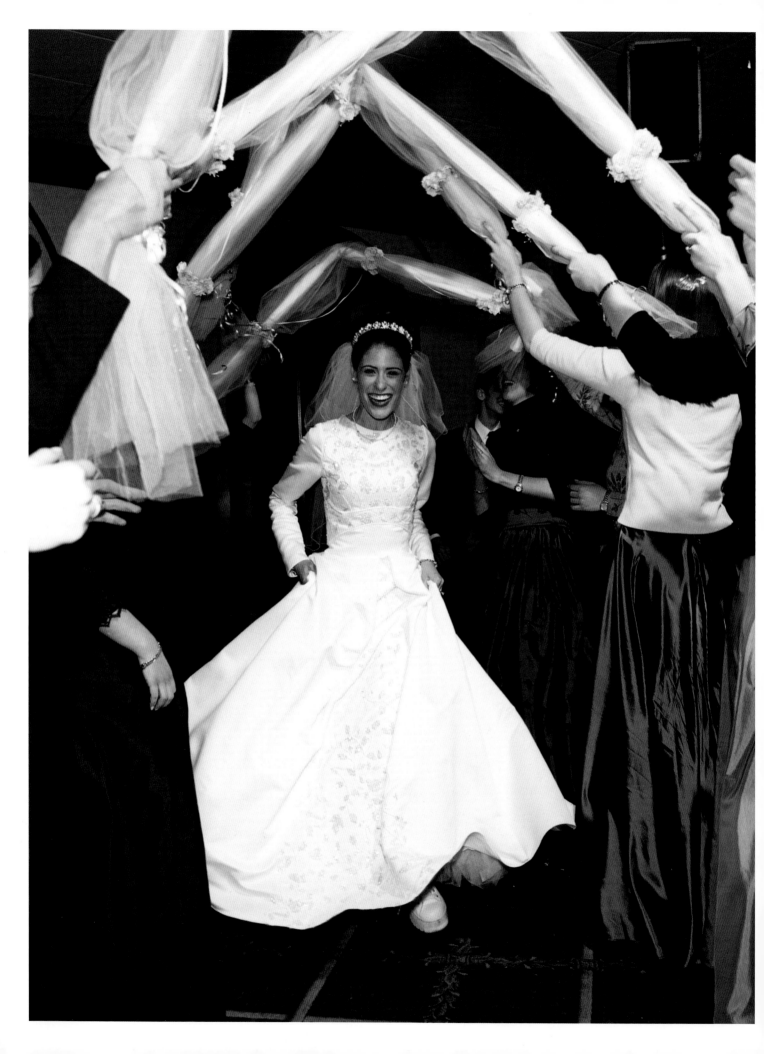

INTRODUCTION

When I was a young man I wanted to be a professional photographer in the worst way. I devoured books on photography (as many of you do), lusted after the latest lens (as you probably do), shot tons of what I thought were meaningful images (as you, no doubt, do), and couldn't make a living at my craft. As luck would have it, through a friend of a friend of a friend, I met the head photographer at CBS. He was "The Man"—UPI Press Photographer of the year and Nixon's campaign photographer—The Man! He looked at my meaningful images and asked, "How are you planning to make a living?" Luckily, I understood that this was precisely the problem, so he let me in on his big secret. He told me that 30 years ago he started his career by shooting weddings.

This was not what I wanted to hear. I wanted to roam the globe, shoot for LIFE, be a fly on the wall recording meetings that shaped history. The man slowed me down. He told me that shooting weddings could give me the four things I needed to roam the globe.

First, it would give me a chance to expose a lot of film. Second, it would make my camera an extension of my hand and eye, which would help when I became the fly on the wall. Third, he told me that shooting weddings would teach me to finish a job no matter how bad it was. This would give me the patience I needed to sit around waiting for the meeting that would shape history. Finally, he explained that wedding photography was regular work, and by doing it I could get the equipment I lusted after, and I would not have to eat gruel as I waited.

About ten years later, on a Saturday night, my assistant and I loaded my camera cases into a cab to go shoot a wedding in New York City. This was not just any wedding, mind you, but a wedding in the Grand Ballroom of The Plaza. Please understand what this means: Any wedding held in New York's Plaza hotel is one of the biggest parties happening in New York. And that means there was a good possibility that I was covering one of the biggest parties in the world on that particular night.

The cabbie looked over the seat at my cases and our tuxedos and asked what we were doing at The Plaza. I told him that I was a photographer and that were going to shoot an assignment. He asked me what kind of assignment, and I replied that it was a wedding. At the next traffic light he looked into the back seat again and told me that he was a photographer too, but that he could never lower himself to shoot a wedding! I thought for a second and told him that I understood, but I could never lower myself to drive a cab. To this day, I remember that cabbie, and I'm glad I shoot weddings.

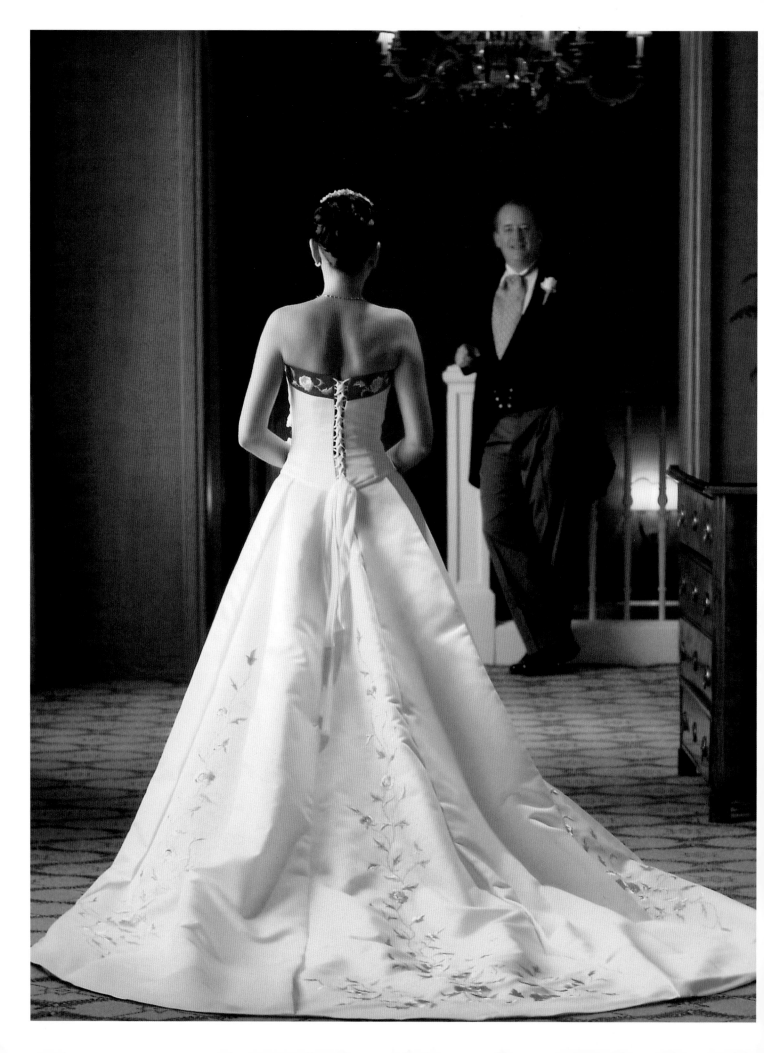

GETTING STARTED

No way, no how, was I going to make it on time. It was a humid Saturday in June. The morning mass had run late and the cake cutting after the luncheon was delayed. On the way to my afternoon wedding I knew I was going to be late . . .

Speeding a bit—a big bit—I crested a hill as my tires barely touched the pavement. There at the bottom of the hill was a police officer with his radar gun pointed right at me. He motioned me to pull over and as I did, a rivulet of sweat dribbled down my brow . . . this was it, I was definitely going to be late, or worse—I was going to jail!

The officer sauntered to my window and asked, "Do you know how fast you were going?"

I looked him right in the eye as the words tumbled out of my mouth, "I'm a wedding photographer who's late getting to the bride's house . . . I'm sorry I was speeding but if you're going to give me a ticket please, PLEASE, no long lectures . . . just write the ticket and let me get on my way."

The officer looked at me for a second and then asked where the bride's house was. I showed him her address on my information sheet and after what seemed like forever, he just said: "Follow me."

I stuck to the officer's tail for the next 15 minutes following the flashing lights on his screaming cruiser. As I ran up the walk to the bride's house, the officer touched his fingers to the brim of his cap in a mini salute. All I can say is, "Bless that cop!"

Many people consider wedding photography an art, but I disagree. Although there are moments when it may be elevated to an art form, I prefer to call it a craft. Once learned, the skills of a craft are ones you will always possess. In fact, it can be argued that a wedding photographer can go to any major city in the world and, with a minimum of equipment and a nice suit of clothes, make a living. This being the case, there are two different scenarios in which you can succeed as a wedding photographer. Both are worth considering.

Scenario #1
Open a Wedding Studio

The first way to make money at the wedding game is to contract with couples so you can produce their wedding photos. While this may seem the obvious way to proceed, it is a very laborious process.

First you must find customers (the bride and groom). Then you must show samples of your work to the couple (and often to the parents), draw up and sign a contract with them, and solicit a deposit. Depending on whether you use film or shoot digitally, you will need to buy film, shoot the job, process the film or files, deliver the proofs, go over the proofs with the customer, take the order, order the prints, send the prints for retouching, send the retouched prints to a bindery (or assemble the album yourself), place extra prints in folders, check the job over, deliver the finished product, and finally collect the money. As you can see, there are many more steps in the process than just shooting the assignment! In fact, many successful wedding studios say that shooting the assignment is probably one of the easiest parts of the whole process!

Selling the photographs is the name of the game. While it is very important to sell the couple on the idea that you are the best person to shoot their wedding, stiff competition in most regions demands that a studio offer its customers a competitive rate that builds only a small profit into the price. In this kind of environment, if you want your studio to be successful, you have to create the desire in your customers to buy extras after they see the proofs. These include extra prints for the albums, loose prints for family and friends, album style upgrades, or even frames and plaques for displaying the pictures. The key to success is selling, both before you've been hired and after the proofs have been delivered.

Many wedding studios offer their prospective customers a package that includes the basics that most newlyweds want. An example of this might be: one 8 x 10-inch bridal album that holds 24 photographs; two 5 x 7-inch parent albums with 12 photographs each; an 11 x 14-inch portrait; a dozen wallet-sized photos; and 50 or 100 photo thank-you cards. Some studios think it is smart to offer three or four different starter packages that present variations in the number of photographs in each of the albums and possibly a package that doesn't include any parent albums.

However, if you are going to offer an inexpensive starter package of photographs, you must remember that you will be locking yourself into an assignment on that particular day that might not be as profitable as another wedding in which

the customers might order a larger package. It pays to consider this if a couple wants to book you at your minimum rate for a Saturday night in June (prime wedding season).

Wedding work is seasonal. Understanding this fact comes with experience. In the northeastern United States, you will be riding high in June (and also in April, May, August, September, and October), but you might find that the pickings are slim in February.

Selling your work as a package, whether large or small, has its advantages and pitfalls. On the positive side, packages give you an idea about how much profit can be made on the assignment before you commit your dollars to film and processing costs (you can save some costs on film if you shoot digitally). This lets you make economical choices right from the start. For example, if a couple

contracts for a 50, or better yet, a 75-photograph bridal album instead of your minimum of 24 prints, you can afford to take more photographs, because the profit built into the higher package price will pay for the extra time and expenses incurred. On the negative side, large starting packages can often make customers resistant to purchasing extras. For instance, very often when a couple decides on a more elaborate package of photography from the start, their budget is carefully considered, and "building the order up" during the proof viewing session may be more difficult. So, larger, more elaborate starter packages often mean few, if any, spur-of-the-moment additions later on.

Some studios don't offer wedding packages at all. These operations usually serve the "carriage trade," where the customer is

Brides and grooms are looking to you for ideas to make their day idyllic. Suggesting scenic locations for their pictures can increase your sales. Become familiar with the scenic spots in your area; rock outcroppings, willow-rimmed ponds, lovely architecture, and public gardens can all make picturesque backgrounds for formal portraits. © Photography Elite, Inc.

relatively well heeled and less encumbered by budgetary considerations. These studios very often start with a minimum order, which by most standards can be quite high. Then they sell their customers all the extras (from parent albums to portraits) on an à-la-carte basis. These studios cater to the wishes of their affluent customers, and very often their next assignment is obtained because of whom they shot previously.

There are also wedding studios that specialize in shooting for a specific ethnic group or community. They, too, often get their next assignment from referrals within that community. This can be very lucrative, and if the community is large (or affluent) enough, there may be work within this specialized area to keep a studio going for generations.

Scenario #2
Become a "Candidman"

In medium-to-large metropolitan areas, there is another way to make money at the wedding game. If you own camera and strobe equipment, you can sell your services to wedding studios on a per-job basis. When a photographer does this, he or she becomes a "candidman," and playing the wedding game this way has both advantages and disadvantages.

Let's digress with a quick history lesson. The term "candidman" started in the late 1940s (soon after World War II) with the advent of portable flash units. Before this invention, couples went to a photographic studio to have a wedding portrait made. If

the couple could entice the rest of the family to come along, then more photographs (with different combinations of people) were taken.

Once portable lighting joined forces with smaller, more portable cameras (the venerable Speed Graphic, for example), a new type of wedding photography—candid wedding coverage—was born. This new style turned out to be a brilliant marketing ploy because it opened the door to selling entire albums. Simply put, photographers could sell a lot more pictures by filling an album than filling a single picture frame!

What followed was a need for photographers—wedding photographers! While one studio photographer could handle many portrait sessions in a single day, the brave new world of candid wedding coverage required that many photographers be hired on a single day, one for each wedding. A new breed of photographer developed, aptly named the "candidman" ("man" because at that time men dominated the profession). The candidman, armed with a Speed Graphic and some flashbulbs in the trunk of the car, was a "gun for hire," and to this day good candidmen are in high demand.

While wedding studios must do all the work involved in selling and producing the

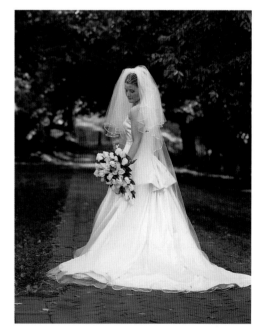

Weddings are steeped in tradition. Traditional poses such as this are almost always chosen for the album. Though clients often desire creativity, they also want a flawless visual record of their special day.
© *Freed Photography*

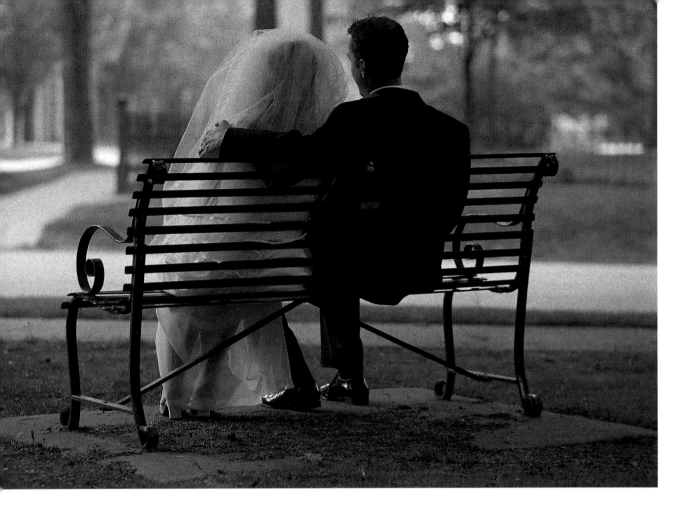

final product, a candidman just has to show up on the day of the wedding, shoot the event as specified by the contracting studio, and deliver the exposed images to the studio after the job is completed. Compensation varies with location—you will command more in affluent regions or major urban areas. Depending on the size, length, and importance of the job, and the level of expertise required, a good candidman can earn from $50 an hour all the way to $1200 per assignment. It's simple really—get the required film and information about the job from the studio, shoot in the studio's style, return the exposed images (either as film or burned onto CDs if shooting digital), and get paid.

Good candidmen often shoot for more than one studio. In large cities a candidman can shoot for many different studios without ever encountering a conflict of interest. Many candidmen (myself included) change their style or repertoire when they shoot for

different studios so that the pictures they produce match the style of the samples the studio has shown to the customer. Some studios show very formal portraits to prospective customers, while others present photos shot in a more candid, relaxed style. Some studios expect (or their customers want) to see creative double exposures, available-light photographs, or soft-focus effects. A good candidman can switch from style to style to satisfy his or her customer, namely, the wedding studio itself.

Being a candidman is a good way to supplement a regular job, and for that it is terrific! A good candidman is always in demand, and he or she can find work on a regular basis. But some candidmen can make a good living at it full time. These include the very top candidmen who are guaranteed a specific number of assignments per year from one big studio, or those who are so complete as photographers (i.e., they are gifted at shooting a broad range of sub-

Although this photograph is posed, the fact that neither subject seems aware of the photographer gives it a candid air. Good wedding photographers mix the two styles throughout the assignment to add variety to their coverage.
© Mark Romine

jects and applying a wide range of techniques) that they can shoot for many different studios. Candidmen in this position are often capable of becoming studio owners if they choose.

While the life of a candidman may seem perfect because there is no selling or album-producing involved in the job, it does have some disadvantages. First, candidmen don't build a clientele like wedding studios do. This means that at the end of their career there is no business to sell or pass on to a child. The candidman's eyes, hands, voice, and equipment are the only assets of the business (although by the end of a long and fruitful career, most of the used equipment is usually in pretty rough shape) .

However, for some photographers the first step towards opening their own wedding studio is to become a candidman. Established studios (especially in larger cities) have many assignments that a good candidman can pick up while building a sufficient reputation to support his or her own studio.

Many owners of small studios switch hats and shoot as candidmen to supplement their studio's income. While this supplemental income can be helpful, many established studios are wary of hiring a candidman who is also a studio owner. Plainly put, an established wedding studio is not in business to further the reputation of one of its freelance employees' studios. Why help the competition? With this thought in mind, it is easy to understand that it is a big "no-no" to give out one's own studio's business cards while shooting as a candidman for another. Photographers who do this usually find that assignments from other wedding studios will be few and far between.

However, in densely populated areas it is possible for a studio owner to have his or her own clientele and shoot as a candidman for studios that cover an entirely different segment of the population. Examples of this can be found most readily in areas where there is a great deal of ethnic diversity. For example, if your studio mostly handles Christian weddings, you can shoot as a candidman for studios that cater to an Orthodox Jewish clientele with little chance of running into a conflict of interest. Or, if

Like fashions, wedding photography styles go through cycles. Men's ties narrow and widen, hemlines go up and down, and wedding pictures switch from traditional to avant-garde. Soon after color photography was first introduced you couldn't give away black-and-white photographs, but once color photos became the standard, many couples began asking for more "daring" black and whites. © Mark Romine

your studio is on Long Island (a New York suburb), for instance, you could shoot as a candidman for a studio in New Jersey. Once again, this scenario is really only possible in large metropolitan areas.

Regardless of which career path you choose, success in wedding photography, like in real estate, is a matter of location, location, location! Smaller cities and towns with only one photo studio and one catering hall limit your possibilities. Big cities, on the other hand, offer an incredible variety of options and opportunities.

While some may think that being a great candidman requires superhuman photographic skill, this is really not the case. While the list of required skills and equipment is long, it is not unobtainable. Here's what I think you'll need to play at the top of the game (i.e., elegant, big-contract weddings) in any big city:

1. An easygoing, engaging personality.
2. Good communication skills.
3. You must care about what you produce—have an intense desire to treat any assignment as if you were shooting a center spread for a national magazine.
4. The ability to keep your cool and your wits about you.
5. Good to very good (notice I didn't say "great") photographic skills.
6. The ability to make studio owners confident that you are as interested in the quality their customers receive as they are.
7. A complete film and/or digital camera system with at least two camera bodies and backups of all other major camera equipment: meters, sync cords, lenses, etc. The camera system might be a 35mm, roll film, or digital SLR system, depending on the studio you are shooting for.
8. At least two battery-powered strobes with extra batteries and spares (flash tubes, battery charger(s), brackets, light-actuated slaves, radio slaves, and batteries for the radio remote slaves). However, for a big-contract, elaborate wedding, three or four battery-powered strobes would be better.
9. At least two AC strobe generators (three would be better) and three to four strobe heads.
10. Light stands and supporting accessories (barndoors, clips to attach barndoors, umbrellas, bank lights, boom arm) for the lighting system.
11. A tuxedo or equivalent formal attire and a neat, clean appearance.
12. A reliable car.
13. Liability and theft insurance.
14. A date book for keeping organized.

While some may think the equipment required is unobtainable, let me point out that its acquisition can be spread over a long period of time. Also, please note that I list photographic skills as fifth in importance. Your friendly personality and a caring attitude are more noteworthy assets.

With all the effort required, it might pay to establish your own studio. Many top candidmen do! On the other hand, in a densely populated area, it's possible to make a comfortable living just being a top candidman without the hassles and responsibility of owning a studio. Just remember, getting to the top is not an easy proposition . . . you have to compete with guys like me! Being a top candidman requires commitment and a solid reputation for reliability that can only be built over time.

THE WEDDDING REPERTOIRE

It's a crisp, autumn evening. The table centerpieces, made of dried flowers and leaves, are surrounded by votive candles. I go for a table shot, asking four people to remain seated. The guy at the far left says, "Hey . . . you can't see me. I'm behind the flowers!" Flipping my pointer finger between us I smile and say, "If you can see me, I can see you. It works that way!" He thinks for a moment and then pushes the centerpiece aside anyway . . . right over a votive candle. The dried flowers and leaves become a burning bush. I push the button.

I once shot a wedding for one of America's great families. I worked all day, into the night, shooting 500 pictures. Within a week I received a check for the entire amount called for in my contract. But when the proofs were returned, the customer wanted only three 8 x 10-inch portraits. I called to find out what was wrong with the rest of the pictures and was told (by a secretary) that my clients loved the pictures, but they needed only one print for the bride and groom and one print for each set of parents. I had sold three 8 x 10s for $1,000 each!

Years later, as I toured the estates of America's aristocracy in Newport, Rhode Island, I realized what had happened. For those people with a mansion in New York, a villa on the Riviera, and a horse farm in Kentucky; for those with a second (or third) home on the Seine and a chauffeur on the house staff; for these beautiful people, a wedding is just one more nice day in a life filled with nice days. All the pomp and circumstance surrounding a wedding is just that: pomp and circumstance.

But for every one of these people there are millions of others for whom a wedding is a most special event, a once-in-a-lifetime occurrence. To these people, every nuance of the traditional wedding is something to be savored and remembered—and photographed. A repertoire, as used in the context of this book, is a list of all the photo opportunities that record those nuances and traditions.

Building Your Own Repertoire

This repertoire contains all the pictures I feel are necessary to cover a Christian wedding assignment and produce an album that will tell a story about the day. If you go through it carefully you'll notice that, although the shots are listed, exactly how they are produced is not always mentioned. This is where your individual creativity comes into play.

A repertoire is a living, breathing thing. You can use this one, but the best repertoires are filled with individuality. So use this list as the basis for creating your own. Feel free to add, subtract, and combine it with your ideas and those of other photographers. But always remember . . . the best repertoire for you is YOURS!

For the novice, having a repertoire is essential. Very often when new wedding warriors go on their first assignments, they draw a blank when it comes time to start taking pictures. By memorizing a list of pictures and going down that list, you always have something to fall back on. This is not to say that a wedding photographer shouldn't be constantly trying to build and improve his or her

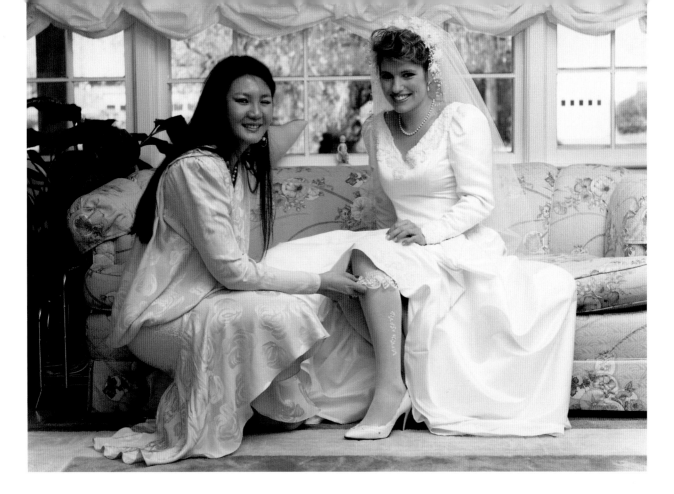

repertoire. That is one way to keep assignments fresh over a long period of time. But if a new wedding photographer can capture 95% of the photographs on this list, he or she will be able to produce a traditional wedding album that tells a story and has great sales potential.

Looking at wedding photography through the eyes of a pro can be enlightening. Every wedding (both the ceremony and reception) has specific events that occur. Realistically, after you've shot 100 (or 500, or 1,000 . . .) weddings in your area, you should start to see which things happen regularly. As your experience grows, you'll find that brides and grooms are constantly explaining to you how unique their wedding will be, and in reality you've seen the same "flaming bridal cake in the shape of a volcano" at the local catering hall a hundred times. No matter what, do not diminish or deflate the excitement they show. Your delight in their enthusiasm will sell photographs for you! Just smile to yourself and remember that the volcano photograph is paying for your new car.

There is a growing feeling today that brides and grooms want nontraditional wedding photographs, and I see this happening to some extent. The phrase "reportage style" is often bandied about. I've heard some current shooters tell their customers that their shooting style "goes with the flow," or "is a photojournalistic style," or "follows a nonintrusive approach," . . . etc. It is best to remember that this technique is a sales tool. To shoot an assignment competently—any kind of assignment—a pro must have some idea of what he or she is going to shoot. Whether it is called a shot list or a repertoire doesn't matter. Such a repertoire is a good idea, even for shooters who think that reportage is the wave of the future. If you decide to shoot in a nonintrusive, totally candid style, the list of combinations that I'm proposing should still be covered, even if the photographs are casual.

Here's a traditional approach: Find an attractive couch, sit the bride down, ask the maid of honor to adjust the garter and wink, and you'll have a very cute picture. This shot will probably be included in the album if the couple does a bouquet and garter toss at the reception.

Personally, I don't subscribe to a style of photography that is entirely reportage. I like a more traditional approach, with posed portraits of certain people and a completely unobtrusive style saved for situations where the photographer is just an observer (though not a casual one!). While some think that nontraditional is where it's at, remember that weddings by their very nature are steeped in tradition and custom. Weddings are a time when families dress up and come together. A large majority of couples getting married revel in the traditions and, more importantly for us, they want pictures of them.

One time I was 45 minutes late to a bride's home because another wedding I covered earlier that morning had run late. I shot a minimalist repertoire at the bride's house, and all afternoon and into the evening I picked up my missing photos in bits and snatches. Because of my tardiness, the bride's mother was not enthralled with me, and try as I might I couldn't turn her around. My people skills just weren't working with her. As we walked into the country club, I asked the bride to adjust her father's boutonniere. Using a candid style I snapped the picture and, as if by magic, the bride's mother became sweetness and light. She told me later that the boutonniere shot was in her wedding album, and she had been wondering when (and if) I was going to get it.

A repertoire is based on the first pro axiom: Plan Ahead. This doesn't mean you don't have to be prepared for the unexpected. You may go to an assignment knowing you want to do a formal portrait of the bride and her sister because it's in your repertoire. You want formal, but they want to throw their arms around each other and hug. The photographers with the best people skills can get both, but even if you get only the hugging shot, you're still working from a repertoire.

Please note, this list is not engraved in stone. Often a photographer will suggest where to start, and the bride will make a face signifying she doesn't like the idea. At that moment it's time to modify your repertoire (or at least that small section of it). It's equally true that sometimes you take a photograph during one of the five basic segments of coverage (at the bride's home, at the ceremony, the formals, family pictures, and at the reception) and discover it fits somewhere differently than the place it would fall in the normal scheme of things. That's OK . . . there are no hard-and-fast rules dictating the order in which you must take the pictures!

There is, however, safety in working to a plan. Not only do you not want to lose a sale, you do not want to be responsible for missing a memory. In addition, by having a specific idea of what you're going to shoot, you can manage your time better. When shooting with film, a plan helps you figure how many rolls you'll need to complete the job, as well as the costs for film and processing (OK, OK . . . only approximately!). This type of information is very important because, although you want to be the "harbinger of happiness" to the bridal couple, you still want to have a profitable business.

Another advantage of shooting to a repertoire is that you, as a studio owner, can book more than one job on a beautiful Saturday in June, sending additional photographers who know your repertoire to other assignments. After all, if you're selling a specific content and style of photography, your repertoire can serve as a blueprint to

Getting Your Sea Legs

For the beginner, it might pay to go to the ceremony's rehearsal before the real thing to get a feel for how things happen, but remember that your time is worth money. One mistake green photographers often make is to minimize the value of their own labor. After all is said and done, the most expensive part of creating any photographic product is the time (i.e., labor) involved.

teach other photographers whom you hire.

As mentioned, this freelance addition to a staff is called a candidman. Candidmen populate every city, but good ones can be hard to find. These photographers can look at a studio's set of proofs and copy the assignment. And the best candidmen bring individuality and creativity to the situation while still emulating a studio's style.

To follow this repertoire, the photographer should arrive at the place where the bride is dressing an hour and a half before the ceremony, spending at least one hour working with the bride, her parents, her siblings, and the bridal attendants. While some feel that an hour shooting in the bride's home shortchanges the groom's side, many consider a wedding to be the bride's day. From a photographer's point of view, more can be done with a beautiful gown, headpiece, and bouquet than with a tuxedo. So the bride therefore takes more time to photograph (so much for equality of the sexes!).

If a customer insists on pictures of the groom's preparations, that would be a perfect time to sell them on the idea of hiring a second photographer from your staff. The photographers can start at the two principals' homes, shoot parallel pictures, and meet at the church. (If that is the game plan, note that the order of the repertoire changes with regard to when you shoot the groom's family pictures.) Like many extras in the wedding photo game, this can be a situation that allows you to make additional profit.

Between the ceremony and the reception, the photographer has one to two hours in which to take formal and family photographs. This can be spent at a park (weather permitting), a backyard, or even at the photo studio or reception hall. The time can be broken down further by taking the bride, groom, and bridal party to a park and then shooting the family photographs once the bridal party gets to the reception hall.

In any event, if the photographer's time

It pays to remember where the beautiful settings are in your area. After shooting weddings for a few years, you will compile a good selection of possible locations to recommend to your clients. You'll even know what time of day and in which season certain settings look their best.
© *Photography Elite, Inc.*

becomes limited, either because the subjects are not ready or because of how long it takes to travel from one location to another, he or she must start to prune the repertoire. In that case it's best to concentrate on photos of the bride and groom, the parents, and larger groups. A picture of the bride and each of her six sisters will take six times as long to shoot as one of all the sisters together.

A well-planned order in which pictures are taken can also expand time. You can create a group picture in such a way that you keep adding people to a pose, shooting as you build the scene. For example, you can start with the bride and groom, picking a pose for them that can serve as a foundation, such as the bride with her back to the

groom's front. You can then add a set of parents with the mother facing the bride and the father behind the mother. After taking that picture, you can add all the siblings and shoot, then add the grandparents and shoot again. After that, instead of letting the pose dissolve, you can remove the parents and grandparents and be left with a pose of all the siblings together—a perfect picture for the album or, better yet, the parents' living room wall!

I designed this repertoire to include most of the basic combinations. Whoa, Steve. What is a combination? Well, I guess some definitions are in order. I think of people placed together in wedding photographs as combinations. Furthermore, I refer to a one-person picture as a single, a two-person picture as a two-up, and a three-person picture as a three-up, etc. A work-up, such as "the groom's family work-up," refers to all the pictures of a family treated as a group.

The Bride' Home

Become an Insider

The photographer is the first in a long line of people who will direct a couple through their wedding day. The priest or minister will tell them where to stand, the maître d' or caterer will tell them when to eat, the band leader will tell them when to dance, and you, the photographer, will pose them, even if only by suggestion. While the others may direct, the smart photographer suggests.

You have a terrific advantage in being the first of these authority figures to see the bride on her day. You can use your first-in-line position to your advantage. While I can (and do) shoot 48 different pictures in one hour at a bride's home, I also use this time to become an insider—a friend.

Insiders have privileges. Their counsel is heeded. This is just what I (and you!) want in order to do a better job and generate recommendations. During my first hour with a bride I ask questions. Even these questions are a repertoire of sorts, because at every wedding I'm interested in the same sort of information. It is always helpful to know such things as: How long has she known the groom? Who is her maid of honor? How close is she to her sisters and brothers?

If the bride confides in me that, for example, she's close to her sister or doesn't like her future mother-in-law, I'm on my way to being an insider. Every question I ask, every bit of information I get, is absorbed for later use. Where are they going on their honeymoon? This can be used sometime later when the groom has a hard time smiling. I can say, "Think of you and (bride's name) on the beach in Malibu (or wherever)."

A standard photo is the bride surrounded by her attendants as they fluff her gown. You can add your own creative touches to this. It can become something more if you shoot it by window light and let some of the subjects go into silhouette.
© Marcia Mauskopf

Always check your flash sync before you load your camera! And just to be safe, also check the sync before every segment of the repertoire (if not more often). That way, if your sync goes out sometime on the job, at least you'll know which photos you have to retake . . . which is another good reason to follow a repertoire!

I ask questions about the ceremony: How well do they know the cleric? Is the person performing the ceremony a friend of the family? If so, a picture of him (or her) with the couple is in order. And if the cleric married the parents too (!), you might want to take a shot of him with the parents and the couple. As important as it is to ask questions, it is more important to listen to the answers. This takes a high state of concentration. Even though a new photographer might know his or her first subjects intimately (because they're probably friends), it still pays to ask questions.

Equipment Concerns

Logistically, once you get to the bride's house, it pays to create a base of operations—a safe place where you can put your equipment. I often choose the kitchen table, but what you need is any flat surface that's away from the areas in which you'll be shooting. I usually lay out a longish normal and a wide-angle lens, some filters, a few film magazines (I shoot roll film), and so on. I also test-fire my flash equipment a few times. This is called checking the sync (synchronization).

There is nothing that puts a flash photographer's mind at ease more than knowing that the flash and camera are on the same page of the playbook. I shoot with a leaf shutter camera. These cameras let you check the flash sync relatively easily. I check my sync at every wedding before I start shooting and at breaks in the action just to be sure everything is working smoothly. I also check it each time I mount a lens.

In truth, checking the sync is one of the first things that should be taught to a green assistant. Before you teach your assistant however, have a little fun. Tell him (or her) to check the sync, and when he asks how, tell him to go into the kitchen and make sure the faucets work. Ha, ha, very funny. The point of this rite of passage is that very few assistants ever forget how (or how often) to check the sync. Just for the record, I thought I'd explain the procedure for checking a leaf shutter camera here . . . and you don't even have to go into the kitchen.

Attach the flash unit and the sync cord to the camera. With the camera empty and its back open, aim it at a light-colored wall. As you release the shutter, look through the camera from the back (where the film goes). If you see a circle of light when the shutter and flash fire, you are indeed in sync. As long as you're back there, you might fire off a few more blank exposures at different apertures to make sure the camera's auto-diaphragm system is working properly. With a smaller f/stop you should see a smaller opening, and with larger f/stops you should see a larger opening. Consider changing the shutter speeds a bit as well so you can be sure your leaf shutter is syncing at every speed.

With digital cameras, checking sync doesn't require opening the back of a camera and peering through it. After all, with the vast majority of digital solutions there is no camera back to open! But, very happily, the act of sneaking a peek through the camera back has been replaced by looking at the LCD monitor instead. This has now become so easy that there is no longer any excuse for

failing to check your flash synchronization. But before you move on after snapping off a single file to check the sync, make sure to take several test shots at different apertures and shutter speeds to verify that all the mechanical components (the auto-diaphragm and the shutter) that support the digital sensor are working correctly.

Finally, after my flash, the most important accessory I carry is my tripod. More than half the pictures I shoot at any wedding are taken with my camera mounted on a tripod. In fact, any time my shutter speed drops below 1/60 second, I mount my camera on a tripod. There are times when the tripod may be impossible to use, for example, during the church processional or on the reception hall dance floor. But generally my tripod is my constant companion. Not only will it free your hands for holding filters in front of the lens as well as sharpen your available-light pictures, it also adds a presence to your camera and it smacks of professionalism. Now we're finally ready to make pictures.

A photo of the invitation just begs to be accessorized. In this instance the bride's garter and beaded shoe play supporting roles in personalizing the image. Remember to save the invitation for the information it contains.

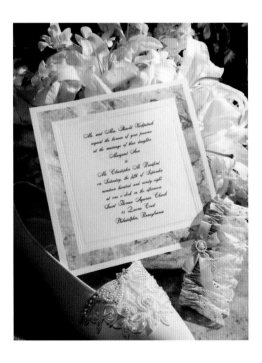

The Bride's Home List

THE DRESSING ROOM

Doing pictures of the bride's reflection in the mirror over the dresser in the master bedroom might seem a bit old-fashioned . . . and it is. However, often the bride can remember those very same photographs in her mom's album. Remember, traditions can be nice. More importantly, reflection shots can give you a few moments alone with the bride, which can help you establish rapport with her. To get some privacy, you can always point out to onlookers that you can see their reflection in the mirror (you usually can). They will ordinarily scatter. Notice exactly what the reflections in the mirror reveal. It isn't attractive to shoot a beautiful bride and her bouquet in the mirror if the reflection also includes dad's dirty socks lying next to the bed! Finally, if you're going to take photographs of reflections, remember to straighten up the bureau top. Maybe you can decorate the scene by laying the bridal bouquet (and possibly the bridesmaids' bouquets) at the base of the mirror.

1. **The Invitation and Possibly the Ring Bearer's Pillow with the Bridal Bouquet**

If you don't have a ring bearer's pillow, you might use the bride's engagement ring and/or her garter (if she's wearing one) as accessories for this invitation photograph. Bridal props are all around you on the wedding day. Don't overlook shoes, rings, champagne glasses, parasols, beaded gloves, sun hats, and bouquets as possible props.

This photo is very important for two reasons: (1) a photograph of the invitation is a great beginning to the album. You can always sell this idea at the proof review, so even if you don't shoot it here, shoot it sometime during the day; and (2) after you shoot the invitation, pick it up and put it in your camera case so you are sure of the address and name of the church!

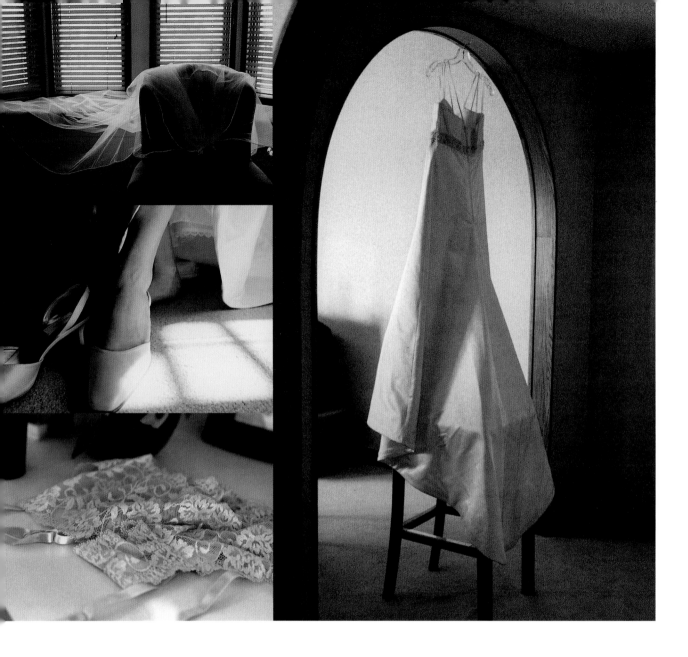

While you may laugh at this (what kind of photographer doesn't know where the church is?), if you're in a new neighborhood or lose the limousines that you're trying to follow, the invitation complete with the church's name and address printed on it, can be your salvation! Since you have it, you might even invest another shot or two and capture a the invitation propped on the wedding cake, or with two champagne glasses later on at the reception.

2. Mirror Photos

If you're doing these photographs in the traditional "candidman" style with flash on-camera, you might consider using bounce lighting to even out the illumination between the bride and her reflection. If you use direct flash, you'll find that the bride is much closer to the camera than the reflected image is, and she will therefore be hopelessly overexposed compared to her reflection. The flash unit may be only 1-1/2 to 2 feet (0.5 to 0.6 meter) from the bride herself, but to illuminate her reflection the light has to travel from the flash to the mirror and then back to her face—a total distance of

The gown is worth a picture even before the bride puts it on. And a few additional still life photos of the bride's accessories can create a montage of different but related photographs that fit together so well they end up in the album as a group of pictures.
© Marcia Mauskopf

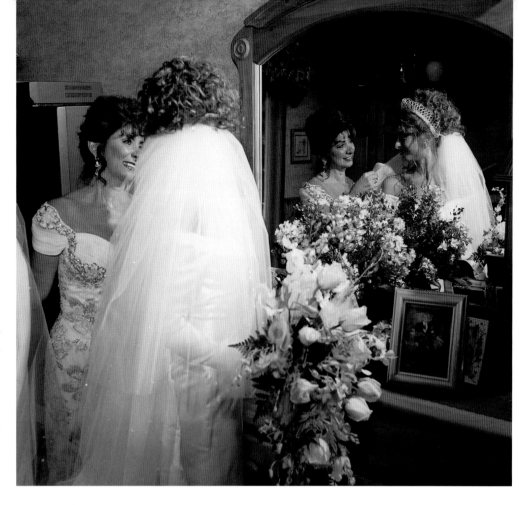

Though some consider mirror photos to be old-fashioned, most brides enjoy them because they're like photos from their Mom's wedding album. Since tradition is such a big part of weddings, it is often a nice idea to include a cherished picture from a previous generation. © In-Sync Ltd.

about 6 to 8 feet (1.8 to 2.4 meters)! In this instance, mirror photographs and bounce lighting work together to make salable images. If the dressing room has a dark ceiling, however, bounce lighting won't work. In that case, try to shoot only the bride's reflection to avoid the problem of lighting both the subject and reflection.

◆ Bride Using Comb or Brush
◆ Bride with Compact
◆ Bride Applying Lipstick
◆ Bride's Hands Holding Parents' Wedding Photo, with Her Reflection in the Mirror Behind

The first three photos are modifications of the more traditional "mirror poses," and they make use of the reflection in the mirror and a foreground item in front of the reflection. They're interesting and different from the run-of-the-mill dressing room photos, so it's worth taking one or two. In addition, if

you include one of the parents' wedding photos, you can often sell the same image for the parents' album.

◆ Bride's Hands Holding Invitation, with Her Reflection in the Mirror Behind
◆ Bride's Hand Holding Engagement Ring, with Her Reflection in the Mirror Behind
◆ Bride and Mirror Together (only if the bride can position her body close to or actually touching the mirror)

These types of photographs are not really a traditional dressing room photos and can be done anywhere. It is an especially convenient pose to use in catering halls with mirrored walls, and although it is a simple picture, the results look special. Remember it when you're up against the (mirrored) wall! Try shooting the bride's face and reflection, either with her looking at her ring or at the bouquet.

3. Mom Adjusting Bride's Veil

4. Bride and Maid of Honor

As an aside, for this picture you might want to do something really corny with the maid of honor such as having her adjust the bride's garter. If you decide to go this route, consider including the flower girl covering her eyes as the bride lifts her dress to reveal her garter.

THE LIVING ROOM OR YARD

In colder climates, bad weather, or houses without beautiful yards, you'll find yourself taking photographs of the bride, her family, and her attendants in the living room or family room. If the room has a white ceiling, once again bounce lighting is the way to go.

Shooting indoors has some limitations. Photos of groups require a wide-angle lens, and between changing lenses and putting down your camera and flash to arrange each picture, things proceed more slowly than outdoors.

Shooting outdoors usually takes less time, especially if your camera is tripod-mounted and you're shooting under natural light. If you decide on the outdoor route, here are a few hints: Look for open shade so you don't have to use flash fill. Open shade makes complexions look smooth, which is just the effect you're after. When you're searching for a portrait location in open shade, imagine what the backgrounds will look like. If the backgrounds are lit by direct sunlight and your subject is in open shade, you'll find that the backgrounds are overexposed and will generally detract from your primary subject. As with all rules, though, this one begs to be broken. But if you decide to break it, do so only occasionally.

I find that some of the best backgrounds are out-of-focus green smudges created by such things as high shrubs or low trees. While the smudged background really isolates the subject, shooting with greenery in the background is another rule ripe for breaking. Even the bride's house can be an effective, if busy, background. Some might say that if you can include in the background the place where the bride grew up, so much the better.

Sometimes you'll have an embarrassment of riches, and both the front and back yards will be photogenic. In this instance, try to use both locations because the variety of backgrounds can increase your sales. When I first arrive at the bride's home, I spend five minutes looking for backgrounds and deciding which sections of my repertoire I'll shoot where. It's time well spent. Don't overlook little nooks and crannies that might be good for single or two-up portraits. A porch or corner of the yard might be great for a small photograph. Equally true, look for stairs and banisters that might help arrange larger groups in an interesting composition.

Ring boys are always worth a picture, especially if the little guy is all puffed up with pride. Not only might the bridal couple want this picture, but you might sell the image a second time as a portrait to the boy's mom. © Michael Zide

One of the primary emotions of any wedding day involves "daddy's little girl" moving on to a new life. A photo sure to be cherished is one where Dad gives his daughter a kiss good-bye. © In-Sync Ltd.

1. Bride and Dad: Formal

2. Bride and Dad: Kissing Him on the Cheek or Hugging Him

This picture may appear to be a relaxed version of the previous "Bride and Dad" shot, but you can have two possible sales if you change the background and the pose enough to make the photos different.

3. Bride and Her Parents: Two Images

You'll notice that I call for this and some other photos to be shot twice. That's because this photo is a specific "bread-and-butter" picture that's in every album. It would be a pity to have one of the three principal subjects blink during the only time you shot that image.

◆ Bride and Her Parents: Selective Focus

The idea is to focus on the bride with her parents in the background, slightly out of focus. This different approach to a bride-with-parents photograph is a perfect candidate for selling a two-page spread, but to pull it off you must shoot the same picture later with the groom and his parents (see page 66). You can even take this spread idea one step further and reverse the pose for the second photograph. Put the bride on the right side of a horizontal composition; when you shoot the other half of the spread, "Groom and His Parents: Selective Focus," you will place the groom on the left side of the frame. That way, when the images are viewed as a two-page spread in the album, they will fit together better and it will make selling the idea easier.

4. Bride's Parents Alone: Two Images

Once again, this picture is a sure-seller, and it might even find its way into a parent album or a frame. Because it's a must-have image, it's worth taking two or even three shots.

5. Bride and Mom: Regular and Soft Focus

The relationship between the bride and her mom can be particularly close. Your photograph of the two of them should show that bond. I try to make this a special picture and almost always shoot more than one.

A popular variation is of the two women together taken with a soft focus or diffusion filter over the lens. Almost any time you photograph a mature woman in this kind of stylized atmosphere, it pays to shoot a photo or two with a diffusion filter. My case has four different diffusion filters so I have a selection to choose from (see pages 157-158).

Shoot Matched Sets

Here is an important point that I will mention more than once: Think about selling and producing album pages in twos, as a spread. That way you might convince the bride to use a formal spread that includes her with her mom next to a photo of the bride and her dad. Somewhere later (or earlier) in the album you might be able to sell another "bride and individual parent spread" if you have two more casual, different images to put together.

6. Three Generations: Bride's Side

Three generations in one photograph are something special. If they are all of the same sex, it is even more so. If the bride's mom's mom (whew) is present at the house, a picture of the three women will almost always make the album. I don't know if the three-generation picture was the invention of some enterprising photographer, but regardless of whose idea it was, the picture has become a standard. If the bride has a sister who has a daughter that is there, then you have a four-generation picture. Once the picture has ballooned to five subjects (grandma, mom, the bride, the bride's sister, and the sister's daughter), you should add in any other sisters of the bride for one, grand, multi-generational extravaganza!

7. Bride and Sisters (and optional, Bride with Each Sister or Bride with All Siblings)

This group of images (and the next category as well) can create a sticky dilemma. If you shoot the bride and all her sisters together, chances are good that you won't sell pictures of the bride with each individual sibling. Likewise, if you shoot the bride with her brothers and sisters together, you won't sell the photos of the bride with her sisters and of the bride with her brothers.

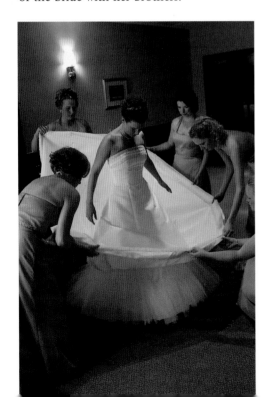

While a posed picture of all the bridesmaids with bouquets neatly displayed is usually part of any wedding album, a more casual rendition is also a nice image. But, if pressed for time, this shot can be done at anytime during the day. And don't forget, it pays to look for a similar casual photo of the groom with ushers that can create a possible two-page album spread.

Why should she buy two (or more) photographs when she can have the same people in just one? This is a double-edged sword, because one photograph of all the siblings together usually finds its way into a parent album and is often the type of photograph parents display in their home.

Here are some suggestions: If you decide to shoot the bride and each sibling individually, you must get all of them if you expect the pictures to sell. A bride won't include photos of just four of her five siblings in the album. It can become political.

Realizing this, if you can't get each sibling alone with the bride, you may decide to shoot all the siblings together. If so, it pays to remember that often the youngest sibling has a special place in the family (which is especially so if he or she is noticeably younger than the rest) and might be worth a single image with the bride or groom anyway. Further, if the bride (or groom) is half

*One problem with bouncing a flash off the ceiling is that anyone looking downward has her (or his) face in shadow. But in this case the crafty photographer used the flowing hem of the bride's gown to turn the gown into a giant circular fill card.
© Mark Romine*

It pays to single out special people in the bridal party for individual pictures with the bride. While this obviously includes the maid (or matron) of honor, you should include separate pictures of the bride with flower girls. This photo is less formal and more intimate because the bride is kneeling at the same level as the kids. © Freed Photography

of a pair of twins, a separate image of them together is worthwhile because of the special bond between them and how the family perceives them. Finally, if any siblings are married, you can leave their spouses out of the sibling shot, but be sure to do a few special pictures of the married siblings and their spouses together with the bride and groom later in the day.

8. Bride and Brothers (and optional, Bride with Each Brother)

See above.

9. Bride and Bridesmaids (and optional, Bride with Each Maid)

The bride with all the bridesmaids and the maid of honor (and matrons of honor, and the junior bridesmaids, and the flower girls, etc . . .) is a must-get picture. However if the house is tiny or the yard is not photogenic, you can always pick up this group picture while the formals are taken after the church ceremony (see page 61).

Shooting a series of the bride with each maid is interesting for its sales potential. Although it won't produce photographs for the album, it will give the bride a nice memento to give to bridal party members. Remember, if you go this route, you'll have to produce the same set of pictures for the groom with his ushers. You might even try to get photos of couples within the bridal party for more sales possibilities. In the same vein, with an eye to future assignments, if there are any bridesmaids and ushers who are engaged, they too are worth a separate portrait. Because these pictures aren't specifically for the album, they should be eliminated from your repertoire if you are pressed for time.

◆ Bride and Flower Girl

Like the extra photo of the bride with the youngest sibling, this picture is also a stellar seller because dressed-up little kids are so cute. You can make this kind of photograph a real Norman Rockwell. Don't be afraid to ask them to touch noses or something else equally as sweet.

10. Bride Alone: Three to Four Close-up Poses, Two to Three Images per Pose

Formals of the bride alone are often the centerpiece of the entire day. It pays to invest some extra effort here. Every misplaced flower petal and lock of hair will be proudly displayed for decades by the bride and her family!

To get as much sales potential as possible, vary the framing and poses you shoot. Traditional bridal close-ups are often framed from the bottom of the bouquet to above the top of the bride's head, but sometimes, when she's holding a long, trailing bouquet,

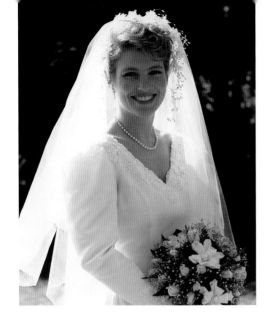

you can do some poses that don't include the floral trail. Investigate both formal and relaxed poses and change the background frequently for variety. A few tight close-ups of the bride's face, shot with a longish lens, are also great to add to the mix. Remember to use your diffusion filter for some of the shots.

Don't be afraid to try unique poses either. Some of my most successful formal bridal close-ups have found me shooting from behind a couch with the bride leaning over the back, facing towards me, or with the bride lying on the floor among rose bouquets. The picture you take will probably be in someone's wallet for a long time. Even better, it will be pulled out of that wallet and shown to many people who are all potential customers. If you can make every bride look like a supermodel, your future's assured!

◆ By Window Light: At Least Two

Many of you are going to think that because I say you should shoot this picture twice, it is a "must-have" image. While the resulting picture is attractive and different, the real reason you should shoot it twice is because the relatively long shutter speeds required mean that any motion created by the subject or camera might ruin one of the images. The real trick in window-light photography is to

have the lens axis parallel to the window. In other words, the window isn't in front of or behind you, but next to you.

The bride must also be carefully placed. If she is next to the window, you will end up with lighting that will split her face down the middle . . . not an attractive effect. If, because of the physical layout of the room, the bride must be next to the window, you can snatch victory from the jaws of disaster by turning the bride's face toward the window's light. In a perfect world, if you have the space and you pose the bride just past the window's frame, the window light becomes a 45° frontal light, which is quite beautiful.

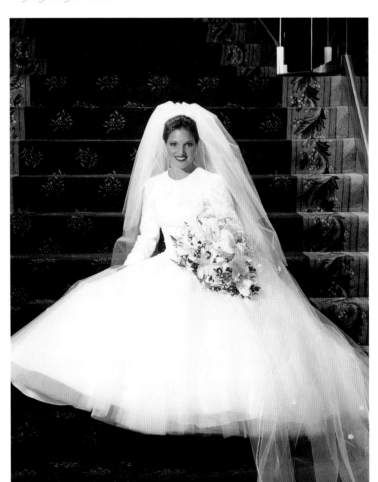

Using Masks

To make double exposures, some photographers make black paper masks that slip into slots on the front of a matte box lens shade. This allows them to be very precise in placing the two images within the frame. The mask used when shooting the bride's face covers three-quarters of the frame and is large enough to support itself in the shade. However, the mask used when shooting the church (covering only one-quarter of the frame) won't stay in position without some type of support. This can be solved by mounting it onto a sheet of clear plastic. When the two masks are aligned, the image is completely blacked out.

Some shooters prepare a whole set of two-part masks for different situations, each made from black paper glued to clear plastic sized for the matte box they are using. Personally, I find it faster to work with my hands, darkslide, or pocket date book (or some combination of them), but going the mask route is more reliable.

11. Bride Alone: Three to Four Full-Lengths

Like the close-up shots, these pictures are in the "got-to-be-good" category. Once again, variety is key. Show off the line of the dress by placing the train behind the subject. Make the train stand out by posing the bride facing away from you and having her swivel at the hips so she's looking back over her shoulder at the camera. Try a frontal pose, but pull the train around from behind her and drape it in front of the gown. Every bridal album you see can be a source of new full-length poses of a bride in a gown. Buy a few copies of *Bride's Magazine* or *Modern Bride* for fresh full-length ideas. Considering

This is what the double exposure of the bride looking at her ceremony looks like in its completed form. You can make photographs like this only if your camera has interchangeable magazines. Take the first photograph at the bride's house and remove the magazine from the camera without advancing the film. Save the magazine until you get to the church and take the second half of the image. The only tricky part is to remember where you placed the bride in the first image.

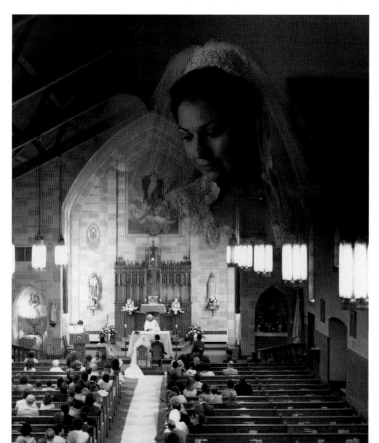

the importance of the bridal formals, sometimes I'll reshoot a few ideas after the ceremony because the bride is more relaxed then.

12. First Half of a Double Exposure

This special-effect photograph is really two shots in one. For film cameras, it works best with those that have interchangeable magazines, and it helps to use a tripod. If you plan things carefully, you will do the first half of this effect near the end of the first roll so you don't tie up a magazine unnecessarily.

In the first half of the double exposure, I photograph the bride's face in an upper corner of the frame while blocking off the remaining three-quarters of the composition. For this "in-camera masking" I use my hand to block off part of the frame, creating a soft-edged mask so the two images will eventually blend. By stopping the lens down to the taking aperture, the edge of the mask comes into focus allowing me to see exactly what I'm blocking and what I'm including. I position the bride's face within the frame so that she is looking down at the opposite (lower) corner of the composition. After the first exposure, I "save" this magazine without advancing the film, and later when I get to the church, I reattach the magazine and photograph the church interior with the altar in the place where the bride's face is looking. When I do the second exposure, I use a dark slide or a small piece of black cardboard to block off the quarter of the frame where the bride's face is.

Many digital photographers know that combining two images in the computer is little more than a mouse click away. I have found it is much easier to sell double (or multiple) exposures if the couple (and their families) can see the resulting image on the proof. If you show a bride an image of her looking down in one picture and the ceremony in another, she might not be able to pre-visualize how the two will look together.

This fact hasn't been lost on digital camera manufacturers, because some of the latest models have just such a double exposure capability built into them.

LEAVING THE HOUSE

1. Bride, Parents, and Bridesmaids in Front of House

This photograph gets all the principals and the bride's homestead in one photograph. It can be argued that if you're late to the bride's home (a flat tire, a car accident, your pet goldfish died, you had another wedding just before this one, . . . etc.), this is the one picture you must get. All the other photographs that you would have taken at the bride's house can be picked up later in the day. From mirror shots at the catering hall through formal bridals at the park after the ceremony, everything else can be patched as the day progresses. But once you leave the bride's home for the church, you won't be returning there for the rest of the day.

2. Dad Helping Bride into Limousine

One night I was watching a very good wedding video cameraman. He was doing a slow pan of a Viennese dessert table, followed by shots of individual displays of desserts to be used for wipes and dissolves. I asked him how he chose which ones to shoot, and he said, "If it costs extra money, I shoot it."

Now back to the limo. Limousines cost extra money. Couples spend even more money on top of that for specialty rides. Antique cars, white Rolls Royces, horse-drawn buggies, and other unique vehicles often spend their weekends hauling around bridal parties. If the couple went to the trouble of hiring a limo, or an even more unique vehicle, I include it in the pictures. After all, it cost extra money.

Sync Check, Take Two

Check your sync and the frame number you're on before the ceremony starts! If you are on a "short end" (the end of a roll), it pays to dump it and enter the aisle with a full load. If you're using a camera with interchangeable magazines, switch to a fresh one now. You won't be able to change film easily once the processional begins!

ARRIVING AT THE CEREMONY

1. Dad Helping Bride out of Limousine (or variations)

This picture doesn't really have to be of the bride being helped out of the car or limo by her dad. It could be the bridal party, the bride and the crowd, or the bride and her mom standing together. Whatever I shoot, I try to include the church in the background of this photograph. If the church is beautiful, this type of photo can set the scene for the ceremony section of the album. If the church exterior isn't photogenic (or the weather is crummy), I forget the limo shot and try to catch a photo of the bride and her dad in the church vestibule. This totally candid moment between the bride and father is often filled with emotion. Sometimes you can ask the bride to kiss her dad on the cheek or ask him to kiss his daughter on the forehead. Mom will cry for sure . . . AND they'll buy the photo!

All of this must happen quickly. I can't waste a lot of time, because I still need to meet the cleric and the groom before the ceremony starts. Before I walk down a side aisle to introduce myself to them, I stash my tripod in a rear pew of the church so it's available quickly when the time comes for some fairly long exposures during the ceremony. Then I drop my small camera bag filled with shooting essentials in a front pew on the side of the church. Now I'm ready to go meet the minister (or priest), groom, and best man.

The Ceremony

Although I am a hard-core professional, I try to remember that the reason for the entire wedding day, from flowers to fancy limos, is the ceremony. Without it there would be no bride, groom, or party to shoot in the first place. On a pragmatic level, your respect for the institution will also make your dealings with the clergy much easier. In the scenario this repertoire is painting, once you arrive at the church you have two important contacts to make: the person performing the ceremony, and the groom.

Time has a funny way of turning small calamities into fond memories of the wedding day. So, don't necessarily gloss over those little foibles. If it's raining or there's a snowstorm be sure to document it. Twenty years down the road this bride will remember rummaging through the closet and only finding her mom's old red umbrella.
© *Michael Zide*

Meeting the Cleric

Once you walk into the church you are on G-d's playing field, and the cleric is the referee. Clergy have specific ideas about where, when, and how to take pictures in the church and during the ceremony. In their house, they make the rules. Because of this, I usually seek out the cleric first before meeting the groom.

In a small community it is good business to be friends with the local clergy. The longer you are in the business, the more familiar you will become with the churches and the clergy in your area. There have been times, on a busy weekend, that I have seen the same priest in the same church four times! Cultivating a good working relationship with area clergy will serve your reputation well.

Just as I do when I meet the bride in her home, I have a few agendas to cover when I introduce myself to the cleric. First, once again, I want to become an insider. After all, it never hurts to have G-d on your side! Usually the first words out of my mouth after saying hello are, "What rules would you like me to observe?" This question accomplishes several things: I get information not only about the ceremony, but more importantly, about how rigid the cleric is. If I'm presented with a laundry list of "Don'ts," my first response is to say, "I wouldn't do that!" If the cleric tells me he or she has seen too many photographers who have broken the rules, I usually say, "I don't know what other photographers do, but I know that I don't." Actually, I'm being very sincere, because I really don't want to do anything to spoil the couple's day. On the other hand, if the cleric tells me, "Anything goes as long as you don't climb up on my shoulders!" I know that the situation is more relaxed. Some members of the clergy do not allow flash during the ceremony, others don't care. Some will re-pose the important pictures after the ceremony, and even though I know there is no eleventh commandment that says" Thou Shalt Not Use Flash," I go along with the clergy's requests. Remember, it's their playing field.

After reading the cleric's personality, I ask questions about the ceremony. Is it possible for the bride and groom to face each other during the exchange of rings? During the exchange of vows? Is the couple making any presentations or coming off the altar to greet the parents? Are they lighting a candle? Where will the candle be? When will it happen? Absorb, absorb, absorb.

My last question is conspiratorial. I ask if another ceremony is being performed in the church after this one. This helps me know

A private moment between the groom and his dad is always worth a picture. This often is particularly interesting because of the role reversal it depicts— there was probably a time when dad helped his son with his tie. A photo with roles reversed is symbolic of a major passage in life. © George Weir

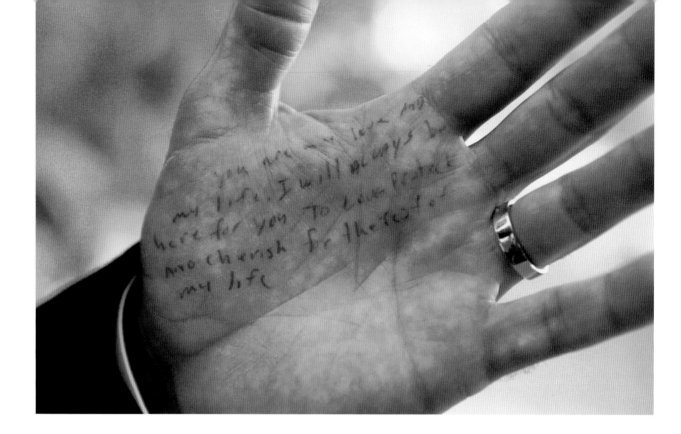

Details! You must keep your wits about you and take the time to capture them. The photographer who shot this photo told me that it was the clergyman who pointed out the groom's crib sheet scribbled on his hand. Kudos go to her, though, for taking a picture of it! © Marcia Mauskopf

how to pace myself, for instance, whether I should rush my photographs after the receiving line. These questions are usually the clincher, because clerics know I am now thinking about their schedule as well as mine. This puts us on the same team! This two-minute investment of time usually leaves me satisfied with my relationship, and it will then be time to move on to meet the groom.

At this point I must sadly say, however, there will come a day (I can promise you) that you will meet a crusty old cleric who is having a bad day and no matter what you say or do, he or she will be peeved with you! There is nothing you can do about it. Weird as it may sound to neophyte shooters, there are some people who just do not like photographers—not just you, but all photographers! And you will also find other people like the crotchety cleric who make your job more difficult; for example a florist with an attitude, a maitre'd who thinks he's a prison commandant, or a bandleader who assumes his microphone makes him the appointed leader (it actually does!). When you meet one of these 'special' people, always try to be polite. But remember, you still have a job to do, and regardless of anyone else's outlook, you cannot let them affect how you feel about both your work and about the bride and groom, who probably feel just as frustrated by a sourpuss as you do! No matter what happens, never ever lose your temper or self-control. Happily, I can tell you that as your people skills improve, you may find it both interesting and challenging to try and turn such a cantankerous person into a friend. Some of these individuals have turned out to be real friends of mine. Since you're going to be running into them anyway, because both of you work the wedding world, your efforts at diplomacy can be very fruitful.

Without a doubt it is always better to sell two pictures instead of one. Sometimes you can even string together a few pictures that work as a unit. When you are shooting the action, don't be so fast to lower your camera after taking the first picture . . . in situations like this try to be aware that seconds later there might be another photo op that will augment the first picture you took.

Meeting the Groom

Meeting the groom is just like meeting the bride, except when you meet the bride at her house, it is an hour or two before the ceremony. When you meet the groom, the wedding ceremony (probably the most significant life change he's ever experienced) is staring him right in the face.

If you're a studio owner, this is the first time you will be seeing the groom on his wedding day. If you're a candidman, this will probably be the very first time you will have met the groom, ever. Since you're going to be photographing this person for the next five to seven hours, first impressions are important. You could walk up, say hello, shake hands, and off you go. If only life were so simple. While the bride hadn't yet reached a precipice of panic when you met her, the groom is definitely there! And, although you had an hour to build a rapport with the bride, you've got just 30 seconds (literally) to make the groom comfortable with you. That is one tough act! So right after my hello, I usually start by telling the groom that his bride is not only GORGEOUS, but is a really nice person to boot (whether I truly think so or not . . . after all, he is in love with her so who am I to say otherwise?). If he seems a little nervous, I offer that she's a bit nervous, too. Misery loves company.

Mostly though, I choose my words and responses to the groom based on his body language and demeanor. I've met grooms who are so languid they looked like they were about to fall asleep. On the other hand, there are others who bounce around like a jack in the box. In the end I try to shoot an unobtrusive, easy photograph of the groom and best man together, shaking hands or maybe hugging, with some church-type stuff in the background.

Sooner or later you are sure to meet a surly groom. For whatever reason, he just doesn't like photographers (or any authority figure for that matter). Who knows? Maybe he started celebrating early (some people become more aggressive once they've hit the sauce!) or he's paying for the photography even though he had no input in choosing the photographer or the size of the picture order. Despite the amount of time you will need to spend with an irritable groom, never lose your temper or self-control! Consider yourself as "human Valium," and regardless of what the groom throws your way, remain easygoing. Never let anyone stop you from doing your job. When the proofs are delivered, the groom won't remember his own attitude, but his bride will not understand nor be happy with whatever your problem was that day.

Photographers who prefer "PJ" or photojournalistic style will often tell you that the best pictures are the ones in which the subjects are unaware of the camera's presence. This may be true but if you tell the groom and his best man to look up the aisle (and not at you) it's not a pure "PJ" shot but it sure looks like one. © Jan Press Photomedia

The Ceremony List

GROOM AND BEST MAN: TWO SHOTS (POSSIBLY THE SECOND AS A GAG SHOT)

A photograph of the groom and best man in church can be a simple affair, but sometimes a corny gag shot can also be fun. I've seen pictures of the best man holding onto the groom's coattails as he tries to bolt for the door or the best man pointing to his wrist watch as the groom tries to stretch his shirt collar with a finger tip. You can always shoot the best man adjusting the groom's tie or boutonniere. Although I personally find some gag images tasteless, they do offer a variation on the typical "groom and best man shaking hands" shot. In certain instances, when the groom seems especially close to the person performing the ceremony, I've included him (or her) in a photograph with the groom and best man.

THE PROCESSIONAL

For many, the bride being escorted down the aisle by her dad is the most important photograph of the day. The problem is that many candidmen go weak in the knees when it comes time to shoot pictures of people walking straight at them. You can't possibly focus on your subject and shoot simultaneously as he or she is walking towards you. By the time you move your hand from the focusing ring to the shutter release button, the subject will have moved out of the plane of focus.

So, prefocusing on a specific pew can be a great help. When the subject is one step away from the prefocus point, raise the camera to your eye and push the shutter button. By the time you've brought the camera up, the subject will have walked into the prefocused spot!

There is another way to prefocus, but it requires a lot of practice. In this technique, you must learn to judge distance accurately. All you need to do is preset your focusing scale to a specific distance (let's say, 10 to 12 feet [3 to 3.7 meters] with a 50mm lens on a 6 x 6cm camera, a 28mm lens on a 35mm camera, or a 20mm lens [approximately] on a DSLR that has less than a full-sized sensor). After all the practice I've had, I've learned how large the subjects look in my viewfinder when they are the correct distance away from my camera. My brain (twisted as it is) even takes into account the different heights of different subjects in order to ensure sharp focus.

I can hear many of you saying that this pre-focus mumbo-jumbo doesn't apply because you have an autofocus camera. However, I believe the photograph of the bride and her dad on the aisle is not the place to put your trust in an autofocus system. I know you've all seen photographers at pro football games shooting with autofocus without a second thought. But football stadiums are lit for TV cameras. Church interiors, where a man in a black tuxedo is walking with a woman wearing a sail-like expanse of pure white, are dim! In fact, I might even be willing to trust autofocus in a candle lit church, but only if both the bride and her dad were wearing orange jerseys with 12-inch high white numbers sewn to them.

Truth be told, every summer I teach a wedding photography course at the Maine Photographic Workshops, and my class goes to a church where we try to photograph two models (resplendent in tuxedo and wedding gown) as they walk down the aisle. The vast majority of my students come to the course equipped with an autofocus SLR and all of them get set to do the aisle in autofocus mode. Unbeknownst to them, I instruct the models not to stop as they walk down the aisle. Invariably, most of the students freak out when their autofocus cameras start to hunt in the dim church as they try to lock onto the featureless subjects! The bridal couple glides by and the students never get off a shot. If you believe, as I do, that the bride and her dad on the aisle is a must-get photo, then I implore you to forsake autofocus and go with a preset manual focus technique in this situation. There are no do-overs on the aisle!

1. Mother of Bride and Mother of Groom Being Escorted Down the Aisle

These two photographs are important because many times a mother is escorted down the aisle by one of her sons. While both pictures are important, I always take a moment to introduce myself to the groom's mom as soon as she is seated (remember, we haven't met yet). Because the ceremony is about to start, there isn't a lot of time, but I can usually say, "Hello, I'm Steve. Congratulations—we'll talk after the ceremony." While our after-the-ceremony "talk" will probably be limited to "Congratulations," my simple introduction lets her know that I know who she is, and it helps break the ice for shooting the groom's family pictures later.

Taking a photo of flower girls walking down the aisle should be a no-brainer. Even if they're crying from nervousness they are still just so cute! And, even better, not only will the photo make the bridal album, but the flower girls' parents and grandparents will probably want a copy too.
© Mark Romine

2. Each Bridesmaid Walking Down the Aisle

Some feel that a picture of each bridesmaid walking down the aisle is a waste of effort and material. To a certain extent they are right. These pictures are used infrequently in an album. They are competing with those taken of the bride and her maids at home. However, the bride and groom's sisters walking down the aisle are definitely worth a photo each. Even if they don't make the bridal album, they may be used in a parent book.

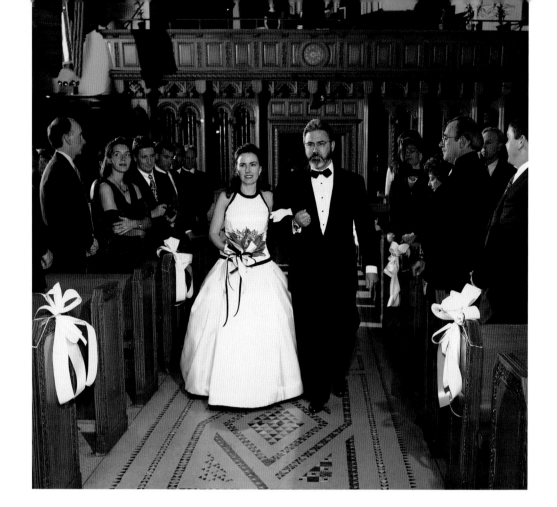

One of the most important images of the whole day is of the bride walking down the aisle with her father. This example shows the effect that room lights can have in illuminating the background and guests. While the bride and her father are lit by the two battery-powered frontal lights, there is a third AC-powered light set off to the side that is illuminating the rear of the church. Some of the third light's output is spilling onto the bride's right side, but the overall effect is that the "miner's helmet light" look has been eliminated. © In-Sync Ltd.

3. Maid of Honor Walking Down the Aisle

A picture of the maid of honor often makes it into the album, and even if it doesn't, the bride often presents a print to her as a memento.

4. Flower Girl and Ring Bearer

Pictures of little kids always seem to be purchased by someone. Many times the children are the couple's nieces, nephews, or cousins. If the photograph doesn't make it into the main album, someone else in the family will buy the image.

Although all the other aisle photos are taken from an identical distance, these shots require the candidman to wait for the sub-jects to take one extra step closer to the camera so they fill the frame. You must change the focus setting and the f/stop, but the results are worth it. It then becomes important to reset the camera for the bride and her father walking down the aisle because they are next and that is the most important shot.

5. Bride and Dad Walking Down the Aisle: At Least Two Shots

Remember, this is "The Shot" to get at the church. Every album I have ever seen (and that's been thousands) has a picture of the bride in the aisle. While in many other situations, one shot is all that's required, in this instance you should splurge and shoot at

least two. Without this picture, you have not completed the assignment, no matter how nice everything clse looks. You can produce a beautiful 80-photograph album, but if you miss this photo, your "great wedding photographer" reputation will be tarnished... at least in the eyes of this bride and groom's families!

With today's SLRs and DSLRs, the mirror flips up and blocks the viewfinder at the moment of exposure. It's amazing how many brides and their dads glance at people along the aisle at that same moment. If they don't do that, then they blink. With a little practice, you can lock the camera in position and then move your head so you are looking at the actual subjects instead of the image on the ground glass. That way you can see exactly where the subjects are looking the moment you press the shutter release without having the mirror block your view. This is a technique that's well worth practicing.

6. Dad's Kiss Good-Bye

This scene is always viewed through tearful eyes, but you, as the candidman, can't afford to enjoy the precious moment. You have to record it.

If you back up into the altar area, getting this picture can be tricky—you run the risk of people blocking your shot. That's because the area where the father is kissing his daughter good-bye also puts you into the space where the groom, the cleric, the best man, the maid of honor, attendants, and assorted ring and flower little people are. Not only are all the big folk craning to get a better view of the bride and her dad, but as you try to position yourself, you have to avoid the stationary or moving children! Shooting the father kissing the bride from the "altar side" can sometimes leave me feeling like a pinball in an arcade game.

By doing some fancy footwork you can avoid the "altar-side" trap. Right after I shoot my last photograph of the father escorting the bride down the aisle, I stop back-pedaling and step forward, towards them. As I'm moving forward, I step to the bride's father's side of the aisle. I then step up against a pew as the bride and her father pass by. Right after they glide past, I re-enter the aisle behind them, being careful to avoid stepping on the bride's train. I take one more step back up the aisle, away from them, and when I turn around to face the altar the father is kissing his daughter good-bye right before my eyes. AND, all of the "problem people" in the "altar-side" scenario are now background onlookers helping my picture instead of potentially ruining it! As an added benefit, I'm approximately the same distance away from the subjects as I was when I shot them coming down the aisle (but now I'm facing the opposite direction), so without changing my camera's settings I can literally lift it to my eye, frame the shot, and push the button. That is, only if my picture is rushed. Given a few extra seconds, I reset the camera and move a step or two closer to the bride and her dad.

Although this dance of the candidman generally works well, there are some important rules worth remembering:

1. You must step to the "father's side" of the aisle as you're moving forward so that when you re-enter the aisle, you have less chance of stepping on the bride's train, which is a definite no-no.

2. If the aisle is very narrow (or very short), you might not be able to "get by" the bride's father, and your only recourse is the dreaded "altar-side" view.

3. The priest or minister may ask you to stay in one position during the processional. Whenever I'm faced with having to shoot from the "altar side" for the kiss good-bye, I consider it a challenge as opposed to a problem. It's a harder photograph to do than the "aisle-side" photo, but that can keep life interesting.

READINGS OR MUSIC

During the readings or special musical entertainment, you must work as candidly as possible . . . that is, if you decide to photograph them at all. Since I left my camera bag in a front pew, it's readily accessible, and I can change to a longer lens and try to shoot these from a side aisle. I try to get these shots early so I can then leave the front of the church and go to the back, where I stashed my tripod, for the next few shots.

SECOND HALF OF A DOUBLE EXPOSURE

Remember back at the bride's house when we did the first half of a double exposure (see page 39)? If you're using film, now is the time to find that magazine and re-attach it to the camera. I use a dark slide to block off the area where the bride's image is and

arrange my composition so that the bride appears to be looking down at her own ceremony. Although I used my hand to create a soft edge on the first half of the image, the hard-edged dark slide will suffice now because the soft edge of the first image is enough to create a nice blend.

You may be nervous the first time you do this, but after a while these simple types of double exposures will become the proverbial piece of cake. Because doubles sell, other double-exposure possibilities are also worth exploring. If there are great stained-glass windows in the church, you might try shooting the couple at the altar while blocking off the top of the frame. You can then make a second exposure of a suitable piece of stained glass. Sometimes I'll go outside and photograph the facade of the church

I like to think that choir lofts were part of a divine plan so photographers could capture a bird's eye view! Each time I enter a church or banquet hall I make a point of looking for lofts and balconies that can help me get a distinctive view.
© *Glenmar Photographers*

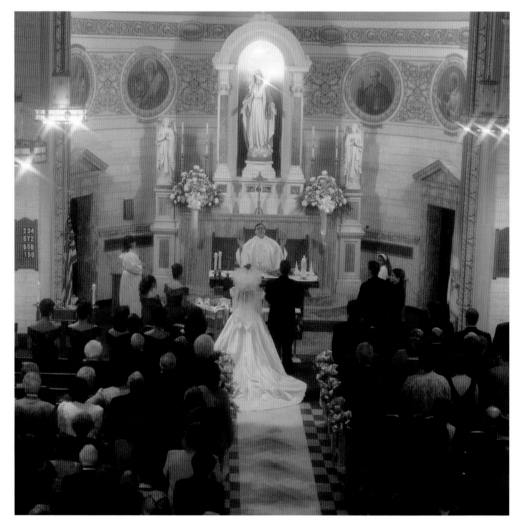

while blocking off the area where the church doors are. The second half of this double is an interior view of the altar, positioned in the frame where the church doors would have been in the first half. When I do the second half of this double, I mask the parts of the frame that overlap my exterior view. The resulting double exposure is of the ceremony floating on the church facade where the doors would be. It's very effective.

LONG EXPOSURES FROM REAR

After the second half of the double exposure, it's time for some overall views of the scene. Slower shutter speeds are possible and often necessary with these long views to achieve good exposure. And don't worry too much about motion blur, because even if someone moves, they will probably be too small in the frame to have it be noticeable.

You can do some things to add variety to these photographs, often resulting in multiple sales. Place a star or soft-focus filter over your lens to create an interesting, romantic effect. Look for a door leading to the choir loft and get a bird's-eye view of the proceedings. Or, you might take your camera off the tripod and lay it on the floor for a worm's-eye view. If you go the floor route, you can slip your pocket calendar or wallet under your lens hood to raise the front of the camera a bit. Last, you might consider taking a few shots with a wide-angle lens and then switching to a short tele for more possibilities. Although orangey in color, these types of shots create variety because they are different from flash exposures.

If you're shooting with a digital camera, you can set white balance to easily match the color temperature of the scene to spectral sensitivity of the camera. This means that churches lit with incandescent lights won't appear orangey as they do on daylight balanced film. But, just because a correct color rendition is, well . . ., more correct, that doesn't mean you can't experiment

Even an austere church can be gussied up with a simple double exposure. This type of photo shows off both the inside and outside of the church simultaneously, which makes it unique. If you're the only photographer in your area who shoots pictures like this, you will get a lot of referrals because of its uniqueness.

with other white balance settings for a different look. If your camera has Kelvin settings, you can try both 2400K (the approximate color temperature of low wattage incandescent bulbs) and 3200K (which is the color temperature of quartz halogen bulbs). The 2400K will probably be most accurate, but the 3200K will be slightly warmer (but not as orangey as using a setting of 5600K) and possibly more to your liking. Regardless of your choice, you absolutely must remember to reset your camera's white balance back to its flash setting when you go back to using your flash!

By the way, a photographer once told me that his long exposures of the church are always one second at f/4 on ISO 160 color negative film. In general, I hate sharing exposure information because of the vari-

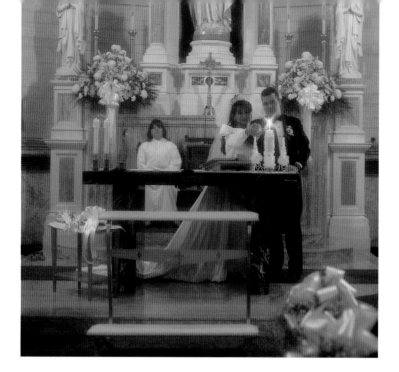

ables involved in every situation, but after shooting 3,500 or so weddings I can tell you that one second at f/4 using ISO 160 is usually just about right, as long as the sun isn't streaming through the church windows!

Once again, there is no time to dawdle. The instant you're finished with the long exposures, it's time to put the camera back onto your flash bracket, because the ring exchange is next.

RINGS TIMES TWO

Most ceremonies today include the exchange of two rings, and that's worth considering when you plan the album. It is a very easy sale to suggest placing both ring shots on facing pages. If it's only a single-ring ceremony you lose out, but that one shot is still a keeper for the album.

CANDLE LIGHTING

Very often today's couples light a candle during the ceremony. Because my camera's not on a tripod when this happens, I try to shoot a hand-held exposure just by candle-light, and if I can throw on a star filter, so much the better. Before I gamble on my steadiness however, I try to grab a quick shot with flash. While the flash picture isn't as unique, it is cheap insurance if my steadi-

ness isn't up to snuff. If I can't get an available-light exposure of this moment, it can sometimes be posed after the ceremony, but even then it's usually rushed.

SPECIAL TRADITIONS

1. Mass

It's hard to believe, but the most difficult thing to do during a wedding Mass is to stay focused (pun intended). During a simple wedding ceremony, there is always something to shoot, and there is little down time. Everything you do must be carefully orchestrated to fit within a very limited time span. However, a ceremony that includes Holy Communion features long periods of time during which you do nothing but wait for the next photo op. While this may seem like the easy part of the assignment, it could turn into a series of missed opportunities. Forewarned is forearmed, . . . so leave your IPod in the car and stay alert!

2. Couple Kissing at the Sign of Peace

Very often the priest or minister doesn't allow the couple to kiss at the end of the ceremony. But between the vows and Holy Communion (if it is offered), there is often an intimate moment between the couple at

the Sign of Peace. So before the service, one of the questions I ask the cleric is if the couple will kiss at that point. If so, I place this moment in my repertoire. I also ask if the couple is going to share that moment with their parents. If the answer is yes, then …

3. Bride and Groom Kissing Parents at the Sign of Peace

When the bride and groom come off the aisle to exchange greetings with the parents, you are faced with an interesting dilemma. Usually the bride goes to the groom's parents while the groom goes to the bride's. After the exchange of kisses the couple switches sides, and each greets his or her own parents. If you try to shoot the bride with the groom's parents, you miss the groom with hers, and when the two exchange places you're faced with the problem again. I wish there were some pat answer for this, but there isn't. Who's paying your fee? You make the choice. Whichever way you go, you'll be leaving someone out. Even if you try every trick in the book to speed up the operation of your camera, you will still probably be limited by your strobe's recycle speed. Get over it.

In the rare instance when the couple (as a unit) greets each set of parents, your problems still aren't over. As the bride kisses the groom's mother, she leans forward, effectively blocking the exchange between the groom and his father. It happens again on the bride's side, but now the groom is the blocker (and the bride's the blockee). Once again, get over it!

4. Drinking Wine and/or Receiving the Host

Photographing the bride and groom receiving the host and drinking the wine during Holy Communion is a bit tricky. In the first place, you're going to need to take at least four pictures in rapid succession, so you need to check which frame you're on (just as you did when the bride was coming down the aisle) and, if shooting with film, reload your camera if necessary. You can often get these pictures through the door to the sacristy, but it still requires quick thinking and reactions. Watch out for wine cups and hands blocking faces. Sometimes the bride watches the groom, or vice versa, and that too makes a great image. So as not to intrude on this sacred moment, it is a good idea to use a medium or short telephoto lens.

5. Presenting Flowers to the Church

Often at the conclusion of the ceremony the bride will present a bouquet of flowers to the church. In all the times I've seen this, she has been accompanied by the groom as she lays the flowers at the base of one of the statues in the church (Blessed Mother, Our Lady . . . etc.). Sometimes you can move in for a close-up of the scene, but you might consider shooting from a greater distance to include the groom, statue, and some of the ambiance of the church. If you move in too tight on the scene, the shot can become meaningless . . . after all, the statue and floral arrangement could be anywhere. Including the groom in the scene is a nice touch because this is one of the first things the couple does as husband and wife.

6. Other Religious Traditions

In different parts of the country there are sizable ethnic communities that don't have typical religious ceremonies such as those I've discussed. Many of these communities can be large enough to support a wedding studio all by themselves. Developing an ethnic specialty can be very lucrative. In the greater New York area (a diverse melting pot), there are large communities of Italian Roman Catholics; Orthodox Greeks; Ukrainian Catholics; and Reform, Conservative, and Orthodox Jews to name only a few. Some religious customs you might encounter include placing floral

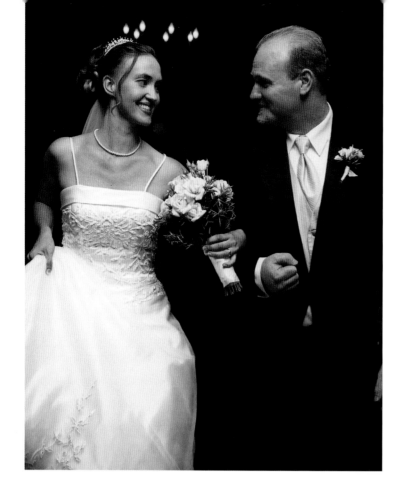

When the groom kisses the bride and the recessional begins, be prepared to go "down the aisle backwards" shooting as you go. As with the processional, you will want to set focus manually for a distance, which you maintain as you walk backwards while capturing all the action. © Michael Zide

wreaths on the bride and groom's heads, binding the couple's hands together, breaking a glass, and the bride and groom circling the altar.

Through my years of photographing weddings, I have found that first (and sometimes second) generation immigrants tend to buy pictures. Why is that? Though many of these people left their countries willingly, they also left behind their roots. Language barriers and differences in customs sometimes make assimilation into American culture difficult. Preserving both family and community customs, therefore, offers these folks a sense of comfort and security within this new culture. Family photographs become treasured items, which can be profitable for you. Shoot a photograph of grandma, and you'll sell a bunch of photos!

These groups also have a tendency to be clannish, and if one member uses a particular photographer, many others in the community follow. With this thought in mind, investigate the ethnic groups living in your area. Try to understand their culture and their photographic needs. Ask their clergy what is important photographically and find out why those scenes are important. You might find yourself with a lucrative specialty.

THE RECESSIONAL

The recessional can turn into a bit of a footrace, so you have to be on your toes. Like the processional, it is a time for prefocusing so that you don't have to worry about focusing on the subject as you backpedal up the aisle.

1. Bride and Groom: At Least Two Images

If you've been relating well to the bride and groom up until now (and as mentioned earlier, that's an important part of the game), it should be easy to catch their eye for a photo of them looking at the camera. Before you try that, though, watch to see if they stop by their parents on their way back up the aisle. Sometimes they stop for a kiss from a grandparent. Keep your wits about you! A shot of the recessional with the couple smiling at friends as they pass by is often as interesting as a shot of them looking at you.

2. Bride and Groom: Kissing in the Aisle at Rear of Church

When the couple reaches the very end of the aisle at the rear of the church, I usually ask them to stop and kiss each other. I wait for them to get to me and then say to the groom, "Stop here and give her a kiss." Be warned, though, if you can't get this shot quickly, things are going to get crowded very fast because other bridal party members are coming up right behind the couple. Therefore it is imperative to take this picture by prefocusing. There just isn't time to stop

the couple, backpedal, and fumble with your focusing ring.

While they are moving their lips towards each other, I backpedal 10 feet (3 meters) from them, which is where I've preset my camera's distance scale, lift my camera to my eye, and press the shutter button. As when shooting the processional, you must learn to estimate distances accurately. Thankfully, estimating distances between 5 and 15 feet (1.5 to 4.6 meters) is pretty easy. With shorter and longer distances I find it harder to be accurate.

RECEIVING LINE: THREE TO TWELVE CANDIDS (FINISH THE ROLL IF YOU ARE USING FILM)

Because I use multiple magazines with my roll-film camera, I often find myself with two or three magazines that are each near the end of the roll. I started a fresh magazine for the processional and a fresh magazine for Holy Communion. Now is the time to finish off all of these half-used rolls. Try to concentrate on getting candids of parents, grandparents, siblings, and other bridal party members.

Sometimes the receiving line is positioned outside at the front of the church. If this is the case and there are stairs leading up to the church entrance, I put my camera on a tripod and work from the top of the stairs. (I'm always on the lookout for a different viewpoint.) Even though some might think

candids are hard to shoot with a tripod, I find that a tripod allows my shots to have greater depth of field because I can use slower shutter speeds, and it minimizes camera shake. Also, I can pick up some great candids with a short tele lens.

As soon as I have a few candids, I put my shoulder bag and tripod into my car because I want to travel light for the next group of pictures. All you'll need is your camera and flash. Depending on the type of camera you are using, you might want to stuff an extra memory card, battery, magazine, or roll of film into your pocket as well.

BRIDE AND GROOM WITH EACH SET OF PARENTS

Once the receiving line is finished (with a big wedding it can take 30 to 40 minutes), I try to get a shot of each set of parents with the bride and groom. I arrange the two women (the bride and a mom) in the center with both men (the groom and a dad) on the outside. I have the men shake hands with each other, and their outstretched arms form the bottom of my composition. While I usually get some candids of the parents and couple exchanging hugs, this posed picture is usually the one that makes the album because all four faces can be seen. It is also an easy two-picture sale because the couple can't slight either set of parents by leaving out one set or the other, and the two photos together make a great album spread.

A backlit silhouette of the couple in the church doorway is always a great shot but a camera set to auto exposure will probably not give you the effect you want. Try setting your camera to manual and taking a light reading of the outside, so that your couple will be a dark silhouette. After a few weddings you'll be able to guesstimate the perfect exposure without using the meter at all!
© Jan Press Photomedia

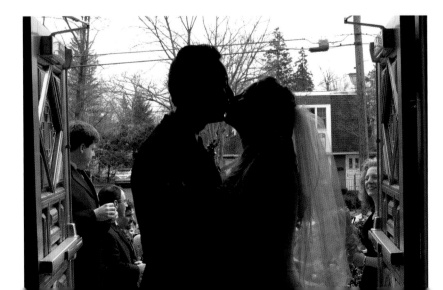

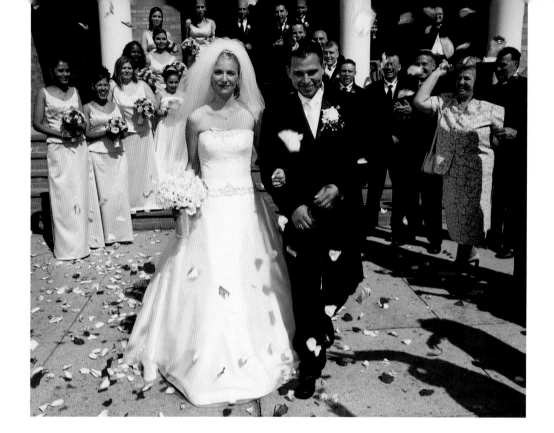

While it's fine to say you want to shoot a candid of the rice or rose throwing extravaganza, you will have a much better chance of success if you can get the crowd to time their throw to the count of three. There's still a good chance that a big rose petal will be right in front of the bride's or groom's nose, but it is better than missing the moment. © Photography Elite Inc.

1. Possible Pictures of the Couple with Their Grandparents

Sometimes, elderly grandparents make it to the ceremony but don't go to the reception. If that's the case (and you'll know only if you ask), then you should get some photos of them at the end of the ceremony. At the same time, if the grandparent is the bride's mother's mother or the groom's father's father, you should pick up a three-generation picture. This photograph is almost always included in one album or another, and having three (or even four) generations of a family in one photograph is a nice thing to have.

LEAVING THE CHURCH

While I'm shooting the photographs of the couple with the parents, I try to work very quickly because there is usually a large group of guests milling about outside the church waiting to throw rice or confetti at the bride and groom. However, there is another reason to work quickly. Church time during the wedding season is often at a premium, and frequently there is another bridal party waiting to use the church for their ceremony. If you didn't have time to ask the cleric at your first meeting, now is the time to touch base and find out what his or her schedule is like for the day. Your consideration for the church's schedule will always be well received and appreciated, and may result in recommendations later!

1. Bride and Groom: Silhouette in Church Door

One of the easiest special effects to do is a natural-light silhouette, and an ornate church doorway gives you the perfect opportunity to shoot one. I ask the bride and groom to stand in the church doorway facing each other, and I have the groom place his hands on the bride's waist while she cups

Bridal Party on Church Steps...Then the Rice Throw!

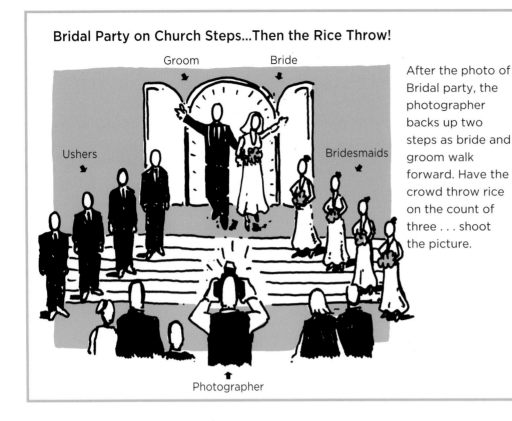

After the photo of Bridal party, the photographer backs up two steps as bride and groom walk forward. Have the crowd throw rice on the count of three . . . shoot the picture.

her hand under his chin. I turn off my flash unit and set my camera's f/stop and shutter speed for an exposure that is correct for the light outside the church. I stand inside the church, looking out towards the doorway that's framing the couple. The resulting picture silhouettes the couple in the doorway, and I have a winner . . . as long as I remembered to turn off my flash unit!

2. Bride and Groom with Bridal Party on Church Steps and the Rice Throw

Trying to get a photograph of the bridal party on the steps of the church while controlling all the guests who are waiting to pelt the bride and groom with bushels of rice (or birdseed or rose petals) is an exercise in mob psychology. I usually line the bridal party up inside the church (women to one side, men to the other, in order of size, with the bride and groom in the middle flanked by the maid of honor and best man) and tell them to wait there for an instant while I go outside to talk to the crowd. The next part is tricky.

I walk out onto the top step of the church, and as I look at the crowd I say loudly (with a big smile on my face), "I heard some people here want to throw some rice at the bride and groom, and I want a picture of it!" Then, after the laughter and jeers die down I say, "Look, if we all wait until I count to three, we can pull this off together." By using the pronoun "we," I've made myself part of the mob. Next, I pick out some young person in the group, look him right in the eye (again with a smile on my face), and say loudly enough for everyone to hear, "Now remember, when I count to three . . . no cheating!" It doesn't really matter whom I single out (although I try to single out someone I think could be trouble), it's just something I do to repeat the message for the crowd, and I always do it with a smile!

I then go back inside to the bridal party and tell the bride and groom (but directing my comment to the entire bridal party), "There are some people outside who want to throw stuff at you!" I then explain my plan

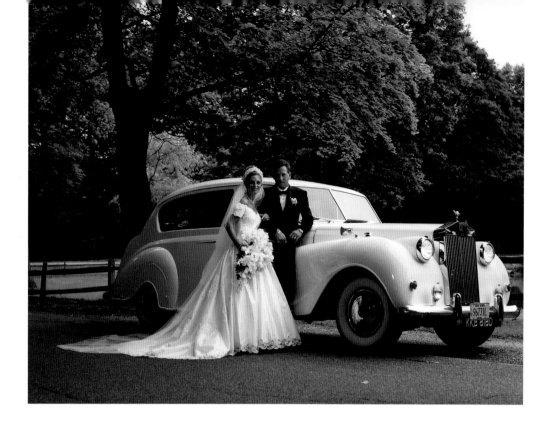

Unless they are very lucky, most couples won't get to ride in a Rolls Royce again until their kids get married. If the limo is unusual, invest a frame or two to create a salable memory.
© Franklin Square Photographers

to the bridal party. I ask all the ushers and bridesmaids to file out first and form a "V," then, at the last moment, the bride and groom will step through the doorway and stop in the center of the V.

As the bridal party is filing out, I move into the crowd saying all along, "Remember now, wait until I count to three!" By the time I get into position, the bridal party is in place, and I grab a quick shot of the entire bridal party in front of the church. This picture has to be made quickly because my control of the crowd doesn't last long. The instant I get my picture, I immediately tell the bride and groom to start walking towards me, and I start to count loudly to three. The trick is to get to three when the couple is about 12 feet (3.7 meters) away from me. My camera is prefocused to 10 feet (3 meters). As they cover the last 2 feet . . . the rice is in the air . . . I push my shutter button . . . and usually the bride and groom (and I) are rewarded with a scene that

looks like a snowstorm! The downside is that I also get pelted with the rice and it gets into everything. Sometimes by the end of a double-ceremony day my tuxedo is filled with it. It goes with the territory.

GETTING INTO THE LIMOUSINE

As I mentioned previously, limo pictures are special because the car itself is out of the ordinary, and it helps signify that the day is also something extraordinary. Cars are so much a part of American culture that they can't help but creep into the gala event you're shooting. For some people, a ride in a limousine will happen only on their wedding day. Other people may hire other types of exotic or antique autos. Actually, I have done many a wedding where the bride and groom travel by horse-drawn carriage. I've seen Rolls Royce drivers in English chauffeur livery, rolled-out red carpets, champagne on ice in a silver bucket on an ornate stand outside the limo, twenties gangster

If you decide to take formals on the church grounds, have the bridal party load into the limousines as if you were all going somewhere else. Have them drive around the block, and then come back to the church. Otherwise you'll be shooting formals with all the guests (who mill about in front of the church until the bridal party leaves) shooting their own pictures of the couple over your shoulders! Before I bring the bridal party out of the church, I secretly explain my plan to them and tell them how it will make for better and quicker pictures. Everyone loves to be an insider on a conspiracy!

It is very important to clear this plan with the clergy first. Remember the words "please" and "thank you," and remember to smile. Sometimes I jokingly explain to the priest or minister that my life is over if he or she doesn't help me (a downtrodden, harried look helps)!

cars complete with gangster-type drivers, and I've even taken shots of a bride and groom laughing and hugging while they stood up through the sunroof of their VW beetle. You can call it what you want, but to me, they're all limo shots. The more unusual the vehicle is, the more I include it in the composition. Although there are a few other opportunities for getting great limo shots, you can pick up a few right now. As far as the album is concerned, limo shots taken before and after the church ceremony are great pictures that can be used to link the different parts of the day.

The bride and groom usually enter the vehicle from the curb, so if you shoot from the street, you might be able to get the limo and the couple, with the church in the background. If there's a "Just Married" sign on the trunk of the car, get a shot of the couple with it now. It'll probably blow off later, once they're on the road.

1. Shooting through the Far Door, Looking in at the Bride and Groom

You can shoot through the limo's open street-side door as the bride and groom, standing on the curb, look at the camera through the limo's open curbside door. If that's your plan, check the traffic before you open the limo's street-side door.

2. Bride and Groom Looking out Limousine Window

You might shoot a picture of the couple through an open limo window. If so, use your camera-mounted flash to "open up" the inside of the car, but make sure the door frame doesn't create a shadow across the bride and groom when flash is used.

3. From Front Seat Looking into Back of Car

You might get into the front seat of the limo and shoot over the seat back. Make sure the window between the front and rear seat is down. Don't laugh . . . I've seen it happen.

4. Bride and Groom Toasting

If the limo is equipped for a champagne toast, a picture is in order.

5. Bride and Groom Facing Camera and Facing Each Other

6. Bride and Groom Kissing

Finally, discuss with the couple where they would like to go for formal pictures and tell the limo driver two things: 1) where you plan to go, and 2) that you will be following him, so you both arrive at the same site together. Nothing is worse than losing the bride and groom as the limo speeds off! When you shoot weddings, you should always have local street maps in your car.

Variety is the Spice of Life . . . and Wedding Albums!

In the dark ages, before digital sensors, electronic flash, and even rolls of film, photographers carried 4 x 5 sheet film holders and a case of flash bulbs. That older technology effectively limited the number of pictures a photographer could take on an assignment. But, considering the new freedoms provided by today's photographic equipment, it is now worth the effort to experiment in order to get pictures that are out of the ordinary. Here are two types of different portraits worth considering.

The Long Shot

While some might think this phrase refers to a race horse running at 50 to 1 odds, I mean something totally different. Many of today's brides purposely choose venues that include beautiful gardens and interesting architectural details. So, instead of filling your frame with the bride for all your photographs, look for a bigger picture that brings more of the beauty of the surroundings into your composition. In addition to the standard picture taken at 15 feet with a normal lens, consider using a wide-angle lens and backing out to 25 or 30 feet. A few (note the word 'few') of these scenic images mixed with more traditional photos can become show-stoppers. Look for archways, overhanging bowers of trees, winding paths, or even interesting windows to include in your shot. By making the bride a small design element within a bigger picture, you can show off both the subject and the total environment. While this type of photo shouldn't be done at the expense of your standard fare, it has the benefit of being different.

Furthermore, this type of environmental photograph is often well suited to a 30 x 40-inch display portrait. (Those of you focused (sorry) on the business side of things should have just heard your cash registers go ker-ching.) But beware! While this type of picture has terrific impact, you can't make a steady diet of it. If you do, you can be certain the bride will complain that there are no photographs that show off her gorgeous gown!

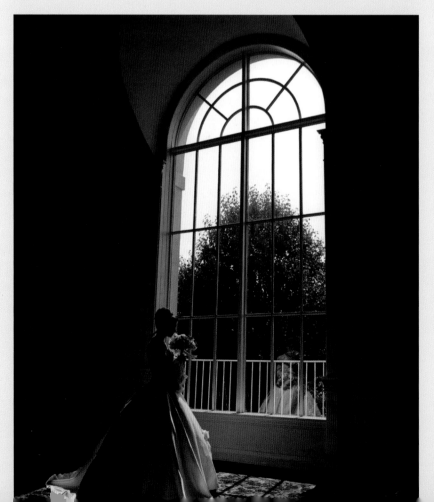

Wide-angle lenses make it possible to do "the long shot" even indoors! Another significant point: Because the bride comprises only a portion of the total environment, you can even let her become a semi-silhouette. However, to make sure you're not accused of being an "artiste" who misses the point of the assignment, just remember to temper this type of grand scenic interpretation with some standard 15-foot full-length photos as well.

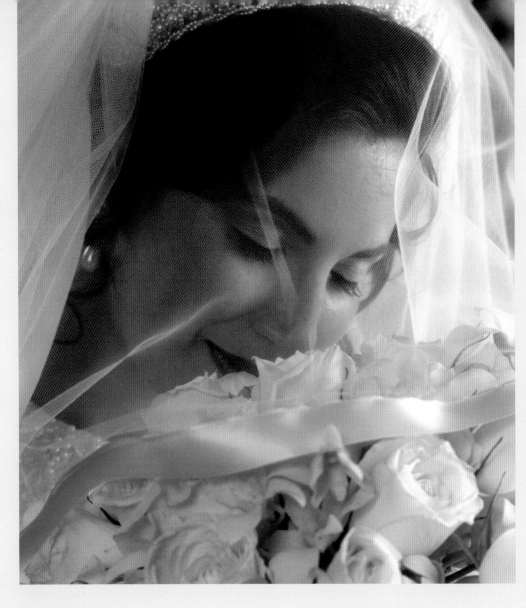

The "tight shot" can be done anywhere. Move in close to crop and eliminate unattractive portions from the background of your portraits. Because this style accentuates complexion problems, I often lower the bride's veil before shooting. Shooting through the bride's veil not only adds interesting variety, it works as a soft focus filter for your subject. To make sure you please your client, balance tight interpretations with more traditional full-length and bust-length photos as well.

The Tight Shot

By using the opposite approach to the long shot, take a few photos by coming in close to your subject to eliminate extraneous aspects of the surroundings. Interestingly, while the long shot requires beautiful scenery, the tight shot can be accomplished against the cinder block wall in a VFW hall. There are a few caveats though. First, use a longer than normal lens for this type of photograph. If you try it with a normal or wide-angle lens, your subject will hate the photo because it accentuates any prominent facial features. Second, because some longish lenses don't focus close enough to get the impact you desire, be prepared by carrying some type of close-up accessory in your bag. In my case, using a 2-1/4-square SLR, I carry a 10mm extension tube that lets me get frame-filling headshots with a 150mm lens (equivalent to an 85-100mm lens on a 35mm camera). You might also consider a plus one close-up lens, which is easier to use because it doesn't require exposure compensation. But again, don't overdo this type of photo. If you do, you can be certain the bride will complain that there are no photographs that show off her gorgeous gown,

As I have emphasized, both styles of photos should always be shot in addition to more standard photographs. With a little creative tinkering, they'll work well for portraits of other subjects at the wedding, not just the bride. These types of photographs should become an integral part of your portraiture bag of tricks. Variety in the pictures you shoot will make for happier brides and bigger print orders for you!

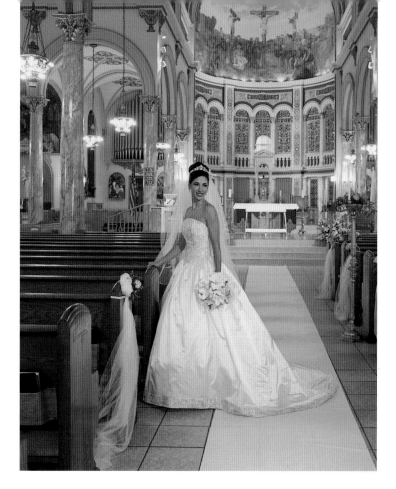

When park pictures are not possible due to bad weather, the church interior can provide a perfect backdrop for portraits as long as there isn't another ceremony ready to start. If you can work on a tripod while still using your flash, you might consider "dragging your shutter" (as in this photo) so the magnificence of the church doesn't dissolve into a featureless, black background. © Photography Elite Inc.

Formal Portraits

After the ceremony and before the reception is a perfect time to fit in the formal portraits of the couple and the bridal party. The question is, where? Very often there is a park on the way to the reception hall. That is the easy solution, but there are many others. Some reception halls have beautiful grounds, and if the reception is at a golf or tennis club, these too offer nice backgrounds. It might even be possible to go back to the groom or bride's backyard and shoot there. But don't overlook the possibility of using the church grounds. Not only are they convenient, but they can also be very beautiful.

In the late spring, summer, and early fall, finding a suitable background is a piece of cake, but finding a location on a rainy day or in the dead of winter can really test your creativity. Sometimes catering halls have a large, separate bridal room that can double as a studio. If not, the lobby can be used, or you might find a drape in the dining room itself that can be used to create a neutral background. Become friendly with the caterers or banquet managers at the reception halls in your region. These people can help you easily come up with an appropriate background. There have been times when I've done all my formals on the steps of the church altar. Again, it helps to have good relations with the clergy in your area.

Other possibilities include going back to your studio or even to the bride's or groom's home for pictures (some living rooms I've been in are nicer than any catering hall or club). While many candidmen feel comfortable working in front of a simple drape, a living room setting can also be beautiful. If that is the plan, remember to use staircases, chairs, couch arms, piano benches, and anything else that is handy for staging multiple subject levels. Try to stay away from lineups if at all possible (see the Framing and Posing chapter). For those days when I'm forced

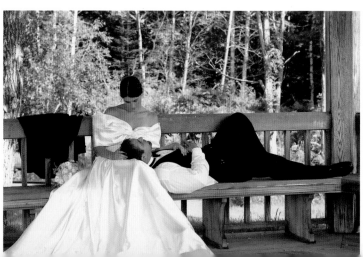

Formal portraits are often too formal! Try a relaxed formal for a refreshing change of pace. If you find a park bench, don't be afraid to have the groom take off his jacket and lie down with his head in his new wife's lap. However, the reverse of this picture (with the bride lying down) won't work if her skirt is made with hoops or multiple crinolines. © Photography Elite Inc.

Telling the Twins Apart
When shooting multiple frames of group poses, remember to change something in every frame. It can turn searching through the negatives from a nightmare into a joy! It can be something simple like having an usher rest his hand on the shoulder of a seated bridesmaid instead of having it hang by his side, or having the groom put his hand on the bride's arm instead of hanging by his side, or something complex like switching the placement of the ring bearer and flower girl. Any change that lets you tell one negative from another is a blessing!

into working against the bare, wood-paneled walls of a VFW hall (for instance), I carry a 10 x 20–foot, gray dappled muslin background and support stands in a small case in the trunk of my car. It has often saved the day.

Before looking at the list of photographs, remember to shoot more than one take of each picture. In fact, the number of shots you expose of each pose should increase with the number of subjects in the picture. It is easy to watch for good facial expressions and blinking when shooting one or two subjects, and with practice you can even catch these kinds of problems when shooting groups of three or four. Once you get to larger groups (five and up), especially in full-length situations where you are 15 to 20 feet away from them, it is impossible to watch everyone's face at once. With larger groups I concentrate on the bridal couple (or the little kids) and take multiple shots. Sometimes I do a countdown for the subjects and try to prepare them by telling them to get ready before I push the button.

Moving 15 to 20 people around a park as a unit can be frustrating, but there are things you can do to smooth the situation and make it less of a burden on your subjects. For instance, smaller groups are easier to organize. So take the largest groups first, then you can send the bulk of them back to the limos where they can relax.

How well you relate to the bridal party is probably your most important tool when it comes to taking great formal pictures quickly. For instance, I always try to call everyone by name. Instead of saying, "Hey you!" or "Could the usher on the end drop his hand to his side?" I prefer saying, "Janet, point your left toe towards me," or "Bob, drop your hand down a little."

The Formal Portrait List

Entire Bridal Party
You should do this shot two different ways (remember to shoot three or four frames of each pose). One might be a tight grouping (see the Framing and Posing chapter, page 110), and the other might be of the group

Standard wedding photography practice is to shoot photos of the bride with her bridesmaids and the groom with his ushers, but turning the tables a bit and encouraging the couple to ham it up (him with her maids and her with his ushers) can result in two other great pictures. If you go this route (and it's worthwhile doing) make sure to get both halves of the two-page spread for the album. In this case that means getting a shot of the groom with all the bridesmaids.
© *Photography Elite Inc.*

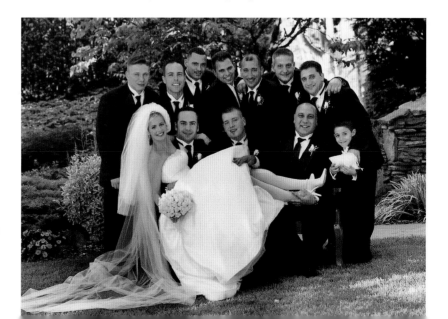

Often, when you shoot a formal photo of the groom and his ushers, after you push the shutter button, one guy will say something hysterical and everyone will crack up. So, always be ready to push the shutter button immediately after the first exposure. © Photography Elite Inc.

arranged by couples, spread out on a lawn, hillside, or wide staircase. If you do the second shot with a wide-angle lens (about 50mm on a roll-film camera, or 28mm on a 35mm, or 20mm on a DSLR), place the bridal couple about 10 feet from the lens and put the rest of the couples 15 feet (or farther) from the camera. This will give you an interesting composition, with the bride and groom larger than their attendants.

GROOM AND USHERS (AND OPTIONAL, GROOM WITH EACH USHER)

While this photo seems self-explanatory, consider the personalities you're photographing. Sometimes they all have sunglasses, and a "shades down" photo is fun. Sometimes the groom can be laid across the usher's outstretched arms or a pyramid can be set up. Before you decide to try these ideas, try to read your subjects' reactions. Look for hints as to how frisky these guys are to gauge how far you can push things . . . but, if they go for one, they'll go for all of them.

Sometimes photographers get so enthralled with the bride that they forget to shoot portraits of the groom. If it sounds like I'm speaking from personal experience here you're right! Even though the coverage will be weighted slightly towards the bride because she has extra accessories to photograph, remember the groom and don't forget to shoot both close-up and full-length portraits! © In-Sync Ltd.

Also remember, if you shot individual photos of the bride with each of her bridesmaids at the bride's home (see page 36), you should now shoot individual poses of the groom with each of his ushers.

BRIDE AND BRIDESMAIDS

Notice that you've already gotten this photograph at the bride's house. By shooting it now, however (a second time), it will match the photograph of the groom and the ushers, and the two can be used as an album spread. The first shot of the bride with her maids at the bride's house wasn't necessarily wasted. They may still choose to include it at the front of the album.

BRIDE, GROOM, MAID OF HONOR, AND BEST MAN

BRIDE AND MAID OF HONOR

GROOM AND BEST MAN

GROOM ALONE: FOUR TO SIX POSES—TWO TO THREE FULL-LENGTH AND TWO TO THREE PORTRAITS

Sometimes, with all the hoopla surrounding the bride, it is easy to forget about the groom altogether. Don't do it! I once fell into this trap and shot a beautiful wedding but forgot to get a picture of the groom alone. Chop my fingers off! Banish me to Siberia! I did it! I'm guilty! I saved the situation by shooting the groom on another day, but I ate the cost of his tuxedo rental and boutonniere and threw in a few free 8 x 10-inch prints. Still, I got off cheaply. The couple was happy eventually . . . but it took some doing.

BRIDE AND GROOM: THREE TO FOUR DIFFERENT POSES (MINIMUM)

One of these pictures will be the most displayed picture of the wedding, and everyone who sees it will consider it to be representative of your work. Because of this, I like to get the bridal party pictures out of the way quickly and concentrate closely on the couple. In terms of importance, these pictures rank up there with the bride and her father walking down the aisle. Good coverage demands 4 to 6 full-length poses and as many close-ups . . . probably a few pictures of each. I try to get variety in both the posing and the background. No matter how lazy you feel (it's hot . . . you're late . . .), no excuses are allowed here. The only time that rushing these pictures is worth it is if the sun is going down and you're losing your light. You can't control the sun.

VARIATIONS ON THE BRIDE AND GROOM PORTRAITS

Even though you are looking to produce a variety of basic bride and groom formals, you might try a few very different approaches for even greater sales potential. Most of the following don't fit into the classic definition of a bride and groom formal, but each can add to the overall look of an album. In addition, they can make great beginning or ending shots in an album and might even end up as a large-print (bigger than 16 x 20) sale.

1. Close-up of Rings on Hands

For many couples, a photograph of their hands together wearing wedding bands is a sentimental favorite. However, hands are not easy to photograph beautifully, and in general they look best when shown from the side and bent back at the wrist. Try to avoid showing the backs or palms of the hands broadside. They will usually appear too large, and you run the risk of having them look like lobster claws.

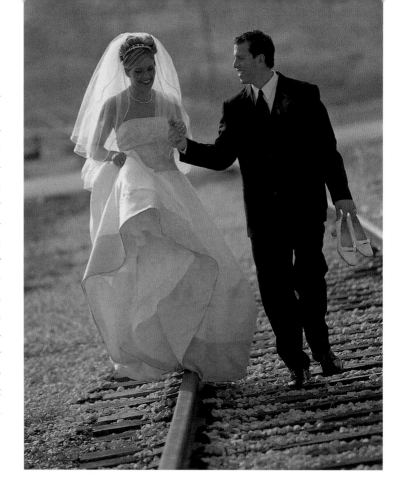

I don't know why but almost every bride wants a picture of herself walking barefoot, shoes in hand. Maybe this is caused by all the Hallmark cards of couples frolicking, barefoot and in love! Regardless, if you are on a beach, a forest path, or even a railroad track, ask the bride if she wants to try a barefoot picture. I'll bet she says yes. To make sure the viewer realizes she's barefoot, be sure to have either her or the groom hold her shoes. © Mark Romine

For really top-notch hand positions, go to a local museum and study how some of yesteryear's painters handled them. After the museum trip, study your own hands in poses by doing variations in front of a mirror—close the bathroom door so no one sees

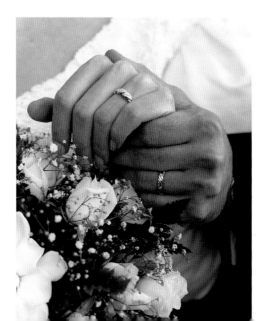

A close-up of the couple's hands displaying their shiny new rings makes a worthwhile image. Sometimes the bride's hands and manicure are beautiful, but that isn't always the case for the groom. Careful posing can eliminate this problem if you have the couple clasp their hands in a flattering manner. I use the bouquet as a base for my images, and I try to take the picture with a longish normal lens (100mm to 120mm for medium-format). If you are using regular non-macro focusing lenses, you are going to need a short extension tube or a close-up lens to pull this off.

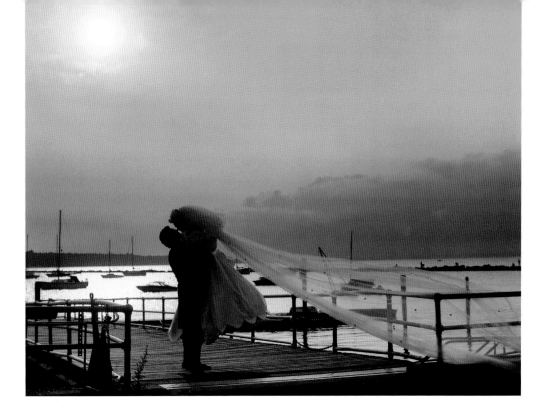

Don't forget to include the environment in your portraits of the bride and groom, especially if it is tranquil and romantic. © Franklin Square Photographers

your antics! Fingers can create repeating patterns that fit into classical rules of good composition.

While you're considering close-ups of the rings, throw in a few really tight shots of the couple's faces. The vastness of the outdoors will let you turn the background into a beautiful blur, and the variety of these shots will make them stand out among the rest at the proof return.

2. A Scenic Image

If you are shooting in a picturesque park, try backing up from the subjects so that the bride and groom are part of a larger scene. Architectural or natural elements can add variety and mood to the photos you offer your customers. The couple could be sitting under a tree, by a lake, on a great lawn, or in a gazebo. Consider using soft-focus or graduated color filters for these pictures to increase their painterly romantic quality.

3. Bride and Groom: Selective Focus

These shots offer a lot of room for creativity. For instance, you can arrange the bride in a bust-length pose and place the groom 5 feet (1.5 meters) farther away from the camera, but still within the frame. Have him look at her (either facing or behind her), focus your camera on the bride, and you'll have a picture of the bride, with the groom in the background, softly out of focus. Then reverse the pose, with the groom in the foreground and the bride farther from the camera.

Two selective-focus pictures of the couple can make a great two-page spread, but placement and posing are crucial to their success as a double sale. When you position the subjects, you must consider how the album pages will look together as a unit. To sell the double-page spread, the poses should be reversed entirely, placing the in-focus subject on the opposite side of the frame than the in-focus subject of the previous pose. This makes a big difference to the two images' final presentation.

or if the light is beautiful, catch a few additional full-lengths and close-ups of the bride even though you did a thorough work-up of her at home before the ceremony. You've got a different background to work with now, and because it's later in the day, the lighting may have a different effect. Further, now that the ceremony is over she's probably more relaxed and that usually means better pictures.

Ask the bride if there are any bridal party couples she would like photos of. If the answer is yes, pick those up at this point. If the groom has any siblings in the bridal party, catch him with them now. When you get to the reception, you're going to shoot his family pictures, and this will give you a head start on that list.

End your park coverage with a relaxed group picture of the bridal party around the limos (ask the drivers first, but try to seat bridesmaids and ushers on the fenders and bumpers, popping through open sunroofs, or anywhere else you can stick them that looks fun), and then you're ready for the reception.

Family Photos

If the families are small, you might invite them to the park for pictures after the ceremony. If that's the case, take these pictures immediately after the ceremony before you take photos of the bridal party. That way you can photograph the parents first, and they can be on their way to the reception. Nothing stifles creativity more than an anxious father wanting to get to the party.

If the families don't come to the park with you, these family photographs will have to be done at the reception hall. When they are scheduled over the course of the reception can vary. Often at the weddings I have covered, the bridal party has had a

cocktail hour separate from the other guests before the reception begins, and if that's the case, I suggest you take the family pictures at that time. By then, however, the bride and groom are probably fed up with pictures (and with you). They want to relax and enjoy a drink, so broaching the subject of taking more pictures should be handled diplomatically.

There is an old saying that it is not what you say but how you say it that gets the response you want. Here's my approach. I go to the bride and groom and tell them two things: First, I thank them for helping me get beautiful pictures at the park, and second, I tell them the only posed pictures we have left to do are a few family portraits. By mentioning that these are the last posed pictures to be taken and that there are only a few left, I've made the idea more palatable to them. I also say that I would like to do these photographs now so that once the reception starts I will be shooting only

Even though the bride and groom are the stars of the day, take a family picture that focuses on the parents or grandparents. Seat that couple and have the rest of the family, including the bridal couple, crowd around them.
© In-Sync Ltd.

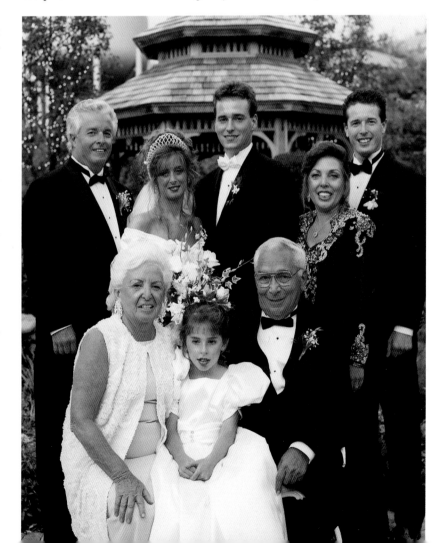

candids and won't have to bug them. Any of those words, "last," "few," or "won't bug," usually do the trick, and I then ask an usher and bridesmaid to go to the main cocktail hour to round up the people needed for the family pictures. I have found that many people like to question everything or are just contrary, but if I can give them a good, solid reason for doing something, they will usually cooperate. In this instance, the good, solid reason is an uninterrupted reception. It works. From a pictorial point of view, it is better to take the family pictures early because as the reception progresses, people undo ties, remove jackets, get sweaty and flushed, hairdos fall, and generally subjects become less and less photogenic as the event wears on.

The Family Picture List
(Note that the first six shots of this group are the same as the set you did of the bride and her family before the ceremony.)

GROOM AND HIS DAD

GROOM AND HIS MOM

GROOM AND HIS PARENTS: WITH OR WITHOUT SELECTIVE FOCUS
This photo is required in order to sell a two-page spread with the "Bride and Her Parents" photo.

GROOM'S PARENTS ALONE: TWO IMAGES

GROOM AND HIS SIBLINGS

THREE GENERATIONS: GROOM'S SIDE
The groom, his father, and his father's father (see page 35, "Three Generations: Bride's Side") shot at the bride's house. Now it's time to add the bride to this mix.

BRIDE AND GROOM WITH GROOM'S PARENTS: TWO SHOTS

BRIDE AND GROOM WITH GROOM'S FAMILY: WITH AND WITHOUT GRANDPARENTS

BRIDE AND GROOM WITH GROOM'S SIBLINGS

BRIDE AND GROOM WITH GROOM'S GRANDPARENTS
You might take photos of the couple with each set of grandparents separately.

Once you've finished with the groom's family, it is time to turn your attention to the bride's family.

BRIDE AND GROOM WITH BRIDE'S PARENTS

BRIDE AND GROOM WITH BRIDE'S FAMILY
Repeat the previous four pictures with the bride's family.

BRIDE'S FAMILY MISCELLANY
Pick up any bride's family photographs that you missed at the house.

GRANDPARENTS ALONE OR AS COUPLES
If successful, these shots of the grandparents can become heirlooms, lovingly displayed on the dressers and side tables of many family members' homes.

EXTENDED FAMILY
Some families are very close-knit, and when this is the case, an extended family picture is in order. This picture includes aunts, uncles, and cousins. There are a few ways to handle these photographs. If the families are truly huge, you can break them down into two separate pictures: one of the mother's family, and one of the father's. Note that this creates four separate family pictures—two of the bride's relatives and two of the groom's. Remember to get the right grandparents in the right photograph!

Even this separation isn't always enough to make the group size manageable. I've actually organized 100 people in a family grouping on catering hall steps! If you're faced with shooting a 100-person family, the quality of the posing isn't the issue, as long as the photograph is sharp and centered. Forget about light quality or composition, just make sure you can see everyone's face and that no one is cut off. If possible, to avoid having to organize such a mob, you might suggest breaking down the family by generations, photographing the couple with all the aunts and uncles and then doing one with all the cousins.

I must point out that you can kill the ambiance of a reception by asking 100 of the guests to get up and go outside for a picture. So, to remain on good terms with the banquet management (remember you'll be seeing them the next weekend at another reception), I ask the manager when he or she would like me to organize the photo. Because banquet managers are interested both in serving a delicious, hot meal and having the party run smoothly, they will usually suggest that these photographs be done either during the salad course (it's a cold dish, so it won't be ruined if it has to sit for a few minutes) or after the cake ceremony (when they're finished serving food). If the banquet manager has any preferences, I follow them to the letter. Once again, I'll probably be back there next week!

The Reception

After having had control over your subjects and events for the last few hours, it is diffi-cult to switch gears and become just an observer, but that's the way you'll get the best candids. Instead of carefully directing the scene at a reception, it is better that you react to it. Good wedding photography is difficult, challenging, and fun because the assignments call for you to have talent in many diverse areas of photography: formal posing one minute, photojournalistic candids the next. While successful formals depend on photographer control, great candids require a photographer's quick reactions. Both are important, and both are quite different.

When using film, you should begin shooting the reception with a fresh roll so that you are ready for a candid when it presents itself. Before you load a new roll, if you're shooting a leaf shutter camera with interchangeable magazines, now is a good time to check the flash sync on your camera.

There is an old Jewish saying that says the smaller the wedding the greater the joy. When shooting a small wedding, you might consider getting one photo with everyone in the picture. It works best if you can find a high vantage point (like a hillside or balcony) to shoot from. While using a wide-angle lens, position the bridal couple closest to the camera so they appear prominently in the foreground. © Freed Photography

The best candidmen usually set up slaved room-lights to eliminate the dark backgrounds created when using a single flash on camera, a problem common in banquet hall flash pictures. I use 1,000-watt-second AC strobes. (My choice is Dyna-Lite, but any brand that doesn't draw a lot of amperage will work.) When I place my lights, I imagine where I'll be shooting from and position one or two units around the room to "open up" the backgrounds. I put my lights up on 10-foot poles. If the ceiling is white, I aim the strobe heads upward at a 45° angle. If the ceiling is dark or colored, I feather the lights slightly toward the ceiling so the subjects close to the strobe are softly lit without being tinted by the color of the ceiling.

As the bridal party relaxes with a drink, I seek the banquet manager, headwaiter, or whomever is running the party, and find out the plan for the entrance and first dance.

The Reception List

THE ENTRANCE

As when photographing in the church aisle, my quick reaction to candid situations at the reception depends on estimating subject distances and presetting my camera's focusing scale. For the bridal party's grand entrance, you might want to prefocus on a specific spot and shoot the couples as they cross that line. One of my favorite prefocus points is the edge of the dance floor because the line of demarcation between the carpet and the wood is an easy focusing target.

1. Siblings
Although it isn't important to photograph every couple in the bridal party as they enter the room, sibling couples are worth a shot. You never know, it might be little Johnny's first time in a tuxedo . . . and without sneakers!

2. Best Man and Maid of Honor
This picture rarely sells (and if they are husband and wife you should have gotten a formal portrait of them earlier) but I'm usually so adrenalized waiting for the bride and groom to enter that I shoot a photograph of them anyway.

3. Flower Girl and Ring Bearer
When the little kids make their entrance, their parents beam and people clasp their hands in joy. Sometimes the children's mothers run in front of the kids using a favorite stuffed animal as the proverbial carrot on a stick. All this fanfare should not go unrewarded, so I shoot a picture.

If the flower girl or ring bearer is a niece or nephew of the bride and groom (i.e., their parents' grandchild), the picture will probably make it into someone's album . . . especially if you remember to mention it during the proof review.

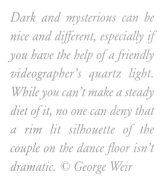

Dark and mysterious can be nice and different, especially if you have the help of a friendly videographer's quartz light. While you can't make a steady diet of it, no one can deny that a rim lit silhouette of the couple on the dance floor isn't dramatic. © George Weir

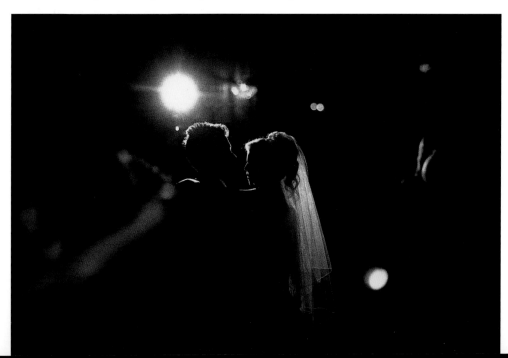

4. Bride and Groom: Two Images

Some banquet managers arrange the bridal party into an archway through which the couple pass (check with the banquet manager beforehand). You may even have the opportunity to shoot a full dress military wedding in which the bride and groom pass under drawn sabers!

If you move quickly, you can get both a "straight" shot and a picture of the bride and groom coming through the arch. The straight shot is good insurance, because when an archway is formed, the couple sometimes lower their heads as they pass through it, and you end up with photos of the tops of their heads instead of their faces. No matter how good a salesperson you are, it's tough to sell a picture of a bald spot!

Very often when you arrive at the end of the arch for your second shot, guests are already stationed there with their cameras waiting to get their big picture. It is impolite to bowl these people over (even if you want to). But if your camera is prefocused, you can stick it into the path for a split second, grab your shot, and be gone before the guests even notice it. If you're using a wide-angle lens, framing when you're shooting blind is not very difficult. You don't need to be peering through the viewfinder for a well-framed candid shot, but to pull it off well all the time does take practice.

THE FIRST DANCE

When I was shooting 10-exposure rolls of 120 film, I often used two or three magazines on the first dance alone. Today, I shoot 24-exposure rolls of 220, and I can usually make it through the entrance and first dance with one magazine change. If you are shooting with a motorized 35mm camera, you'll have a tendency to blow frames more quickly, so you might consider using a quick-release coupling on your flash bracket and having a second, pre-loaded camera body at the ready . . . just in case.

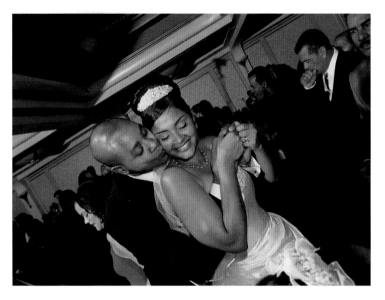

Tilting the camera on an angle can add a photojournalistic flavor to many dance pictures.© Photography Elite Inc.

1. Bride and Groom: Two to Three Full-Lengths and Possibly a Close-up

Three possibilities include: 1) the bride and groom looking at the camera; 2) them looking at each other; or 3) kissing. Instead of stopping the couple to take photographs, as many candidmen do, I prefer to move with them. Since I prefocus my dance pictures, I have taught myself to move in a circle around the bride and groom, following their rotation as they dance. By moving myself in an arc, I'm always the same distance from the couple, which is important since I've prefocused my camera (10 feet [3 meters] for a full-length using a 50mm lens on a roll-film SLR). Because I put up room lights, I "roll" with my subjects until they are in front of one of my illuminated predetermined backgrounds.

If you work with an assistant, you can have him or her carry a slaved strobe on a light pole so you can try a few special effects. By placing the second (assistant's) light behind the couple (especially as they kiss) and covering a portion of the camera-mounted strobe with your hand, you can come away with a very unique silhouette.

2. Bridal Party Couples (especially married ones)

After the bride and groom have danced alone for a few minutes and I've gotten my shots, the rest of the bridal party is invited to join. With large bridal parties, I have to work quickly to capture all the couples because within a few moments the parents join in.

I usually switch from full-lengths to close-ups for a few reasons. To take a close-up I have to backpedal out to only 6 feet from the subject instead of the 10 feet required for a full-length. This speeds things up because it is a lot quicker to move 6 feet instead of 10, so I save precious seconds on each couple's picture. Furthermore, if the dance floor is crowded with bridal-party couples, there is less room to easily back up the full 10 feet. Lastly, with a full-length dancing picture, the couple doesn't fill the frame from side to side, so other, unwanted couples are often included in the picture.

Even in this difficult circumstance, I try to pose each picture professionally. I approach each couple and place my hand on their clasped hands. When they turn to me I say, "Get close together and smile." As I say this, I'm already starting to backpedal out to my 6-foot prefocused distance. The whole thing, hand contact, instructions, and taking the picture takes just a few seconds.

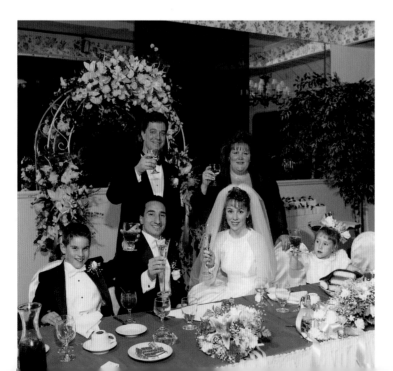

3. Parents

While taking pictures of the two sets of parents seems straightforward enough, keep your eye on each of the couples, because sometimes they switch partners. The parents might switch off with each other or they might even invite a grandparent out onto the dance floor . . . all are worth a picture.

4. Grandparents

If the grandparents are out on the dance floor, get a picture of them!

THE TOAST

Almost every wedding album I have ever seen includes a picture of the bride and groom toasting. Some wedding labs used to have a stock shot of a champagne glass into which they superimposed an image of the bridal couple. My favorite, a straight rendition of this picture, has become a big seller for the album.

1. Best Man Toasting

The best man may be called up to the bandstand to offer his toast to the couple, who are seated at the head table. If that is the situation, a photograph of him toasting is in order. Be aware that the maid of honor often follows with a toast of her own, so be ready to take another photo in case that happens.

2. Bride and Groom with Best Man and Toasting Glasses, If Possible

If the best man stands next to the couple while proposing his toast, try to include the couple and the best man toasting. That way you've got a better chance of making a sale.

3. Bride and Groom Toasting Each Other

Once the toast has been completed, the guests seat themselves, and the dinner commences. My last duty before leaving the couple alone for a while is to take a picture of the two of them toasting, especially if the

Among 'must-get' pictures are those of the wedding toast. Get shots of everyone if several different people offer toasts to the happy couple.
© Glenmar Photographers

picture of the best man's toast did not include them. I ask them to move closer together and to hold their glasses with their outside hands. Their outside hands come together in the middle, clinking their glasses, and I have my shot. For this rendition of the toast shot they can look either at each other or at the camera . . . both look great.

Sometimes the couple tries to intertwine their hands as they drink the champagne. Although it sounds like a great idea (and I always shoot a picture if they try it), it never looks as good as the straight shot. The interlocking arms look very confusing in print, and one of the couple always seems to be on the verge of taking an elbow in the eye or nose.

TABLE PICTURES

If you ask a candidman what he hates most about wedding photography, chances are he'll say, "Table pictures." Someone is always missing ("Please come back later," "Martha is in the lady's room,". . . "Chuck is in the parking lot. . ."), or someone doesn't want to get up and move around to the back of the table ("Don't even think about asking me to stand up. I'm exhausted. . ."), or

someone doesn't want to stop eating ("Come back after the coffee is served, or better yet, tomorrow!").

Many times, even after most guests have cooperated, other guests can still be a nuisance—someone at the table thinks it's funny to cover another person's head with a napkin, make their fingers into rabbit ears, or grab someone else inappropriately. After a few years, this type of behavior gets very old, but there are some ways to ease the burden. I make a point of first looking at the table's guests to note if anyone is physically disabled or if there are any elderly people sitting there. Next I arrange my picture so that they can remain seated. That way, if someone gripes about having to get up, I say that I'm arranging it so that the elderly person or the one with a disability can remain seated. Before asking anyone to move, I tell them that the bride and groom asked for a picture of the guests at this table, and if I do it now I won't have to bother them later. Then, I personally ask each couple whom I want to have stand to please step around to the other side of the table. I usually ask the man and say, "Excuse me sir, but could you

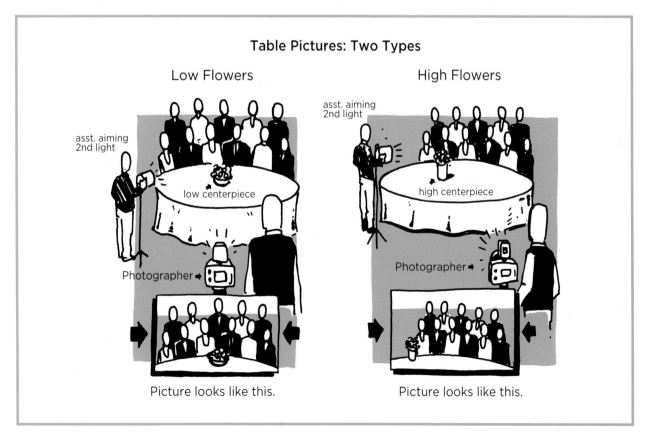

Table Pictures: Two Types

Low Flowers

asst. aiming 2nd light

low centerpiece

Photographer →

Picture looks like this.

High Flowers

asst. aiming 2nd light

high centerpiece

Photographer →

Picture looks like this.

and your lady please step around to that side of the table for a picture?" Invariably, some guy retorts, "That's no lady, that's my wife!" I respond by smiling and saying, "You wouldn't marry anyone but a lady."

At that point the wife usually steps in and takes her husband to the back of the table for the picture. The whole scenario is repeated so often I can do it in my sleep, but every guest thinks he (and it's almost always a guy) is being totally funny, unique, and innovative by creating a hassle.

Another potential fly in the ointment has to do with the many courses of food that have to be served and removed. It is very difficult for waiters and waitresses to serve hot food from hot cauldrons and clear tables while guests are being photographed. Etiquette demands that I not disturb their work. To add to the difficulty, at the end of each course the table is covered with dirty plates, and food scraps don't make for an appetizing picture.

Because of all this, my studio rule is that I will do any table photographs requested, but they must be used in one of the three albums, over and above the contracted number of pictures. Because I've done it so many times, I actually enjoy the quick-witted repartee that goes into making good table pictures. I use it to keep myself sharp. Even so, I don't want to waste my time playing the table-picture game with all the guests if my customer isn't interested enough in the pictures to put them in the album.

1. The Tables for Each Set of Parents

Whether the couple wants table pictures or not, I always get a picture of the two parents' tables. There are two ways to shoot these photos, and the style I choose depends on the floral arrangement at the table's center. If the centerpiece is low and the table has 10 to 12 guests seated at it, I ask six guests to remain seated and ask the remaining guests to stand behind them. I try to let the parents

and grandparents remain seated, and I shoot my picture in a head-on style.

On the flip side, if there is a large, high centerpiece in the middle of the table, I let four guests remain seated and stand the other three or four couples behind them. While my assistant stands to the far side of the flowers and aims his or her light at the people at the rear of the table, my camera's flash unit illuminates those guests in the front. You'll need a wide-angle lens to gain greater depth of field because the subjects are at various distances from the camera. Instead of shooting this shot head-on, I shoot it from the side so that the floral display is on one side of my composition and the people are on the other.

CANDIDS: 24 TO 48 PHOTOS OF BRIDAL PARTY AND GUESTS DANCING FAST AND SLOW, AND GROUPS ON THE DANCE FLOOR

Many couples say that they like candid pictures of people dancing, but I have found that most customers choose only a few when it comes time to make selections for the album. The main limitation with totally "undirected" dancing pictures is a lack of focus. I'm not talking about correct camera focus . . . that part is easy. I'm talking about the lack of distinct subject matter. Typical photographs of people dancing show half of the subjects with their backs to the camera. Shoot 48 of these typical dance photographs, and two will make the grade as an album selection. There are certain types of pictures that are consistently chosen, and they should be your prime focus.

1. Two-Up Dancing Photos: Faces toward the Camera

These include photos of moms and their sons, dads and their daughters, the flower girl and ring bearer (only once), and moms and dads with their parents.

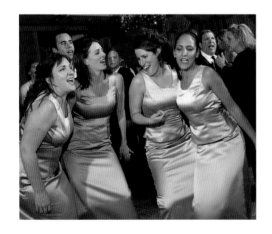

2. Three- and Four-Up Groups Dancing: Facing the Camera

Getting this type of picture requires a bit of extra effort. I dance up to the people and say, "Keep dancing, but look at me!" Sometimes I pantomime putting their arms around each other or getting closer.

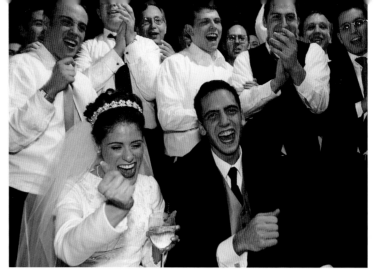

An old candidman's axiom states that if you can't see the subject's face you can't sell the picture. Often photojournalist-style shooters get dancing photos with the back of someone's head. One way around this is to ask everyone to look at you but still keep the picture loose and unposey. Instead I dance up to the people telling them, "Look my way but keep on dancing!"

3. Large, Impromptu Groups of the Couple's Friends

This shot is best if the bride or groom is included in the jumble of bodies. I have actually seen friends throw themselves across the dance floor, sliding on their backs to be included in the picture!

4. Totally Candid Tight Shots (Close-ups) of the Bride and Groom

The idea of working from your stepladder and using a short telephoto lens shouldn't be overlooked. By shooting from a high vantage point you can eliminate some of the "back of someone's head in the foreground" problems.

BRIDE AND DAD DANCING

Whether the band makes this into a ceremonial rite or not, this is a picture to get. Watch and be ready for a quick kiss or hug between the two. If the band or DJ gets into the act, ask them to have the groom join in with the bride's mom. It'll make a great two-page spread.

GROOM AND MOM DANCING

This picture is the converse of the previous one, and it too is a keeper. Once again, be ready for a possible kiss or hug, and try to get a photo of the bride with the groom's dad.

I like to walk around the hall to look for archways, windows, or French doors to shoot through. Then, as the receptions starts to wind down, there's usually time to request a few intimate photos of the bride and groom.
© Freed Photography

ROMANTIC INTERLUDE: 10 OR 12 PHOTOS

I usually ask the bride and groom if we can do a few romantic photos after they've finished the main course. They take only about five minutes, and I try to get them in before the cake-cutting and bouquet- and garter-tossing ceremonies. It is important to fit them in now because right after cutting the cake, guests start to leave the party, and amid all the good-byes it is often impossible to get any alone time with the bride and

You can create special images with sales appeal with something as simple as a black posing drape as a background. This double exposure is the result of just such a technique. When you're faced with cinderblock walls or distracting wallpaper at the local reception hall, you must arm yourself with creative alternatives.
© Three Star Photography

groom. Early in the evening while the guests are eating, I take a walk around the reception hall with my light meter in hand. When the time to take these pictures comes about, I have very specific ideas about where and what I'm going to shoot. I try to get some romantic images, and at the same time I try to include some of the ambiance of the reception hall or club. Even in a VFW or Elks lodge you can usually come up with some creative backgrounds or lighting effects.

1. Double Exposures

One of the easiest pictures to do is an in-camera double exposure of the bride and groom's faces. The picture looks like a special effect (it is!), but because it isn't done in the lab and can be seen on the proof, it is always well received. The trick is to find a dark background, but even if you can't, you can get your assistant to hold a black posing drape behind the subjects for each of the two images. If you block out part of the scene with a dark slide or date book, be sure to view the scene at your lens' taking aperture (use the depth-of-field preview button) so you can see how much of the frame your mask is really blocking out.

Many times I've made my last exposure of the bride and groom in an upper corner of the frame with both subjects looking at the opposite lower corner of the frame. I then take the couple outside and put them

in the doorway of the reception hall. I take a second image of the bride and groom caressing in the doorway on the same piece of film. The finished picture has the bride and groom in the upper corner of the frame looking at themselves embracing in the lower corner of the same image. I've even mimicked a pose from a print on the wall of a catering hall and placed the couple in the same pose in front of the picture. It's a fun image (see page 107).

2. Candlelight Photos

3. Good-Bye Shots or Gag Shots

4. Available-Light Night Scenes Including Reception Hall Scenery

THE CAKE

The cake-cutting ceremony can be a major focal point of the evening or just a small event that takes place on the side of the ballroom, accompanied by some background music. Some couples do away with the feeding and kissing parts and just cut the cake. Although there's a chance that the whole set of photos may be chosen for the album (cutting, feeding, kissing), many couples include just a cake-cutting picture, which is why I do two. If you double-light this picture, put the assistant's light off to the side and behind the cake so that it illuminates the couple and provides a rim light on the cake without burning up the cake's decorations (photographically speaking, of course!).

1. Bride and Groom Cutting Cake: Two Images Bride and Groom Looking at the Camera and then Looking at the Cake.

2. Bride Feeding Groom

3. Groom Feeding Bride

With a horde of people taking pictures during the cake cutting ceremony it might seem impossible for you to come up with something special. However, if you use two flash units properly, your photos will stand out. While all the point-and-shooters pop off picture after picture, their auto-exposure flash will either burn out the detail in the cake or leave the bride and groom hopelessly underexposed. By lighting just the bride and groom with your second light (and exposing for it) you throw more light on them. This also evens out the exposure on the cake and keeps it from becoming a big, white, overexposed blob. As an added benefit, the second light will create modeling on the couple's faces, which makes them appear more three-dimensional. By doing this your pictures will always be a cut above. © Three Star Photography

4. Bride and Groom's Hands over Cake, Showing Rings

If you didn't get a ring shot during the formals, you can grab a quick picture of their left hands clasped together in front of the headpiece on the cake.

5. Bride and Groom Kissing Each Other with Cake in Composition

Even if the couple doesn't use the cake-cutting sequence earlier in their album, this picture makes a great album closer.

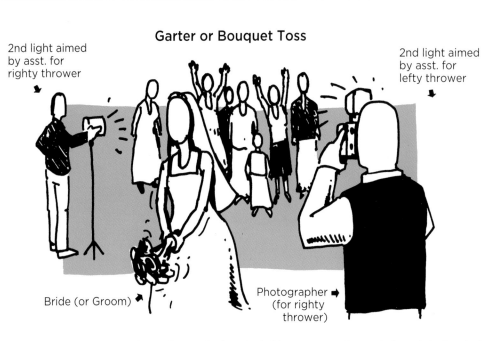

Garter or Bouquet Toss

2nd light aimed by asst. for righty thrower

2nd light aimed by asst. for lefty thrower

Bride (or Groom)

Photographer (for righty thrower)

The photographer's position depends on whether the bride or groom throws left or right handed. Avoid shooting from a position where the thrower's hand or arm blocks the face.

BOUQUET AND GARTER TOSS
1. Tossing Bouquet

2. Removing Garter

3. Tossing Garter

4. Putting Garter on Bouquet-Catcher's Leg
Whether you advocate these rituals or not, they are usually popular additions to the evening's festivities. Sometimes the bridal couple doesn't go for the entire set of pictures and elects instead to just do the bouquet toss. Whatever the case, I try to get at least two lights working for this type of situation. While the flash on my camera lights the bride, I make sure that either my assistant's light (or my room lights) shine on the catchers. Very often the band runs this part of the show; if so, there is usually a countdown, which makes timing the shot a bit easier.

For a general idea of where the tosser, catchers, photographer, and lights are, look at the illustrations. If the couple is into the whole ritual, at least one (if not more) of the pictures will be in the album.

As in the cake picture on the previous page, this situation also begs for a second light. The on-camera flash illuminates the bride throwing her bouquet while a second, more powerful flash (it's got to be powerful because it's further away) illuminates the crowd. The result: No black backgrounds! © In-Sync Ltd.

Make It Your Own

Everything you've just read is meant to augment your own photographic style. None of the suggestions I've presented is the only way to approach your assignment. Pick what you need and add it to your own set of ideas, or use it as a foundation to establish your repertoire. For two years my number one assistant was with me at every wedding I shot. He took a six-month vacation from the business and, when he returned, we went out on an assignment together. After working through a set of formals, he told me that my entire repertoire had changed. Well, that's the way it's supposed to be! A repertoire is a fluid thing. It changes as you mature and grow. Sometimes, after not doing a particular picture for years, I revisit the idea, make some changes, add some new wrinkles, and reincorporate it into my current repertoire. Whoever is my current assistant says, "Wow! That's new!" Little do they know! That's the way it should be. It keeps you fresh and makes it fun.

Just like the groom and his barefoot bride walking on the beach (or railroad track), the couple walking off into the sunset along life's road is a cliché…but it's a cliché that's hard to resist. If you don't have an empty road, keep your eyes open for a garden path, a forest lane, or even a winding stairway. Any of these will work and all of them can help you create a stopper photograph to end a great bridal album. © Marcia Mauskopf

SPECIAL FAMILY OCCASIONS

Bill and I were sitting on a park bench waiting for a photography association's meeting to start. Whiling away the time, he pulled out a stack of about 150 proofs from a family portrait session for an anniversary he had shot and asked me for my opinion of the pictures.

As I thumbed through the photographs, I found two different poses of the group with about 75 photographs of each pose. The group included a mom and dad, three married children, and about a dozen small fry. Two different poses of the group were taken for one 16 x 20-inch final print. There wasn't a single photograph of each married child's family alone! Not a single photograph of each married child with his or her spouse! Not one picture of the grandparents with their grand kids! Not even a single photograph of the anniversary couple alone! Bill had done a two-hour shoot, photographing eight adults in their finest outfits and 12 kids, scrubbed and neat, and he had came back with two (just TWO!) saleable images from which the customer was only going to choose one!

Looking at the stack of proofs and mentally calculating the costs of the film and processing plus his time (labor) for the shoot versus the fee he was charging, I pointed out that he made little or no profit on the job. Bill thought for a moment, then brightened and said: "That's OK . . . I might lose a few pennies on each job, but I'll make it up on volume!"

Weddings are two-family affairs, but there are also a number of photo-worthy single-family celebrations. The list of such celebrations is nearly endless, including occasions like Bar and Bat Mitzvahs, sweet sixteen parties, anniversaries, baptisms, retirements, and family reunions. While many photographers turn up their noses at such parties, these types of assignments can be a great source of profit and they can lead to future wedding bookings. Looking at these jobs with a cold, calculating eye reveals the chance to become a family's exclusive photographer (before the "other family" gets involved). These occasions also usually result in multiple orders from single pictures. So, before you decide to dismiss these kinds of jobs, consider the profit that can be generated by selling a dozen 11 x 14 (or 16 x 20!) prints just because everyone at the event wants a picture of the whole family dressed in their finest clothes.

One way to view these special events is to think of them as a wedding assignment with only one family. Another way is to look at them as a glorified family portrait session. For many photographers, a family portrait session results in the sale of one print. Even though it's often a huge print, you would do well to consider stretching a family portrait session so that you end up selling an album or many (multiple!) portraits. Further, it is easy to imagine your client saying, "Hey, I liked the photographer who shot my son's Bar Mitzvah (or daughter's Sweet Sixteen). We should call him for the wedding." Obviously, you should be interested in this kind of work! You will increase your profit dramatically if you take the family portrait session one step further to create an album (and therefore receive an order for 36, 50, or more prints).

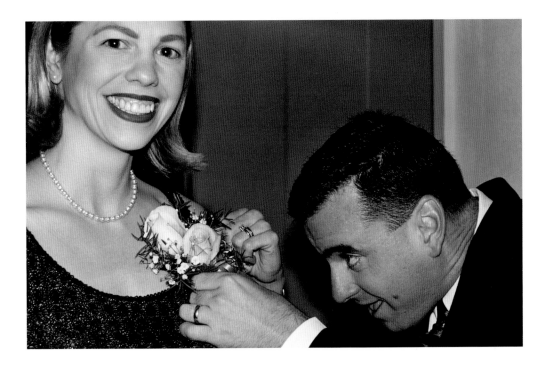

Give some guys a pin and they'll stick themselves! Tell a man to pin a corsage on his date and you'll see one nervous guy. Interestingly though, in the wedding photography game, a case of nerves is worth photographing. © Freed Photography

Family Reunions and Parties

As you do with weddings, you should develop a repertoire of sorts for these types of jobs. Let's examine a list of photos for a family reunion or anniversary party.

1. The Star (or Stars) of the Show: Three or More Portraits

Whether it's an anniversary couple, Dad's 50th birthday, or a teenage girl turning sweet 16, your subject is worth several portraits. Consider bust and full-length renditions. If your subject is an elderly woman, use some sort of diffusion over your lens (see the equipment chapter). Furthermore, if you're shooting a couple, be sure to do individual portraits of each separately. While some may question this tactic, I have seen individual portraits of a mother and a father hanging side by side on a wall in some homes.

In all the hubbub of a big family party, make sure you don't miss the special quiet moments. Pictures such as this one of a sister with her little brother will, no doubt, turn out to be an album favorite. © Michael Zide

Young children or grandchildren of a party's honoree(s) often deserve an individual portrait. But sometimes two sisters (or brothers) are especially close (cohorts in crime!), and when you see a pair like that it's worth getting a photo of the two together. © Michael Zide

2. Each of the Family's Children

Whether shooting a family reunion or anniversary party, make sure to include portraits of each child in the family. This is especially important if it is a 50th anniversary. In this case, the anniversary couple's children will be adults, usually with families of their own. In addition to a picture of each of these second-generation families, shoot an additional one of each family with the grandparents—the 50th anniversary couple. Also, get a picture of each son or daughter of the anniversary couple with their spouse, and a photo of all of the children together. Work your way through these various family groups and you'll have a basketful of different photos for the family to buy.0

3. The Star(s) with Each of Their Children (Extra Credit)

Consider doing a picture of each of the couple's sons or daughters (minus their spouses and children) with the anniversary couple (or matriarch or patriarch). Place yourself in your client's situation: If you were having family pictures taken, wouldn't you want a picture alone with your mom and dad in addition to a photo of you and your spouse with your children and your parents? And going one step further, you might also try to get mom with all her daughters and dad with all his sons, then vice versa—mom with the boys and dad with the girls.

4. The Whole Family

After you've finished with all the satellite families, next is a photo of the anniversary couple (or matriarch or patriarch) and all their children (with and without the children's spouses) before you add in all their children's children. While this picture of the whole family is important, you aren't finished until you get the guests of honor with all their grandchildren.

5. Don't Forget the VIPs

While anniversary parties almost always revolve around family, remember that there are friends of the honorees at these events. These include not only best friends, neighbors, and co-workers, but also brothers and sisters of the matriarch/patriarch. You'll never know about these special folks if you don't ask, but pictures of these groups may result in multiple sales.

If an anniversary couple has four married children, and those married children have a dozen kids of their own, the repertoire I've just sketched will give you approximately 30 different saleable photos. From an expense perspective, if your costs approach $1.00 per photo, and you shoot 4 frames of each different portrait, your investment is about $120.

On the other hand, if you shoot several different poses just of the full, extended family together, for a total of 50 pictures, your expenses would be $50 instead of $120. But your sales would likely max out after 5 prints were sold. The crux of the issue is this: while the single photograph of the whole family is included in the original mix, it is the other combinations and smaller groups that greatly improve your chances for extra sales and more profitability.

6. Decorations and Symbols

Finally, keep an eye out for special decorations or favors. There are almost always special favors and decorations at these type of parties. I've seen events where every guest gets a baseball cap with a "50" embroidered on it, or refrigerator magnets with the anniversary couple's wedding photo on them, even a 30 x 40 print from the anniversary couple's wedding album displayed on an easel. Each of these is worth a photo, and it's even better if you can capture the honored couple while wearing their caps or looking at the easel. Furthermore, regardless of the type of party, there's always a cake that is worth a picture. That, of course, is in addition to photos of the couple blowing out the candles and cutting the cake.

Bar Mitzvahs

Creating a repertoire for what to shoot at a Bar Mitzvah is difficult because there are several groups within the Jewish religion that observe Jewish laws and traditions differently. I have learned, as a professional photographer, that is helpful to understand which set of practices your subjects follow because that will affect which traditions or laws are most significant to them, and you will not want to overlook taking these important shots.

Simplistically stated, the most observant Jewish people (those who follow the teachings in the Torah literally) are called Orthodox Jews. Others, who are less strict in their observance of the Torah, are called Conservative Jews. A third group, called Reform Jews, is even less strict in their observance of Jewish law and custom. There are also smaller sects, but these three groups encompass the vast majority of Jewish people for whom a photographer will be contracted to shoot a Bar Mitzvah.

I've shot hundreds of these parties over the past 35 years. Here are my observations about the most important photographs you will want to shoot.

Personalized decorations such as menus or favors always make an unforgettable picture. Some couples (or families) even have candy bar labels printed with special slogans or the honorees' names on them. If you see these types of things, gather them together and do a quick still life. Dollars to donuts, you'll end up with a treasured memory that your customer will want.
© Marcia Mauskopf

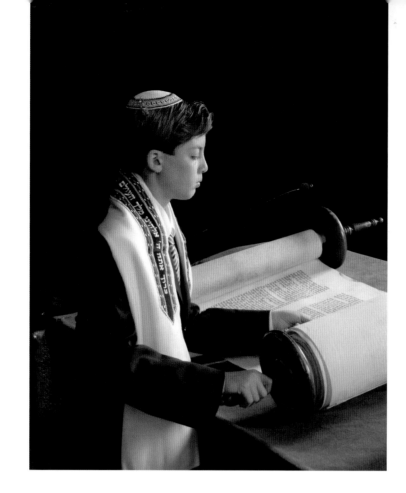

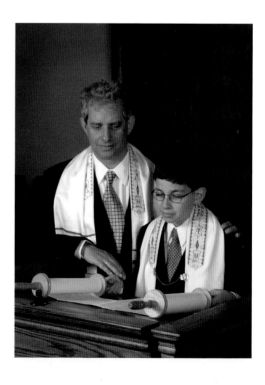

A straight portrait of the Bar Mitzvah boy is probably the most important photograph on your list. But a portrait of the boy reading from his portion of the Torah has the added benefit of showing the religious significance of the day. This picture was done with two lights. However, since these types of photos are often done on a separate day (because shooting photographs is not allowed in temples on the Sabbath), it's important not to light the background when the pews are empty! © Salzman & Ashley Photography

Don't forget to consider the following additional options since you're already there and all set-up:

2. Parents Look on as Boy Reads from Torah

Perhaps shoot with the boy in the foreground with his parents slightly behind him (further away from the camera).

3. Grandparents Looking on with Boy in Foreground

4. Father Looking on

Add the boy's grandfather (his father's father) if possible for a three-generation picture.

1. Bar Mitzvah Boy Alone: Full Length and Close-Up

Take formal and casual shots, both full length and close-ups. Add a few photos of the boy with his "talis" (prayer shawl) and prayer book. Also shoot double exposures, and silhouettes.

A number of temples will not allow photographs during the ceremony because it often takes place on a Saturday, the Jewish Sabbath. However, many rabbis will pose with the Bar Mitzvah boy reading from the Torah on an alternate day. If this is the plan, certainly shoot the boy alone as he looks at the Torah in contemplation; also shoot pictures as he looks at the camera and as he looks out toward the congregation.

In addition to the Bar Mitzvah boy reading alone from the Torah, another photo worth getting is the boy reading as his father looks on. This picture can be followed with ones in which mom, other brothers, or grandfathers are added to the scene. © Salzman & Ashley Photography

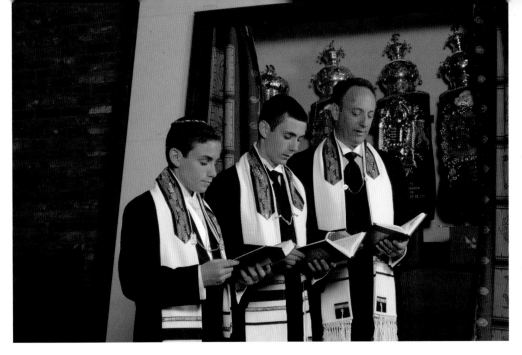

Because of the close relationship between the men in a Jewish family, dad and his sons deserve a special picture. This photo will be even more meaningful if you can include the grand-father (dad's dad) for a three-generation photograph.
© Salzman &
Ashley Photography

5. Mom Looking on.

6. Youngest Sibling Looking on
Stand him or her on a case; it is a picture that always sells.

7. The "Next" Bar Mitzvah in the Family Looking on.

You may want to ask if the boy has formed any particularly close relationships with other teach-ers within the synagogue. This photo shows the Bar Mitzvah boy with the cantor (singer). If the rabbi is present (and he normally is unless the photo is staged before the actual event), then he too deserves a photo with the boy.
© Salzman & Ashley Photography

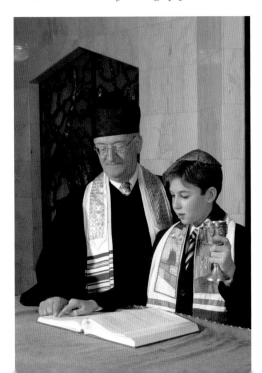

8. Boy with Rabbi Looking on.

9. Boy's Torah Passage
For extra credit, have the rabbi show you exactly where the boy's portion of the Torah starts. Then get on your stepladder and shoot it over the kid's shoulder. Try to include the boy's hands, and the "yad" (which is a pointer that is used so the reader doesn't touch the scroll).

10. The Invitation
For additional extra credit, prop a copy of the invitation over the scroll (use the yad as a prop). This becomes an excellent begin-ning shot in an album.

In order to maximize picture sales, you MUST get visual variety! When shooting at the temple or synagogue, include shots with your subjects looking at the camera or look-ing at each other.

Of course, you should shoot formal por-traits without religious overtones as well.

11. Bar Mitzvah Boy Alone
 (as mentioned above)

12. Bar Mitzvah Boy with Mom

13. Bar Mitzvah Boy with Dad

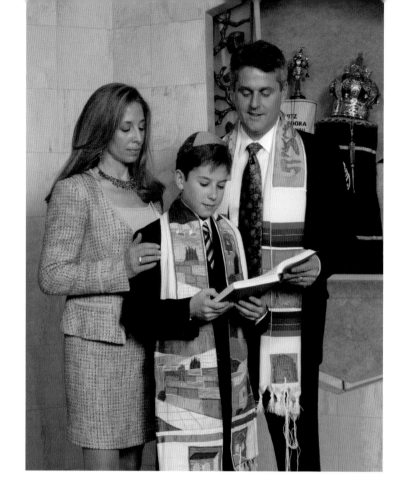

Don't forget mom! While the importance of a father's role in teaching and reviewing the Torah with his son has religious significance dating back to biblical times, remember that mom has an equal share of pride in her boy. © Salzman & Ashley Photography

14. Bar Mitzvah Boy with Both Parents

15. Both Parents: Full-Length and Close-Up

16. Each Sibling Alone
Shoot each the boy's brothers and sisters. Shoot all his sisters close-up, and add a full length of each girl to show off her dress.

17. Bar Mitzvah Boy with Each Sibling

18. All Siblings Together, including the Bar Mitzvah Boy

A Bar or Bat Mitzvah is a family event, and although the boy (or girl) is the star, you should take the opportunity to shoot additional photos that include other siblings. Note that because kids are often short, photographs like this one can be done as a crossover between a full-length and a close-up by sitting the children on a step. This lets you show off the girls dresses but still retain the impact that larger faces provide.
© Salzman & Ashley Photography

19. Mom with the Girls (Extra Credit)

20. Dad with the Boys (Extra Credit)

21. Mom with Boys (Extra Credit)

22. Dad with Girls (Extra Credit)

23. Mom, Dad, and All the Kids

24. Mom, Dad, All the Kids, Add the Grandparents

25. Grandparents with Bar Mitzvah Boy
Be sure to shoot each separate set of grandparents with the boy, as well as both sets together with the boy.

26. Each Set of Grandparents Alone

27. Grandparents with the Boy's Mom and Dad

28. Aunts and Uncles
Remember to catch each different family with and without the Bar Mitzvah boy.

29. Extended Family
Depending on how big the extended families are, you may want to split into different family groupings. Include all the grandparents, aunts, uncles, and cousins.

30. Each Parent of the Boy with Their Parents and Siblings (Extra Credit)
This shot should not include the spouses or children of the parents' siblings.

The Cocktail Hour

During a Bar Mizvah there will usually be a cocktail hour followed by dinner and dancing. You don't want to forget to capture activities and special features that are important to your clients.

1. Bar Mitzvah Boy and Dad Toast at Bar

2. Bar Mitzvah Boy Serving Something to Mom

3. Dad Giving Boy a Cigar (forget this shot for non-smokers)

4. Bar Mitzvah Boy Sitting in Driver's Seat of Family Car

5. Boy with Friends

6 Boy with Girl Friends
This can be kissy, cutesy, or whatever you feel is apropos.

Not only the Bar Mitzvah boy and his parents are given a trip around the floor during the circle dance, but sometimes even a spry grandmother. As a rule of thumb, anyone who is lifted up and carried around in a chair at these types of parties gets a few pictures of the ride.

No matter how many great close-up portraits you do, remember to back out every so often and shoot some full-lengths. © Salzman & Ashley Photography

7. Friends of the Bar Mitzvah Boy

Think about getting a pictures of kids crowded around the hot dog cart (or some other food thing) with the Bar Mitzvah boy serving his friends.

During Dinner and Dancing

1. The Grand Entrance

2. The Bar Mitzvah Boy with Mom during Hora Dance

3. The Same Shot, but Boy with Dad

4. Boy Dancing with Grandparents and/or Siblings

5. The Bar Mitzvah Boy Lifted Up in Chair

6. ANYONE and EVERYONE else who is lifted up in a chair.

At Orthodox affairs there will be two circles of dancers: One of men and one of women. Sometimes the circles may merge, or they might stay separate, or they'll merge then separate again. One shooter on a stepladder will be very busy.

The Motzei (a Blessing Over the Bread)

1. **Shoot All Tables (Yes, It's a Lot of Work)**

2. **Candle Lighting (if there is one)**
Before the lighting starts, take a picture of the cake alone. Then, the boy with his close relatives (or sometimes friends) will light each candle on the cake. Take this shot candidly, then step in and ask them to look at you for a second shot. You can often get great pictures of the boy by candlelight once all the candles are lit, though you'll need a second camera mounted on a tripod and a second shooter or competent assistant to pull it off seamlessly.

3. **Blowing Out Candles on Cake**

Social Dancing

1. **The Bar Mitzvah Boy with Mom**

2. **Mom and Dad Dancing**

3. **Grandparents on Dance Floor**

4. **Siblings of the Bar Mitzvah Boy**
Keep your eyes open for additional pictures, such as assorted kids' activities and dessert tables. Remember who is in the family because pictures of the Bar Mitzvah boy and his close relatives sell, while those of non-descript, non-related kids won't ever become more than proofs.

An Irresistible Closing Shot

1. **The Bar Mitzvah Boy Waving from a Doorway**

2. **The Bar Mitzvah Boy Frozen in Mid Leap**

3. **A Pyramid of Boy and His Friends**
Do this ON CARPETING and make sure you have paid your insurance premiums. Place your Bar Mitzvah boy on top of a three, two, one, stack of kneeling kids. Again—BE CAREFUL!

4. **Boy Sleeping on Catering Hall Sofa**
Don't be afraid to be creative in order to add variety to your shot selection.

Shooting Before the Bar Mitzvah Actually Takes Place

Sometimes the temple services will be held on a Saturday morning with the party occurring on Saturday night. The subjects often change clothes for the two separate parts of the celebration.

Offer to photograph the immediate family at home in their Temple clothes on a different night. Shoot casual portraits, then go to the Temple and shoot the Torah pictures. Now, return home to do formal portraits around the house in their Saturday night party clothes. Sometimes, the grandparents are present for this. After the formal portraits, I will ask the kids to change into their jeans so I can shoot a few casual, fun images.

A candid of grandma and grandpa letting loose on the dance floor captures a great memory for all involved in the day's celebration.

For these portraits I sometimes shoot each child in their own room dressed in their casual clothes. I use props for these fun pictures that are things each child likes. For example, I'll often pose a little sister sitting on the bed in the middle of a pile of stuffed animals, or little brother peering through a goldfish bowl. Get the Bar Mitzvah boy doing something like wearing a football helmet or holding his baseball bat and glove! Anything goes for these photos.

All of this takes two to three hours. It means that all I have left in order to finish the portrait coverage before the start of Saturday night's party is to take the aunts' and uncles' photos (about 30 minutes of portrait combinations). Because of the several outfit changes along with the different locations and photo styles, this method varies your assortment of pictures and really expands the sales potential. Photographers in my area charge $ 400 to $750 additional for this type of "house call."

All these different kinds of posed pictures should give you the chance to create a number of additional saleable images. You can also mix in a ton of looser journalistic images or shoot the posed photos I've described in a journalistic style.

Bat Mitzvahs and Sweet Sixteens

A Bat Mitzvah is a Bar Mitzvah for young ladies. In the Orthodox Jewish community, a Bat Mitzvah girl does not read from the Torah, though she often will in both the Conservative and Reform Jewish ceremonies. If the Bat Mitzvah girl is called to read from the Torah, all the photos listed for a Bar Mitzvah become the basis for the pictures you want to capture at a Bat Mitzvah. But, if the girl is not called to read from the Torah, then the party can be likened to a Sweet Sixteen type of affair! For these types

Girls are not always called to read from the Torah at their Bat Mitzvahs, but sometimes it is allowed among congregations that are less strict in their interpretation of Jewish law. In these instances you can substitute the word girl for boy in the repertoire list. Note that girls don't usually wear a prayer shawl, although they usually wear a head covering.
© Salzman & Ashley Photography

of parties, family photos and general pictures of the occasion (including the décor) should be your prime targets. To develop a repertoire of your own for these types of festivities, review, combine, and prune both the family reunion and Bar Mitzvah sections above to generate a working list of what to photograph.

The affluence and religious customs in your geographic area will determine whether or not family parties and religious passages will become a part of your photographic workload. But, because they represent lucrative assignments, these occasions should not be overlooked as a source of both income and future wedding assignments.

Many girls at their Sweet Sixteen party get a bouquet of flowers from their parents, and in this case a photo of the bouquet is in order. Often it is a detail shot such as this that helps create the precious memories your customers want.
© Mark Romine

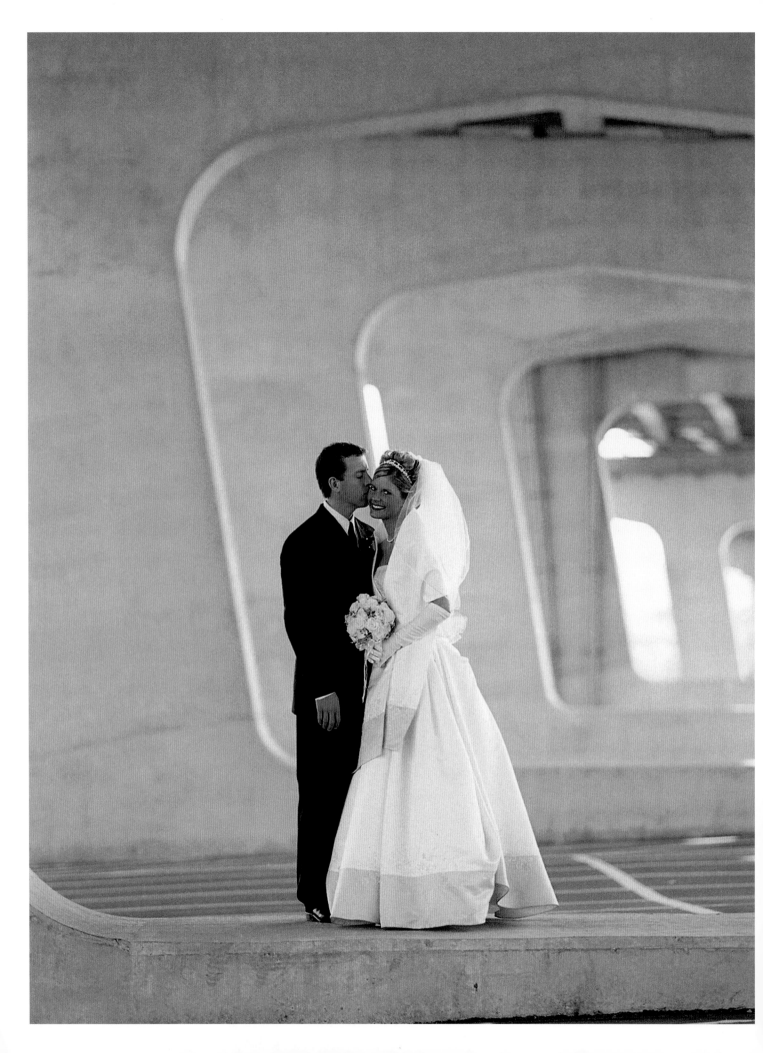

Chapter Four

FRAMING AND POSING

I'm shooting a party at a major New York hotel. There are 800 guests, 80 tables, and at each table there is a bouquet of 100 roses. Four photography crews have been hired to handle the assignment. As a member of one of the first two crews, I have been shooting since 12:30 p.m. The third and fourth crews are scheduled to start at 8:00 p.m. Immediately following the ceremony, at 7:45, I go over to my studio manager and say, "I've established a beachhead and secured my perimeter— bring in the reinforcements."

Over the years, I've watched some friends who are view camera-toting nature specialists agonize over whether an image should be vertical or horizontal and whether they should crop out or leave in a certain branch, leaf, or mushroom. Candidmen don't have the luxury of that agony because everything happens too quickly in wedding photography.

I've also seen fashion photographers zip roll after roll through their motorized 35mm cameras as a professional model dances joyously in front of their lens, hairdressers and makeup artists ready to jump in for touchups at any break in the action. They might burn ten or more rolls of film just to get one picture. Candidmen don't have the indulgence of wasting film or working in a controlled studio environment to make their subjects radiant. In wedding photography, every extra frame of film you shoot affects the profitability of the assignment. Even if you think that digital photography allows you to shoot those extra frames without cost (and I don't agree), you still don't have the time to shoot 300 photographs in order to capture that one (single!) keeper. As a pro, while always considering the limitations of production expenses and time, you must also do what you can to help your subjects look great in front of the camera.

So, to be good (and successful) at the game, you must get to the heart of the matter quickly! That demands that you have some preconceived notions about how the final photograph will look. Framing and posing, two separate and distinct operations, are governed by rules that eliminate wasted time while you're searching for an elusive image. The rules speed up the process of capturing the "bread-and-butter" pictures, therefore creating time for you to shoot those extra pictures that are out of the ordinary and produce additional sales. Without casting anything in stone, let's explore some simple framing and posing axioms that add a professional touch to your pictures, let you take more photographs in less time, and make your subjects look better. But remember, every rule needs to be broken occasionally.

Framing

In the good (?) old days when photographers used press cameras, framing and focusing were completely discreet operations. Most press cameras (both 4 x 5 Graphics and early 35mm rangefinders such as Leicas) had peep sight rangefinders through which the photographer performed the focusing operation. The peep sight was too small to view anything more than the spot on which the candidman was focusing. After correct focus had been achieved, the photographer shifted his or her eye to a framing device and decided whether the picture was a vertical or horizontal and what the image's boundaries were. By separating the focusing and framing operations, this design made each act important and minimized neither. Then the range-viewfinder camera came into being, followed by the twin-lens and single-lens reflex. All these designs combined the framing and focusing operations through a single eyepiece.

Now, with the advent of the autofocus SLR, the placement of the autofocus sensors often dictates composition, which has caused the art of framing to lose some of its individuality and importance. This is a pity. Many images shot with autofocus cameras have the subject placed smack-dab in the middle of the composition. Framing is achieved by default: The autofocus spot is placed on the primary subject, focus locks onto it, and then, regardless of where the other elements fall in the composition, the picture is taken. Also, many novices who use SLRs shoot mostly horizontals simply because the cameras tend to be easier to hold that way. But this does not necessarily result in the best picture.

There are basically three types of posed, formal wedding photos. These are:
1. Full-length pictures
2. Bust-length pictures
3. Close-ups

At one time a bust picture was considered a close-up, but with the emergence of the SLR (and its parallax-free viewing) and the growing popularity of telephoto lenses for wedding work, photographers have been able to get in closer and explore the intricacies of the face. This led to the bust-length image changing in status from being a close-up to a mid-range shot.

One image that smacks of amateurism is the ankle chop. This occurs when the photographer can't decide between a bust-length and a full-length shot, and instead goes for something in between. In my opinion, it looks awful, is a waste of shooting time and material, and should be avoided at all costs. Of course, in a fast-action, candid situation in which expression and subject interaction are paramount, sometimes the candidman must settle for an ankle chop or risk missing the moment. In that case it's better to have a great ankle-chop candid than nothing at all. If the image is posed, however, there isn't much excuse for shooting the "dreaded ankle chop." Take a look at my example so you can remember to avoid it!

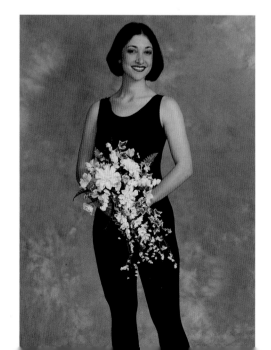

The Dreaded Ankle Chop ... something to avoid!

FULL LENGHTS

6 or more subjects
HORIZONTAL

1 through 4 subjects
VERTICAL

BUST LENGHTS

1 or 2 subjects
VERTICAL

4 or more subjects
HORIZONTAL

EITHER VERTICAL OR HORIZONTAL

5 subjects full length
HORIZONTAL or VERTICAL
composition depends on
body build of subjects

3 subjects bust length
VERTICAL or HORIZONTAL
composition depends on Ł
body build of subjects

Horizontal or Vertical?

Individuals are generally vertical subjects. Groups of people standing in line are generally horizontal subjects. Hold those thoughts while we look at some basic rules of composition.

FOR FULL-LENGTH PHOTOGRAPHS

1. Images with one, two, three, and four people are vertical compositions.
2. Images with six or more people are horizontal compositions.
3. Images with five people can go either way. When all the subjects stand in a line and they are heavyset, the image is horizontal. If they are thin, the image might be a vertical.

If you can pose multiple subjects at different heights (such as a mom sitting, dad standing, and their three kids sprinkled around), the "lineup" can be rearranged into tiers and fit into a vertical composition.

FOR BUST-LENGTH PHOTOGRAPHS

1. Images with one or two people are vertical compositions.
2. Images with four or more people are horizontal compositions.
3. Images with three people in them can go either way. Again, depending on the subjects' builds, the composition could be framed as a horizontal or a vertical. Sometimes a vertical frame will crop out the shoulders of the subjects at either end, while a horizontal frame may leave too much empty space to either side. Often, by arranging the subjects so that they are at different heights, you can easily fit them into a vertical.

BREAKING THE RULES

These guidelines are helpful in making snap decisions. However, it is important to remember that nothing in photography is cast in stone, and every rule can be broken if the spirit of the picture or the subject demand it. But that doesn't mean the framed print of the betrothed hanging over the mantle should be a horizontal.

Posing

This is so weird! Regardless of what a couple tells you about not wanting any posed wedding pictures, invariably they will ask you to shoot posed photos sometime during their wedding day! And, no matter how much prior discussion to the contrary you've had with the bride and groom, when it comes time, they always choose formal portraits of themselves, their parents, and their families. There might be 20 or 30 unposed moments in the mix, but almost always as many posed pictures also make the cut. I say this based on my experience of shooting weddings for 35 years (over 3500 of 'em), and helping to create over 10,000 wedding albums (parents buy albums too!). Sure, the bride and groom really like the great candid images and the catch-as-catch-can moments they have asked for, but a formal portrait of the bride and her grandma makes it into the album more often. Because of this, your directions for posing must go beyond "stand over there and smile."

Being aware of this, once you've figured out how to arrange the frame around the people, the next step is to arrange the people within the frame. That's posing—and it's an art, not a science. Posing sometimes strikes terror into the hearts of subjects.

Often, photographers who are oriented toward photojournalism treat posing like the plague. They consider it dishonest, disingenuous, manipulative, intrusive, and a whole bunch of other nasty, slimy, evil

words. My response? "Phooey!" However, I do believe that there are times when no posing or photographer's control will get you the best picture. In other words, at those times, the photographers who extol the virtues of candid photography are right.

Over the course of a wedding day there is more than enough time for both posed and candid photographs. Your coverage should include a great number of pictures that you take as a casual observer. Don't direct, just observe. A candid situation is just that. However, that said, many of my best wedding photographs are posed.

And what of posing and truth? Although I'm trying to create an accurate record of the wedding day, my photographs are not intended to be a hot news item for a supermarket tabloid. I can picture the headline: "Bride Has 73 Chins!" A wedding is a celebration of love that I personally will not tarnish. The bride and groom are my clients. There is no reason for me to expose their flaws to the world. In fact, I strive to make them look as attractive as possible on their important day. If I move a light or suggest to my subject a slight turn of the body in order to present him or her in a more flattering way, then I'm just doing my job. If my clients want to live a fantasy day, I'll do my best to help them create one. I see no difference between doing this and making an advertising client's product beautiful, sexy, or desirable.

Poses produce effects that may be overbearing or may be subtle. Turn a body slightly, and the subject appears slimmer in the resulting photograph. Extend the subject's hand gracefully, and instead of it looking like a lobster's claw, it beckons the viewer with a sense of intimacy, as though revealing a secret.

During my many years of professional commercial photography, I never shot an advertising photograph that wasn't rigidly controlled, contrived, planned, and posed!

Tricks of the Trade for Painless Posing

I list three fundamental rules that always help your subjects look their best when they pose. In addition to the 45° angle, the pointed toe, and elbows away (see page 102), there are several more tricks that also work well. These techniques for posing are generally simple, and they are designed to make your subjects look as attractive as possible in their photographs. For the most part, the secrets about how to pose someone are optical illusions often caused by the fact that the camera is monocular (one-eyed) as opposed to binocular (two-eyed).

Stand Up Straight

This may seem obvious, but something as simple as standing straight can do wonders for your subject. Although the groom can benefit from this too, it is especially petinent for the bride because she's probably never worn a headpiece and veil for a whole day before. All too often, brides look as if they are balancing a bowl of fruit on top of their heads! Keep assuring the bride that her headpiece won't fall off . . . and if it does there will be plenty of willing hands to help her fix it.

No: slumped

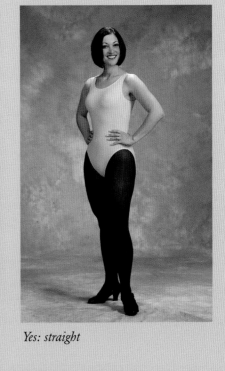

Yes: straight

No: raised shoulders

Yes: relaxed

Relax the Shoulders

When people get nervous they have a tendency to tighten and raise their shoulders. This makes their shoulders look narrower, their necks look shorter, and most importantly, it creates a subte feeling of tenseness. To combat it, get your subject to relax their shoulders so they fall naturally. Getting married doesn't require someone pull their shoulders up to their earlobes!

No: backward tilt *Yes: lean forward at waist*

Banish Those Double Chins

In an effort to hide a double chin, many people tilt theirs head slightly backward. This actually has negative effects. The chin becomes more prominent, the insides of the nostrils are visible, and the eyes (the most expressive facial feature) look smaller. The real foundation for banishing double chins is found way down at your subject's waist. If they lean slightly forward at the waist and then tilt their head slightly backward, the end result will leave their face in its normal position. The slight forward tilt at the waist cancels out the backward tilt of the head and results in the face being parallel to the camera's film plane (without the adverse prominent chin, nostril interiors, or small eyes). Importantly, the skin is pulled tighter which helps eliminate the extra unwanted chin(s). Equally effective is shooting from a higher camera angle.

What about Eyeglasses

Photo gray lenses are a big no-no! They darken when outdoors, and even when non-grayed, they look darker than regular lenses. Non-glare lenses are available at reasonable cost, and you could mention these at a pre-wedding meeting. Also suggest they get their frames adjusted before the wedding. The surface of the lenses should tilt slightly downward so the flashback from the camera's flash will reflect harmlessly toward the ground. This trick can also be accomplished by having the subject lower their chin slightly, which also presents another benefit.

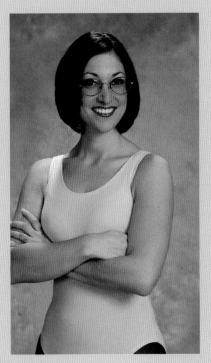

No: catches flash *Yes: lowered chin*

No: looking straight ahead

Yes: slightly lowered chin

Accentuate Those Eyes

When your subject lowers their chin a fraction of an inch, it accentuates their eyes, which are anyone's most expressive facial feature. This movement causes the eyes to tilt closer to the plane of the recording medium (film or sensor). Now closer to the plane than the chin and mouth, the eyes appear larger. Just a tiny dose is all you need, so use it cautiously.

Relax That Forehead

In an effort to accentuate their eyes, people will try to open them as wide as possible. Consequently, subjects also raise their eyebrows, which in turn wrinkles their foreheads—an undesirable look. When this happens, I tell my subject to relax their forehead. Once subjects are aware of what you are saying, they figure out a way to unfurrow their brows.

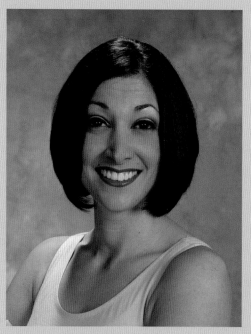

No: eyes wide, raised brows

Yes: relaxed forehead

Lower the Bouquet

Many times a bride looks as if she's hiding behind her flowers. But, the bodice of her wedding gown is beautiful and often intricately detailed, so she shouldn't hide it behind her flowers. Further, if she holds her bouquet high it hides her bust line. Better still, if she holds the bouquet lower it can cover a little potbelly or broad hips. As an added advantage, holding the flowers a bit lower places her forearms at a 45-degree angle, which makes her body look longer and leaner. So, no matter what type of bouquet a bride chooses, your best advice is to tell her to, "Lower your bouquet."

 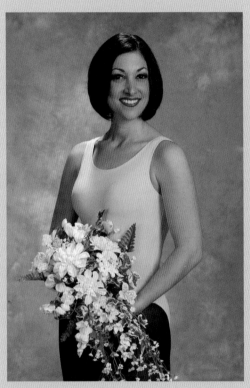

No: raised bouquet *Yes: lowered bouquet*

All the suggestions I've made here should be used judiciously. Remember, overdoing a good thing can result in disaster! Your application of these ideas should be measured in fractions of an inch.

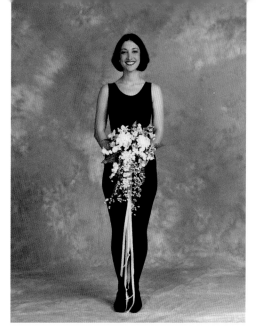

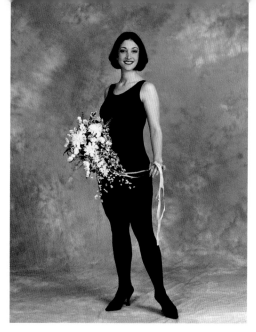

Posed photographs run the gamut from images in which the photographer controls the subject's every finger position to images in which the photographer's input amounts to, "Stand over there." I find there's room for both posed and candid pictures, and my only criteria for success is that the photo should look natural. Aha . . . that's the real issue. People can position themselves many different ways. Some poses make the person look much better; some make the person look much worse. But any position is natural if the person does it without direction. Posing is the art of placing people in natural-looking and flattering positions.

I've found that the vast majority of the photographs my customers purchase are manipulated by me in some way. Shoot 100 totally candid photographs and the bride and groom will buy 10 (if you're lucky). "But mom's face is turned away," . . . "But my veil

is in his face," . . . "But you can't see Aunt Martha," . . . etc. Shoot 100 posed pictures and, if you're good, the couple may well choose 100 . . . OK, OK, 80.

A Quick Guide to Posing

With all the layers of material that make a bridal gown, and all the accessories that go with a tuxedo, it is sometimes hard to see exactly how the subjects' bodies are situated. But posing starts with the subject's body position. Therefore, instead of explaining how the subject's body is positioned under all the vestments of the wedding day, I will show you just the basics, the bodies, unencumbered by the clothing of the event.

To do this, I got some help from the students and teachers at Great Expectations, a Staten Island dance school. Although I've also included standard bridal photographs, those that are worth extra study are of the

Important Hint

Looking at a pose and deciding that it is stiff and unnatural is easy. But deciding what to change so it will look more relaxed and natural is hard. One trick that works for me is to break the subject's pose down into sections and examine each one separately. Many times the subject just has to relax her shoulders, shift her hips, or tilt her head a little (one way or the other) to create the natural, relaxed look you're after. I have found, through sheer repetition, that most subjects often show a lot of tension in their shoulders. You probably know the look—their shoulders are up around their ears. I try to pose using a soothing voice and frequently remind my subjects to relax their shoulders and breathe!

dancers in leotards. In these photographs you can see how bodies are arranged to fit together and look flattering. As a counter-point, I've also included a non-posed, "Stand over there" image of various group-ings, so you can understand and visualize the difference. The time it takes to clean up a pose (tucking someone's belly behind someone else's elbow, showing a shirt cuff at the end of a tuxedo sleeve, strategically placing a hand, or flaring an elbow) takes mere moments and is well worth the effort. The decision about how "tightly" to pose at any given wedding is a matter of choice, both the photographer's and the subjects'. The candidmen who are best at this art form can make it into a gentle game, and even their tightly posed work is not bothersome and does not appear overly intrusive to the subject.

THE BRIDE

The star of the day demands extra attention, not only because she's the bride, but also because a bridal gown and bouquet offer so many aspects to show off. Here's the scoop: While the groom may rent his tuxedo or even wear his Sunday best, the bridal gown is a one-day dress. After the wedding it will be lovingly cleaned, wrapped, and stored in a box. It will become the first of the new family's heirlooms. If you shoot pictures that offer variety, chances are good that you can sell a half-dozen or more pictures of the bride, her gown, and her bouquet (single pictures of the groom always sell fewer). Variety starts with full-lengths, busts, and close-ups, but continues to include back-ground and lighting changes.

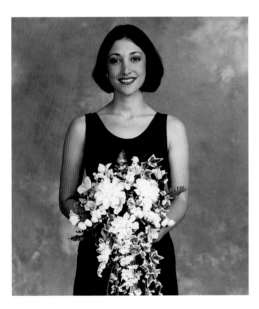

In the "Stand over there and smile" non-pose, notice that the bride's bouquet covers the bodice of her dress (I know the model is in a leotard, but use your imagination!), and it looks like she's grow-ing out of her flowers. When I see this I usually say, "The bodice of your dress is beautiful, lower your flowers." If the bride still doesn't get it, I tell her to rest her wrists on her hip bones. That's usu-ally about the right position.

In the more finished pose I've added two wrinkles to the full-length rules. In addition to lowering the flowers, I had the bride move them to one side, which shows off the bodice of the gown, and I tilt-ed them at a slight angle so the bottom of the bou-quet wasn't lost in the crop. Finally, I used her left hand as a place to drape the bouquet's ribbons, which allowed me to 1) show the ribbon train, and 2) take her elbow off her side.

Long-stem bouquets are usually best laid in the crook of one arm. The free hand can be used to stabilize the lower end of the bouquet. This type of bouquet almost always looks best with the flowers presented in the camera's direction. The hand used to stabilize the bouquet doesn't allow you to use the "elbow out" theory to achieve a slimming pose, but you can try a shot with the bride placing her free hand on her hip, which will also show off her waistline. In either event, pay attention to how the ribbons fall in the frame.

Cascade bouquets often have a handle underneath. I ask the bride to hold the handle with her back hand (remember, her shoulders are at a 45° angle, so there is a front and a back hand) and use the front hand as a palm-up support under the bouquet. This helps with the elbow game and, because the hands are at different positions under the bouquet, the arms appear asymmetrical, which is usually pleasing. If the bride is holding a cascade bouquet and the gown has a long veil, you can often drape the veil over her arm to create a diagonal line that leads the viewer's eyes back into the photograph.

THREE SIMPLE RULES FOR POSING

The three basic axioms about full-length pictures of the bride are:

1. Turn the subject's shoulders to a 45° angle.
2. Have the subject point the forward-most toe towards the camera slightly.
3. Place the subject's elbows slightly away from her sides.

The 45° turn narrows the subject's shoulders, and narrower looks thinner to the camera because of its monocular view. And naturally, thinner is almost always a plus. For example, if the bride is standing with her shoulders parallel to the camera's film plane, her torso might be 24 inches wide when measured from shoulder to shoulder. But, if she turns her body to a 45° angle, the measurement from shoulder to shoulder (in the photo) might be cut down to only 18 inches. In effect, you've traded one dimension for another.

The toe-pointing routine forces the subject (unknowingly) to put her weight on her back foot, which causes her hips to shift, giving her a curvy look. The goal here is to get one hip and buttock to be slightly more pronounced than the other. A little goes a long way; you're looking for just a slight shift of her hips.

Finally, if her elbows appear to touch her sides in the resulting photograph, she will appear as wide as her elbows (remember,

Leaning the groom into a pose tilts the body slightly and eliminates the tension caused by the ramrod stiffness of a "Stand over there and smile" pose. You can be very creative in finding things for a man to lean on. In this particular instance I had the model lean on a camera case standing on end on a step of my posing ladder. You could just as easily find a more natural prop for him to lean on.

narrower looks thinner!), but if there is a touch of daylight showing between the subject's elbow and her side, it shows off her waistline, which usually improves how a bride looks.

The elbow move is a tricky one because, if exaggerated, it looks as if the subject is doing the chicken dance. In addition, subjects sometimes lift their shoulders when moving their elbows. Both of these problems can detract from the image and should be gently corrected. Usually when it happens I smile and say, "Don't let it look like you're doing the chicken dance," or "Relax your shoulders."

The three rules are so telling that many a good close-up can be taken just by moving in on a properly posed full-length, then simply reframing, refocusing, and reshooting. Look at the examples on pages 100 and 101 to see the differences between "Stand over there and smile" and posing the subjects using these three little rules.

DIFFERENT POSES FOR DIFFERENT BOUQUETS

Bouquet shapes and sizes can dictate how they are held, and they can even dictate the pose. Different names include snowballs, cascades, and long-stem bouquets.

Snowballs often have ribbon cascades, and in the poses on pages 100 and 101, the bouquet is a floral cascade with ribbons. Florists mix and match all three varieties between brides and their bridesmaids, and one type isn't better or worse than the other, just different. The photos on the opposite page show how poses are affected by cascade and long-stem bouquets.

DON'T FORGET THE GROOM

A guy in a tuxedo (or a suit) is just a guy in a tuxedo (or a suit), and that is what the groom is. In reality there is less to work with in shooting a portrait of a man compared to a bride, with her gown, veil, and bouquet. Still, he is the other star of the wedding.

Just as with the bride, the groom should hold his shoulders at a 45° angle to the camera when posing for full-length portraits. The feet, however, are a different story altogether. Usually, separating them slightly and splaying one foot outward a bit will do the trick. The simple fact is, a woman's gown, usually with a wide base, lends itself to a pleasing composition, while men's attire often makes them look as if they are about to topple over (especially if the men have broad shoulders).

The elbow game for the groom is a bigger challenge. Arms naturally fall straight unless you have something to "hang the hand on" that is slightly higher than its normal position. God bless pockets! Often, by having a subject place a hand in his pants pocket, his arm will bend naturally at the elbow. There are some caveats, however. If the groom puts his hand in a pants pocket and is wearing a jacket, be aware of how the hem of the jacket looks with the hand snaking under it. On vested suits it is often helpful to have the subject open his jacket and push the jacket back out of the way before he puts his hand in his pocket. (This also shows off the subject's vest.)

Often a stance with both hands in both pockets, the jacket sides pushed out of the way, creates a relaxed pose, especially if the subject is leaning against something. If the man is not wearing a vest or cummerbund, just make sure his shirt is tucked in and

smooth at the belt line. Some guys look great when they hook a thumb in their belts. This too can get the elbow/body separation you are looking for. As an alternative, you might try having him remove his jacket and drape it over his arm or flip it over his shoulder, à la Frank Sinatra.

The shoulder width and its potentially top-heavy aspect is a problem in the bust-length portrait as well. There are ways around this, and my favorite is to lean the man's torso into the picture. Have the groom lean an elbow on whatever may be handy. This can be the back of a high-backed chair, a fence post, the fender of a limo, or a camera case on a posing ladder covered with a drape, depending on how tall he is and what is available.

Posing Hands

One of the most difficult things to photograph is the hand. Many fine photographers have nightmares about how to pose hands and where to place them in their wedding photographs. Often the best solution is to crop the hands out of the picture altogether! But there are times when hands are a part of the picture. They can help tie two subjects together, they can be used to frame and support a face, and in a ring shot, they are the most important part of the image.

There are a few facts worth considering. If you pose a hand so that either the palm or the back is parallel to the film plane, you will find that the hand appears unnaturally large. If, on the other hand, you place the hand so that its edge is toward the camera (the little-finger edge—thumbs present additional problems), the hand appears to be much more delicate. A slight backward bend at the wrist and slightly curled fingers will produce an "S" curve, which is pleasing to the eye.

There is one definite no-no. If a hand is peeking over another subject's shoulder, the resulting picture has what appear to be four

Just as when photographing a woman, try to slim a male subject with a flattering pose so that he presents a better silhouette to the camera. Once again the shoulders (and the rest of his body) are turned at a 45° angle to the camera, but in this instance, unlike his female counterpart, I had the subject move his rear foot out slightly to give his body a wider base on which to rest. With someone as fit as my model, placing his hand on his hip shows the "V" of his torso, but you might try having the subject place his hand in his pants pocket or have him take his jacket off altogether.

In this classical bride-and-groom pose, the bride's back is to the groom's front. Once again both subjects' shoulders are at a 45° angle to the camera. Placing the groom's left hand on the bride's left arm creates a connection between the two bodies, and further, his forearm continues the diagonal line created by her forearm. Notice also that both subjects' upper arms are parallel and create lines that lead toward their faces. Although my model isn't wearing a ring, this pose is great for showing off the groom's shiny, new wedding band.

 In this pose the bride and groom are facing each other with their rear shoulders touching. Both subjects have their shoulders at a 45° angle to the camera. By having the groom put his right hand in his pocket, his arm follows the pattern set by the bride's left arm, creating a pleasing symmetry.

pink, foreign dots on the shoulder . . . not very flattering, and quite distracting. If you want to include a subject's hands in your photos, remember to catch them from the side. If all else fails, crop them out!

USE A MIRROR AS A LEARNING TOOL

One of my mentors was able to pose a subject's hands in the most creative ways. When I asked where he got his ideas, he told me he used to practice in front of a mirror using himself as the subject. I have found a mirror to be a perfect teaching aid to help with good posing. A full-length mirror is best, but even a small bathroom mirror can help. Find a suitable mirror, put aside your insecurities, and pose yourself as both a bride and a groom. Wear a suit jacket to try male poses and hold a prop for a bouquet to try bridals. Analyze what you are doing to see how it affects the pose. Tilt your head, turn your body, and try to imagine how and where another person would fit into the composition. This technique may sound silly, but it can be extremely valuable for adding variety to your repertoire.

On a similar note, look critically at magazine images to analyze how the models are posed. Those pages can add to the variety of poses you use, which can make for fat, profitable wedding albums.

PUTTING THE BRIDE AND GROOM TOGETHER

Once we accept the concept that the subject's shoulders should be at a 45° angle to the camera, it becomes obvious there are really only four ways that two bodies can fit together:

1. The subjects can be front to front.
2. His front can be to her back.
3. His back can be to her front.
4. The two of them back to back.

Just as there are thousands of photographers, there are thousands of variations on this theme, but when it comes to formal posing, all variations fall into one of these four categories. Equally true, these basic arrangements apply to bust-length shots, to full-length poses with both parties standing, to an arrangement with one sitting and one

This pose is usually not included in the standard set of poses a candidman uses, but its difference makes it interesting. Neither wedding ring shows, but the way the bride can snuggle into the small of the groom's back and the way in which she can lean her head on his shoulder makes a connection between them that I find appealing. Notice that her arm position mimics his, making this the perfect pose for a bride and her brother.

To get this pose I had the groom sit on my posing ladder. Notice that I've placed the bride on the side that allows her to show off her wedding ring. Equally as important, her hands are placed one on top of the other without interlocking the fingers. If the fingers interlock, the presentation of the hands becomes confusing and unflattering. A pose such as this can be very effective in a shot of the bride and her father because it has very little sexual connotation.

Here the man is turned 45° so he is facing away from the camera, and his head is in profile, framing the woman's face.

Once again his front is turned away from the camera. His profile frames the woman's face.

The Two-up: Posing the Bride and Groom

Each basic pose has several "sub-poses" that you might want to explore. When you place the subject's shoulders at a 45° angle to the camera, you aren't limited to one view. Throughout a 360° circle there are four positions in which the subjects' shoulders hit a 45° mark; two facing the camera and two facing away.

You can also do a lot by changing the heights of the two subjects. Both can stand, one can sit while the other stands, or both can be seated. Below are four variations on the basic poses I've described that vary by the 45° angle I've chosen and the relative heights of the subjects. But even within the parameters I've set, there are thousands of possibilities. Mix, match, be creative . . . Find a mirror and a friend and work out some variations that you like!

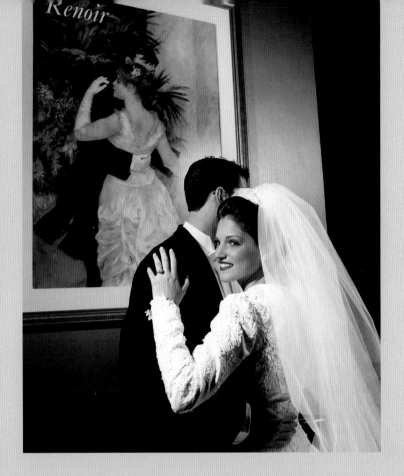

Traditional photographic rules of composition often speak about using repeating patterns for creative effect, and in this case the couple's pose imitates the picture on the wall. To make the picture work, traditional framing rules were left by the wayside and the couple was placed in the lower corner of the frame. © Jerry Meyer Studio

They are facing each other, but this time the woman's back is towards the camera.

Her head is higher than his and she's showing her wedding ring. The couple is now front to front, and they both face the camera.

Like the picture below right, this is a pose that is closed. The two outer subjects sandwich the third, and both outer subjects face the central one. Although it looks very different than the finished, posed three-up shown below, it is the same with a few slight changes. In this instance, the entire line was rotated, and one subject was seated on a low stool. Finally, because of the difference in heights, a line drawn through the three faces follows a diagonal instead of a horizontal. This makes the composition a vertical instead of a horizontal.

standing, or even when both are sitting (as on different steps of a posing ladder). As an aside, these poses work for more than just the bride and groom. Mom and dad, siblings or friends, in fact, any couple, can be posed this way. They are relevant any time you have to photograph two people together. Study some of the variations I've described and then think up some of your own.

POSING THREE PEOPLE

After you've mastered the two-up, the next group is, you guessed it, the three-up. The bride, her mom, plus dad (or the groom and his parents) make three.

For a simple, quick pose of three subjects, it's hard to beat what I refer to as the "line-up." Although a lineup looks easy, make sure to use the posing tips we have already examined. These will make your photograph look more professional. Instead of the "Stand over there and smile" non-pose, remember the basic rules for posing one person—first and foremost, turn the subject's body so that the shoulders are at a 45° angle to the camera.

The Three-Up: Compare the "Stand over there and smile" non-pose (left) with the finished, posed composition (right). By turning the bride's back towards her dad's front you have a perfect hiding place for dad's tummy. Notice that one of the three subjects is turned towards the other two. If all the subjects face inward the pose will hold the viewer's focus. In the posed picture, both parent models are turned towards the bride (the center). If you had four people, you might turn each couple to face the center. Although this is a lineup, it's not unacceptable because the line is short. Once you have more than five subjects though, it's time to do something different.

If you start with the bride in the middle of her parents, and turn her toward her right (which can be called either "subject right" or "camera left"), then dad can fit in behind her (camera right) and mom can face her on the opposite side (camera left). Since this pose usually works best as a horizontal, you might consider having mom place her right hand on the bride's right forearm and dad putting his left hand on the bride's left elbow. The "hands-on" approach I'm suggesting connects the bodies and, what's more important, the arms become a horizontal holding line that stops the viewer's eyes from falling off the bottom of the picture.

You might question why I put the dad's front to the bride's back as opposed to having the mom's front to the bride's back. Although the models pictured in this book are slim and fit, in the real world, placing dad's front to the bride's back gives you a perfect place to hide his belly . . . behind the bride's left elbow! Tucking in (and hiding) a belly can turn you into a star photographer in their eyes!

For variations on this theme, look at the other examples shown. If one of the three subjects is a little person, such as a flower girl, ring bearer, or younger sibling, you can arrange the little one in front of the tallest person so the image becomes a vertical composition. If you follow this route, make sure the two heads do not line up exactly one above the other. If you aren't careful, it will look like the tall subject is growing out of the short one—not a pleasing image! You could also arrange three faces in a vertical composition by posing the subjects so their faces all fall along a diagonal line. At the top of page 108, I sat the mom on the lowest position (the middle step of my posing ladder) and arranged the young girl and the bride in order of their size. Notice also that the mom's shoulders are at a 45° angle, but her back is towards the camera, and she is facing toward her daughters. By placing her

A three-up can be made into a vertical composition if you have one tall, one short, and one medium-height subject. With three similarly sized subjects, you can create the same effect by seating one of them in front. Imagine dad seated, with mom and the bride each on opposite sides of him, leaning in on his shoulders.

and the bride so they both face in, they contain the viewer's eyes as they sandwich the middle subject.

Once you start doing these variations, you might find that you run out of depth of field. As the posed subjects get deeper and you get closer, it becomes apparent that you can't get everyone in focus because all the faces are on different planes. The obvious remedy is to choose a smaller f/stop, which will increase your depth of field, and focus on a point that is one-third into the depth of the subjects. There is only so much this can do.

The other remedy, one that you should always be aware of, is to create a pose that looks deep but isn't. In the variation of the three-up above, notice that the tall subject's rear shoulder is behind the bride's rear shoulder. This creates a little pocket for the short subject to fit into, and the pose isn't as deep as one in which the two taller subjects' rear shoulders are on the same plane. Also note in the pose on top of page 108,

the rear-most subject is leaning in over the middle subject so that once again the pose isn't as deep. If you're posing the subject(s) anyway, you might as well position them so that your technical limitations are minimized.

Carry Posing Tools

One easy way to get variety in the heights of your subjects is to have some of them sit. For this reason I carry six chairs of different sizes with me everywhere I go.

Not really! But though I don't lug a stack of chairs with me, I do carry a posing ladder. I also use carefully chosen hard cases for my lights instead of today's more popular, soft-sided equipment cases. Each of my three cases, when stood on end, is three inches taller than the next. Inside each case I carry a posing drape that can cover the case, converting it into a seat or perch for a subject to sit or lean on. I also carry a fourth posing drape to cover my stepladder when it's used for posing.

These posing aids all perform double duty. The cases are needed anyway to protect my lights as they are lugged around from assignment to assignment, and the posing ladder can serve two purposes by giving me a high vantage point when I shoot over crowds or want to photograph an overall view of the dance floor.

The Large Group

One of the hardest things to do is to make a large group look interesting. If you have no posing tools, you are pretty much stuck with a lineup. In general, I will go to great lengths to avoid shooting subjects in a straight line. If there are short people as well as tall people in the family or bridal party, you can pose a lineup in which you use the various subjects' heights to make the grouping more pleasing. In the stand-up grouping pictured (top left, page 111), notice that the subjects are placed so that lines connecting their faces all create diagonals that lead to the

bride. Also note that the subjects are arranged so that no two faces are directly above another.

In the next picture, pretend that we're in a park and I have my posing ladder with me. Two subjects, in this case the groom and the ring bearer, are seated on the steps of my posing ladder. To create other heights for the pose, I sat two of the girls on the floor (er . . . I mean grass). Some may criticize this pose because the flowers are growing out of the little boy's head, but from sad experience I've found that you're lucky if you can get most little kids to sit still, look at you, and smile for a picture. If he (or she) is still and smiling, I shoot the picture . . . to heck with the flowers!

For my final group shot, I used my posing ladder and two empty camera cases to create multiple tiers. In a real situation, posing drapes and gowns would be covering all the posing tools, but note how all the lines connecting the subjects are diagonal and the grouping looks like a pyramid instead of a lineup.

Creating Your Own Style

Posing is an art form. The photographers I consider to be great take years refining their styles. Many young photographers have trouble changing a pose once they get the bride, groom, or both into it! They think by changing it they are making an admission that their posing is incorrect. Instead of fixing a pose to make it appear more natural, they shoot the picture as is. This drives me nuts!

Before I shoot a posed photograph, I stop for a second and look critically at how my subjects are situated. If they don't look natural or appear too staged, uncomfortable, or just plain hokey, I walk right up to them and say: "This doesn't look right . . . let's change it!"

Even though I hate a lineup, sometimes I'm forced to use it. To make the best of a lineup, try to use the subjects' different heights to your advantage.

Just adding a ladder to your arsenal of posing tools opens up new possibilities. Good wedding ladders have a top step (or seat) between 29 and 30 inches high. The one I use is more like a portable mini-staircase than a stepladder. If you start to use a stepladder for posing, remember to use it to take some high-angle shots at the reception also.

Don't be afraid to make mistakes. And never, ever be afraid to change something for the better!

Your goal is to achieve natural and relaxed poses . . . poses that don't look stiff and contrived. That is not easy. I find that beginners tend to plod along on one plateau for a while, and then, overnight, the quality of their posing ability takes a quantum leap.

Making that leap requires looking at and critically evaluating your posed pictures. Once you can identify stiff, unnatural poses in your photos, you'll be able to notice stiff, unnatural poses when you are setting up the shot. All that's needed then is the courage to change a pose before you push the shutter button. Once that happens, you'll make your first quantum leap.

Once I add empty camera cases to my posing ladder for group shots I can create many different levels on which to place my subjects. After a short while you begin to be aware of the relative height of the different subjects you're working with and the different height steps and boxes you have available to seat them on. With very little effort your family lineups can be turned into family groupings that are more pleasing to the eye than the "stand 'em up... shoot 'em down" style of posing that many wedding photographers practice.

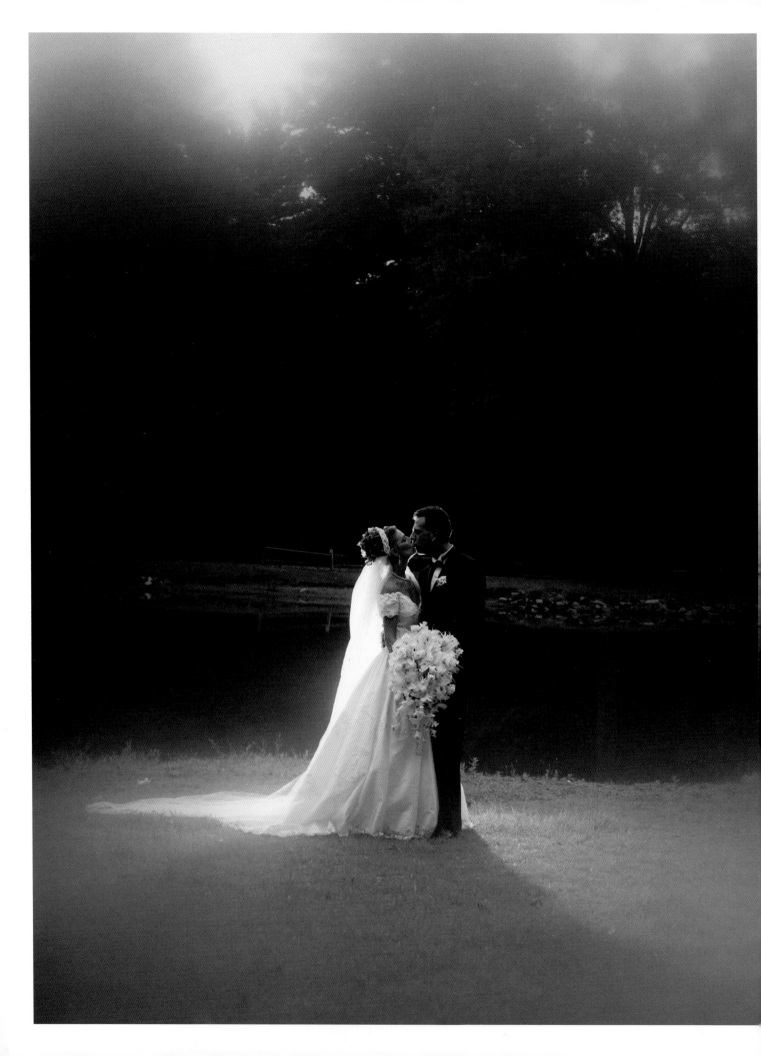

WORKING WITH FLASH

It's a large wedding with two photo crews. The studio manager watches as my assistant and I unload four cases of lighting equipment from the trunk of my car in the hotel parking lot. I pile the cases onto my wheeled cart and the manager asks, "How come Bill (the second photographer) only carries three cases of lighting equipment?" I shrug my shoulders and my assistant starts wheeling the groaning cart across the lot and into the venue. Backgrounds are chosen and each crew starts to set up for a portrait session. Ten minutes into set-up, Bill's assistant comes over to me and asks: "Can Bill borrow a 25-foot extension cord?" With a look at the studio manager, I smile and say, "Sure, take the spare out of my silver case." Five minutes after that, Bill's assistant comes over again and says, "Bill wants to know if he can buy a spare modeling lamp from you." I smile again and say, "Sure, it's fifteen bucks and there are two extra in my silver case." The assistant forks over the cash and hurries off with the precious bulb. I turn to the studio manager, smiling one more time, and say, "I just figured out why Bill doesn't need a fourth lighting case . . . he's got me!"

No matter how you look at it, wedding photographers depend on electronic flash. While anyone can extol the virtues of natural (or available) light, the simple truth is that shooting by natural light is very limiting, and nature isn't always cooperative. It pays to remember that the wedding warrior works in dim churches and even dimmer catering halls. Just as important is the fact that while the ceremony might take place in an outdoor setting on a bright afternoon, the party will extend into the dark of night. While a hobbyist can wait to capture just a single great photograph when the available light is perfect; a pro, driven by profit, can't afford that luxury. And while the novice might want to use all the lens speed for which he or she paid to take pictures, a pro is usually much more comfortable with a smaller f/stop, which can increase depth of field and help cover focusing errors. If you add together a flash unit's power, its action-stopping ability, and the fact that weddings are often covered in "available dark," you can see that a good flash is a wedding photographer's best friend.

There is much debate going on in our industry over which type of flash is best. Should we use automatic flash or is manual flash still king of the Chapel Hill? From my point of view, one aspect of this discussion is a tempest in a teacup, but there are other aspects well worth considering.

Let's look at the teacup tempest first: Many photographers consider manual flash difficult to use, especially when they are concerned that most wedding couples express interest in seeing "creative" photos of themselves. However, when it is time to order prints and enlargements, most couples are interested in pictures that I call "bread and butter" images. These are the classic pictures of the bride and her mom, the bride with her dad, the groom with his parents, family shots, the wedding party, sibling photos, along with all the standard scenes that happen during the richness of a wedding day, from the ceremony through the garter toss. Because the couple always chooses additional bread and butter shots, these are also lucrative types of photos.

Here's where it gets easier—most bread and butter photographs are shot from three separate distances: 15, 10, and 5 feet (about 4.5, 3, and 1.5 meters respectively). Naturally you don't stop your shooting to measure these distances, but with practice you can get quite accurate in estimating how far you are from your subjects. A 15-foot picture will cover full-length shots with a normal lens, or group shots with a wide-angle. The 10-foot picture can cover bust shots of singles, two-ups, and three-ups with a telephoto, bust shots of groups from four to six with a normal lens, or full-lengths with a wide-angle. Finally, the 5-foot distance can cover tight head shots (single or two-up) using a portrait tele, two- and three-ups with a normal, and intimate candids with a wide-angle lens. These three distances convert to three different f/stops with a manual flash unit, and even if you add in a fourth f/stop for bounce-lighting effects, you can see that there really aren't that many possibilities you need to remember. Since many wedding photographs are still shot on

color negative film, which offers an embarrassment of riches as far as exposure latitude is concerned, you can see that a manual flash unit is pretty easy to use. If manual flash is your choice, you'll find that within a short time you'll be able to figure out exposure by feel. Soon you'll be able to forget about calculating an f/stop, because with a little experience you'll become a precise, walking, talking, human flash meter.

However, before you can become a human meter, you'll have to figure out which f/stop to use. That's not as scary as it sounds. Remember, you are usually shooting from one of three approximate distances: 15 feet, 10 feet, or 5 feet. The f/stop you choose for proper exposure with a manual flash is based on the light's distance from the subject. By dividing the flash unit's distance from the subject into the guide number (which is different for every ISO setting), you get the proper f/stop for correct exposure (at that distance and with that ISO). This is not difficult, so follow along as I illustrate further.

If you have a flash unit with a guide number of 80 (in feet, or 24 in meters) for ISO 100, and you are 10 feet from your subject, the f/stop for proper exposure is f/8. To get this I divided 80 (the guide number) by 10 (the distance), and the result is the f/stop to use. This works for metric guide numbers, too, as long as you divide meters by meters. So, in our example above, if you are shooting from 15 feet, the correct aperture is f/5.6 (80 divided by 15 is 5.33 . . . close enough for practical purposes), and when shooting from 5 feet, use f/16 (80 divided by 5 is 16).

There is one small fly in the ointment. Small white rooms push your guide number up slightly because light from the flash bounces off the walls and ceiling, kicks back onto the subject, and adds to the exposure. On the flip side, big dark rooms, such as banquet halls and cathedrals, suck up some of your light and take away from the expo-

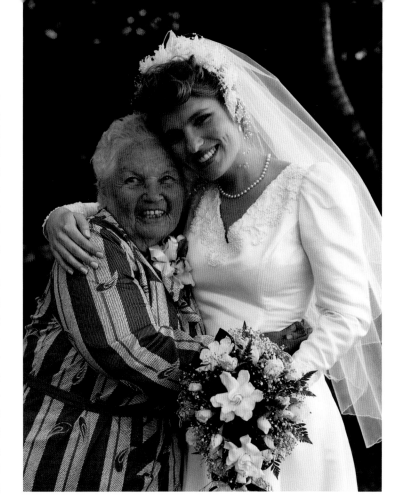

A bride and her grandmother are always worth a picture. If you see that they have a close relationship (and you should try to discover things like that), forget about polished posing and just let them hug. Better still, grab a shot of them posed, then smile and say: "OK, let's forget this. Why not just hug each other?" That way you've got all the bases covered.

sure. To compensate for this, I open up 1/2 stop from the calculation for cavernous dark rooms and close down 1/2 stop from the calculation in tiny white ones.

The term to describe this might be called "Kentucky Windage." During the early years of our country's history, the best sharpshooters were from Kentucky and used long rifles. Their accuracy depended on taking the wind direction and velocity into account as they took aim. Kentucky Windage was the compensation factor the sharpshooters threw into their mental calculations to adjust for the wind's effect. Candidmen do the same thing with regards to room size and color.

Some readers might be concerned about my choice of ISO 100 for my examples when the majority of weddings photographed today are shot at different ISO settings. Well, for the uninitiated, ISO's work just like f/stops (and, although irrelevant in this discussion, shutter speeds too); everything works in multiples of two ISO 200 is one f/stop faster than ISO 100 and ISO 400 is two stops faster than ISO 100. The term "faster" means that a higher ISO medium (be it film or digital) reacts more quickly to the light, so less light is needed for proper exposure. But first a word from our sponsor: quality!

Because I have taken thousands upon thousands of pictures using manual flash, I find this method fast and simple to use. But some photographers may argue that auto flash units are still faster. I counter that the auto flash unit's "brain" is frequently tricked by a huge white wedding gown or a sea of black tuxedos, or worse still, a huge white wedding gown in front of a sea of black tuxedos. And sometimes the flash unit's auto system must contend with a fairly small, light subject in the middle of a huge dark room (such as a banquet hall). These situations, which are common in the wedding world, can addle the brain chip in an auto flash unit.

More importantly, manual flash is a more consistent way to expose your photos because it is based on the parameter of distance from camera to subject, and is therefore unaffected by things like the color of the bride's dress and its distance from the background. Though this increases the effort and technical virtuosity required by the photographer, it is not something to be overlooked! While ease of use is a prime consideration for a hobbyist photographer, it is a poor criterion for a pro making choices about lighting!

One way to greatly increase the speed at which a candidman can shoot with manual flash is the use of pre-visualization. Many photographers think of pre-visualization as the tool for landscape or view camera photographers, but as a fast-working wedding pro, I rely on it all the time. After watching me work, many assistants have commented that I can work as quickly with a roll-film camera and a manual flash as a novice with a 35mm camera and auto flash. This is possible because I pre-visualize my pictures.

Here's how it works: I decide to shoot a bust-length candid picture of two people. I choose my wide-angle lens. Before I approach them I set the focusing scale on my camera to 6 feet (1.8 meters) and set my f/stop for a 6-foot flash picture. After I've done my camera fiddling, I walk up to my subjects and ask them to look my way and smile. I then backpedal to 6 feet away, raise my camera in front of my face, and push the shutter button. No sawing at the focusing ring or wildly computing an f/stop for me! That's already been done because I've pre-visualized my picture. In fact, the whole thing takes less time to do than to read about.

The last point about automatic flash will probably be considered politically incorrect by many, but I feel a responsibility to honestly and transparently provide this information. Here it comes . . . many TTL automatic flash systems use a single or series of pre-flashes in determining exposure. This technology is a huge, deleterious blow to creativity! While this idea flies in the face of what many camera manufacturers would have you believe, it must be remembered that they have a monetary interest in pre-flash systems. Having an exposure system based on pre-flash technology makes it difficult to incorporate flash units from other manufacturers into your flash lighting system. There you are, locked into the flash products manufactured by the camera company. If the Whizbang camera company

sells you a Whizbang flash unit, they have a lucrative sideline to their camera business. Importantly, the profits generated by that sideline mean the company's concept of creativity is colored by the extra dollars the flash unit division adds to the corporate coffers. More importantly, this system has inherent problems. If, for example, you set up slave-equipped, manual, high-power flash units to light up the background in a cavernous wedding hall, an exposure system based on pre-flash will cause those lights to trigger during the exposure measurement part of the process. Because they will be recycling when the actual image exposure is made, they won't be ready when you need them to flash.

There is a huge difference between selectivity and creativity. Suppose a manufacturer designs a pre-flash system that offers ten (remember this number!!!) different ways to control and modify a flash exposure using a camera they also manufactured. They might well try to say they are giving you the ability to produce a great number of creative lighting options because their flash units and cameras are working in unison. In truth, the manufacturer has not offered creativity . . . instead, they have offered selectivity. Your choices are limited to selecting from the menu they have provided. A truly creative system would allow you not just ten different ways to light a picture, but encourage nearly limitless options, letting you choose to experiment with any lighting ideas you've dreamed up in your own little brain.

Almost 40 years ago I got my first good camera . . . a beautiful Canon FT-QL. Inside the viewfinder there was a moving needle and a little circle. To set proper exposure (not flash exposure mind you, this was for ambient light exposure), I would adjust either the aperture or shutter speed dials so that the little needle was centered in the little circle. I had no idea which aperture or shutter speed I had chosen, but that needle

Fight for the Inches!

My philosophy about photographic quality is based on making as few compromises as possible. For example, higher ISOs are easier to use than lower ones. They require less light, resulting in lighter flash units and lighter flash-unit batteries. But with both film and digital media, high ISOs produce images that are lower quality than those produced using low ISOs.

Making compromises becomes a choice in nearly every aspect of photography. Many photographers search out light-weight tripods because they want to reduce their equipment load, even though heavier tripods are better at dampening vibrations that degrade images. Or, in a posed portrait of the groom, it takes an extra 10 seconds to make sure a quarter inch of white cuff shows at the end of his tuxedo sleeve. Yet to some photographers it's not worth the extra time and effort to fix it. It is ALWAYS worth the extra effort to me!

Is it ever necessary to make compromises? Well, sometimes making a compromise means the difference between getting a shot or getting no picture at all. I'm not saying that getting the picture is not paramount, but there are times when compromising comes under the heading of "it's good enough". I will go down in flames before I give in to that. There is a major limitation with the "good enough" point of view, and in the high-pressure, high-priced world of wedding photography, where your clientele is often visually literate, "good enough" is almost never good enough! Plenty of customers feel this way and are willing to pay extra for not having to settle for "good enough!" If each small compromise costs you one percent in image quality, and you make 100 concessions, you will finally reach zero image quality! The point is not that you should never make a compromise, but to be a top tier wedding photographer, you should fight for every inch of quality you can deliver and tread very carefully whenever the thought that "it's good enough" pops into your head!

sure was centered in that circle. Thus centered, I proclaimed to the world that I was a professional photographer!

Thankfully for my creative growth, my mentor at the time made me remove the battery that powered the needle and demanded that I get a separate handheld light meter. This made me use my brain and think about what I was doing instead of limiting my understanding of exposure to centering the needle in the circle!

For some, selecting from a menu will be good enough. But if you look at thousands of pictures, nearly none of the ones that stop your gaze and make you wonder how the photographer got that shot were created from menu selections. They came about from mental effort, practice, and reviewing and improving on mistakes. This is hard work. Some of you will read these words and actually try to use manual flash as opposed to automatic flash. For those I can promise you a more fulfilling career; not an easier one, but one that makes you feel better about yourself at the end of the long day!

Regardless of whether you decide on manual or automatic flash exposure, the important point is to exploit to the fullest whatever lights you happen to be using. I prefer manual, but if automatic flash is your cup of tea, more power to you. The real issue is not which hardware to use, but how to use it. What you should be interested in is the phenomenon called "light quality."

The Single Light and You

Ah, quality! If you are shooting with flash on-camera, then your lighting will often bear a strong resemblance to that provided by a coal miner's helmet lamp–terrible! However, when working with a single on-camera light, there are a few things that you can do to leave the miner-helmet look behind (see examples page 120).

In the "Single Light and You" game, you might remember to keep your eyes open for bounce-lighting situations. Any time you are in a room with white ceilings, bells and whistles should go off in your head shouting, "Bounce, you fool . . . BOUNCE!" In fact, it is so ingrained in me that the first things I look at when I enter a room are the ceiling's color and height. The color is very important because a blue ceiling will give you blue pictures if you use ceiling-bounced flash. From personal experience I have found that most white ceilings (from bright white to eggshell) will give pleasing results, but bouncing a light off any other color is a definite no-no. The ceiling's height is also very important.

Many years ago one of my mentors gave me a formula that gives a ballpark calculation for setting exposure when using ceiling-bounced flash. Determine the distance from the flash to the ceiling and add that to the distance from the ceiling to the subject. The sum becomes the distance the light will travel. Take into account the diagonal slant from the ceiling to your subject. If you are in a

Turning Flash into Available Light

When I first started to shoot photographs I worked as an assistant to a busy New York pro. I once told him that I shot only by available light. He told me that if I had an 800 watt-second strobe in the trunk of my car, then it would also be "available." The truth is that I shot by available light then because I didn't own or know how to use flash equipment. Shooting weddings required that I learn flash lighting techniques. Now I don't take out all my lights on every assignment, but when the need arises, at least I know what to do with them—and they're "available!"

room with a 10-foot ceiling and are 6 feet from the subject, and the height of both the camera and subject is 5 feet, the light will travel about 12 feet (5 feet straight up and then about 7 feet, diagonally, back down to the subject).

Because bounced light from a flash travels indirectly in order to reach the subject, it must have a longer range. Therefore more flash output is required to bounce light off high ceilings than is necessary when working in rooms with low-ceilings or when shooting close-ups.

Using the distance calculation described above, I open up 1 stop for a clean white ceiling and 1-1/2 stops for a dingy tan-colored one. And because bounce lighting is so soft and full (low contrast), you will find that you can overexpose in a bounce-light situation without much image degradation. Personally, I find bounce lighting has a more casual feel than direct flash, and I find it better suited for home portraits or afternoon affairs than formal evening galas.

However, there is an additional consideration that is important to remember when determining whether or not to use ceiling-bounced flash: The ceiling now becomes the light source. This can be a problem. Not only will the light take on the ceiling's color cast, but the overall light on your subject will be from above. This creates shadows in your subject's eye sockets and under their chin.

To get around this, experienced shooters almost always use an accessory called a fill flap to push some light into these shadow areas. A small white plastic or paper card taped, "velcroed," or rubber-banded to the back of the flash head will redirect some of the upward-traveling light forward to help fill in the unflattering shadows. I've seen one candidman use a white plastic spoon as a fill flap to add tiny catch lights to his subject's eyes. Some candidmen use 10 x 12-inch fill flaps for an extremely open effect. I even know one shooter who uses a piece of cardboard covered with aluminum foil—dull side towards the subject—for a more "specular" (his word) result. While all of these effects are acceptable, my own preference is to use a flap about the size of a 4 x 5-inch file card, although the ones I use are made of tough white plastic. As with most things photographic, the size, shape, and reflectivity of the fill flap are a matter of personal taste, so experiment to find your own favorite combination.

Although many photographers think of bounce lighting in relationship to ceilings, a crafty candidman can also exploit white walls for bouncing light from a flash.

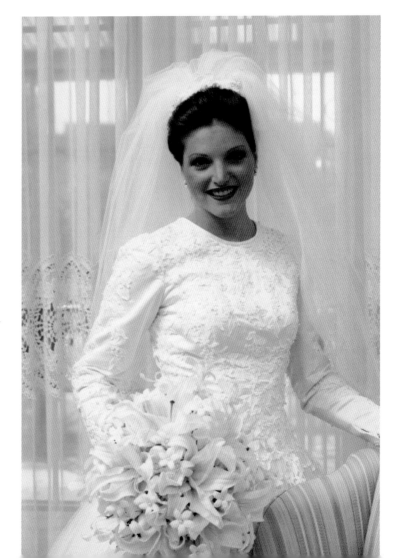

Although bounce flash creates some shadows on the subject's face, it is still a pleasant light source that appears casual and natural, and it minimizes skin imperfections. Many photographers feel that bounce lighting has no sense of direction, but I find if you add a second bounced flash that is stronger than the on-camera bounced flash, you will add dimension to the subject's face.

It is not a good idea to use shoe-mounted flash when shooting vertical compositions. When you flip the camera to shoot vertically, the flash unit is positioned to the side of the lens instead of above it (example 1A). This not only throws light into the eye sockets and under the chin, but also creates an unsightly shadow on the opposite side of the subject (example 1).

One solution (example 2) is to use a swing (or flip) bracket (example 2A). Such brackets employ a pivoting arm that can be swung to bring the flash into position above the lens. Don't worry; you won't necessarily lose the use of TTL flash exposure control by not using the camera's hot shoe. Both Canon and Nikon offer cables that allow you to put your flash on a swing bracket and not lose its TTL flash capabilities.

Wall bounce can often create pleasing effects that emulate window light. Like ceiling bounce, manual exposure calculation for wall bounce is based on the distance from the light to the wall plus the distance from the wall to the subject. From this calculation, I again open up 1 stop for white walls and 1-1/2 stops for tan ones. Also, as with ceiling bounce, the color of the bouncing surface is important.

If you bounce light off green walls, you'll get green subjects! I'm sure your customers won't buy many pictures of themselves with a green cast no matter how many times you tell them it's a creative special effect!

When direct, on-camera light becomes the method of operation for a candidman, light quality is still the name of the game, so evaluate the reflector on the flash you elect to use. Flash units get their power from internal capacitors. That power is measured in watt-seconds. Some physically smaller units often have smaller capacitors. To juice up the output of such units, the flash designers create high-output reflectors. Sometimes these "hot" reflectors don't cover the field of view of a wide-angle lens, or they create hot spots in the center of their flash patterns. If your flash unit has an

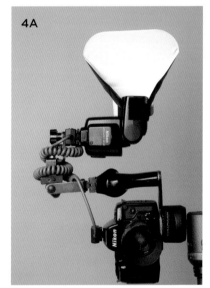

Using bounce flash isn't a perfect answer either (example 3A). While bounce flash eliminates the "helmet" shadow behind your subject, it requires much more power while also creating small shadows under the subject's nose and chin and deep ones under the subject's brow (in the eye sockets, example 3).

Example 4 combines a fill flap and a bounce light on a bracket to get as close to perfection as possible using a single light (example 4A). A fill flap directs one portion of the flash unit's output towards the subject while the other portion heads up to the ceiling. There are a number of ways to do this, from purchasing fill flaps at your photo dealer to holding a 3 x 5 index card around the flash head with a rubber band. Experiment to find the right sized flap for you.

accessory wide-angle diffuser, you might consider using it all the time because it will correct any misalignment errors between your flash and camera, and it will often distribute the unit's flash pattern more evenly.

My flash of choice for battery-powered work is a Sunpak 120J, but I use Lumedyne accessory wide-angle reflectors instead of the one that comes standard with the flash.

Even though the standard Lumedyne reflector has a wide-angle setting, I prefer the Lumedyne accessory reflector because it is wider still, and the pattern is more even. I made this choice knowing that the accessory reflector effectively costs me one f/stop in power output. But it was worth it in my search for improved direct-light quality. While reflector choice is one aspect of light quality, it also

pays to invest significant thought into how the flash will be mounted to the camera.

For most wedding shooters, the bridge between their camera and flash is the flash bracket, and that bracket has to perform many functions. Obviously, if you want to bounce the flash off the ceiling or wall, you must be able to pivot the flash head so it is directed toward the bounce surface. While this

seems easy enough, it is also important for the flash bracket to position the flash head so it is directly over the lens when you choose to use direct flash. If the flash is mounted to either side of the lens, it will cast a distracting shadow on the opposite side of the subject.

Designing a flash bracket for square-format cameras is easy because these cameras are oriented the same way for either vertical or horizontal compositions. However, rectangular-format cameras (digital sensors, 6 x 4.5cm, and 35mm) have to be rotated 90° to change from vertical to horizontal (or vice versa), which changes the relative position of the flash and creates flash-bracket dilemmas.

There are only two ways to solve this. One is for the flash to swing so it can be positioned over the lens for either vertical or horizontal pictures. The second is for the camera to rotate within the flash bracket so the flash remains over the lens for both verticals and horizontals. While a good flash bracket will position the flash head directly over the lens, the real question is how high should the flash be mounted? As with many things in wedding photography, the distance between the flash and the lens is based on a series of compromises. For more information on flash brackets, see the Equipment chapter.

The Extended Approach

In the real world, natural light comes from above, so some might think that the greater the distance between the flash reflector and the lens, the better. However, to move quickly through crowds (not to mention doorways) with the flash head attached to a thin metal arm some 6 or 7 feet above the lens is impractical. Furthermore, the weight of a flash head that far away from the camera exerts substantial strain on a photographer's wrists, so trying to keep the whole rig under control is a difficult task. Some readers may think that I'm wasting time talking

about this admittedly bizarre approach, but I have actually seen shooters working with their flash units on extendible flash arms that can (and do) place the flash that high above the camera!

While 6 feet between the flash and lens is one end of the spectrum, there are photographers who like their candid rig to be as compact as possible. They enjoy the feel of a small package, and on some rigs I've seen flash heads 3 to 4 inches above the lens. However, that gives rise to a problem, because the closer the flash head is to the lens, the more chance there is for red-eye.

The Compact Approach

In addition to achieving better balance and reducing wrist fatigue, another advantage to using a compact bracket becomes evident when you shoot pictures of people who are close to a wall. In this scenario, any shadow the flash creates falls almost directly behind the subject and therefore doesn't detract from your image. However, once the flash head reaches a height of about 12 to 14 inches (30 to 36 cm) above the lens, the shadow cast by the subject's head looks like a dark blob behind their neck. And raising the flash unit this high can create other problems. Specifically, it becomes difficult to shoot pictures through small openings, such as limousine windows, which are often bestsellers.

During my years as a candidman, I have owned a variety of brackets that placed the flash head anywhere from 3 to 14 inches above the camera's lens. I've finally settled on a bracket that lets me move my flash head between 4 and 7 inches from my lens. For tight places I push the flash head close to the lens, but for general shooting I prefer to extend the flash head out to about 7 inches. If you are serious about wedding photography, you'll forever find yourself searching for the perfect distance between flash and lens. Relax, it doesn't exist!

 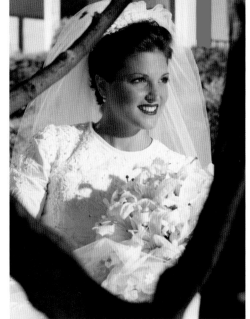

Working outside under bright sunlight can be a challenge, but crafty photographers know to move the subject into the shade, even if it is only under the leaves of a tiny tree! Although the shade from the tree softens the light on the bride's face, the background lit by direct sunlight is overexposed, and the resulting image is high key.

In this second photo the photographer used a single flash off-camera to the right to light the bride, which accomplishes a few things: 1) The background is no longer overexposed; 2) The picture appears crisper; and 3) The picture has a very different feel than those shot with available light, which adds variety to the customer's choices.

So Which One's Best?

Each distance between flash and lens has advantages and limitations, so your best bet is to do some tests of your own. Attach your flash unit to a light stand and hold the camera against the stand at different distances from the light. Remember to also position your subject at different distances from a plain wall. In this way, not only will you discover how close the flash is to the lens when the dreaded red-eye occurs, but also how the distance affects the shadow cast by the subject.

When choosing a flash bracket that delivers your preferred distance between the flash head and lens, take into account the weight of the flash unit you are using. Most self-contained flash units with enough battery capacity to satisfy a wedding professional weigh so much that every extra inch of height creates added torque on your wrists when you whip the camera around for a shot. While you can work out to increase your wrist strength, lighter-weight flash heads with separate, shoulder-hung battery packs go a long way towards keeping your wedding rig from becoming top-heavy. (See the Equipment chapter for more information.)

Red-Eye—What It Is and How to Eliminate It

Red-eye is caused by light shining into the eye, bouncing off the retina, and back into the lens. So you see, red-eye is a reflection problem, and the old rule that states "the angle of incidence equals angle of reflection" applies. Therefore, one good way to eliminate red-eye is to increase the distance between the flash and the lens. Do some testing on your own with a blue-eyed friend (the worst red-eye offender) to determine just how far apart the flash and lens need to be for your setup to eliminate red-eye.

Flash in the Great Outdoors

Most photographers know that midday light is awful. A big, beautiful sun beating down on subjects from directly overhead creates inky black shadows under noses and chins and makes eyes recede into dark sockets under the shadow of the brow. Very often, such beautiful days (though they are what every couple hopes for) don't lend themselves to making beautiful portraits. But whether faced with soft light or glaring light, the wedding photographer must prevail! Every couple wants outdoor pictures, whether the light is cooperative or not. Against all odds, with only a flash unit at his or her side, a candidman can create beautiful pictures. Even though photographers new to the wedding game are often afraid to try flash outdoors, it is a tool that can 'save the day.'

To a novice, mixing ambient light and flash is voodoo, but there really is no alchemy involved. You are just mixing two ingredients, and there are recipes you can follow.

By understanding how the ingredients work, you can control how much of each ingredient to use in your recipe. Ingredient number one is ambient light (you can substitute the word daylight, sunlight, skylight, available light, or moonlight here), which is a continuous light source. You can control the ambient light's exposure on your image by changing either the aperture or the shutter speed.

The second ingredient is the burst from your flash, which is an instantaneous light source. You can control flash exposure by changing the flash's distance from the subject, its power output, or the lens aperture. Flash exposure, for the most part, is unaffected by your choice of shutter speed (as long as the shutter speed allows flash synchronization). This means that by changing the shutter speed you can affect the ambient light portion of the recipe without affecting the flash. Also, by adjusting the flash unit's output or by changing its distance from the subject, you can affect the flash part of the recipe without changing the ambient light. This is where camera designs that offer high flash synchronization speeds really come into their own.

With flash and ambient as your light sources, you must decide if you want one light to be dominant, and if so, which one. Or do you want the two sources to have equal value? Once you've made that choice, getting the two light sources to complement each other is the name of the game. The best way to understand this is by walking through a hypothetical scenario for each possibility.

In the first scenario, consider ambient light the main source and flash the fill light. We are outside at 1:00 p.m. and we're look-

It may go against your instincts to add more light to a brightly lit scene, but bright sunlight causes harsh shadows. Illuminating the shadow areas with fill flash reduces contrast to a range that can be recorded by the film. By adding a little fill, the photographer captured the beautiful ambient light rimming them while preventing them from being hopelessly underexposed.
© *Phil Cantor Photography*

ing at a beautiful bride with black shadows under her brow, nose, and chin. We are in the middle of a field. If there was a nearby tree with leaves, I might suggest we work in its shade. But this setting includes harsh sun and no shade, so we must make do. An incident meter reading of the ambient light falling on the subject calls for an exposure of 1/125 second at between f/11 and f/16. Set the camera to these settings. The next step is deciding how much light will gracefully fill in the shadows.

From hard-earned experience I've found that I can usually eliminate excessive shadows on the face with a fill-light exposure that is about 1-1/2 stops less intense than the main light. That means the flash has to be far enough away and put out enough power to create an exposure of f/8 for the subject. (Why f/8 you ask? Because it creates an exposure that's 1-1/2 stops less than the ambient exposure of 1/125 second at between f/11 and f/16!)

I know the intensity of light from my manual flash unit is f/8 when the unit is set to half power and is 10 feet from the subject. Perfect. So, using a long sync cord I can position the flash 10 feet from my subject, and voilà—I have a fill light 1-1/2 stops under the sunlit ambient exposure. Of course, you could dial the flash unit's power down further as well. There is always more than one way to skin a cat.

Although this scenario may seem easy, maybe the ambient light intensity is something different, like 1/125 second at f/5.6. What should we do then? Well, remember that flash exposure is unaffected by a change of shutter speed as long the shutter and flash are synchronized. Then, remember that 1/125 at f/5.6 is equivalent to 1/60 second at f/8, which is equivalent to 1/30 second at f/11. We could shoot at 1/30 at f/11.

I know that my manual flash at half power puts out f/8 at 10 feet. I also know that when a flash unit is 15 feet from the subject, the situation calls for f/5.6 (see the guide number explanation on page 115). So, if I want an f/stop between f/8 and f/5.6 (which would be 1-1/2 stops below my ambient f/stop of f/11), I can move the light to approximately 12 feet from the subject (about half way between 10 and 15 feet). Now the fill light will be 1-1/2 stops below the ambient light exposure. Just for the record, if we were to decide to shoot at 1/60 second at f/8, we could leave the flash 12 feet from the subject and drop its power output to one-quarter. It would produce enough light for an exposure between f/4 and f/5.6 (which is 1-1/2 stops below the new ambient f/stop of f/8).

Now let's look at a scenario in which we want the light from the flash to overpower the ambient light falling on the subject. This might be desirable when the subject is in shade but the background is a sunlit sky. If we expose for the light falling on the subject's face, which is in the shade, the sky in

Capturing a photograph of the bride and her dad walking down the aisle is a must at any wedding. Even if there is no time to set up room lights to illuminate the background of the church, you can often pick up some of the ambiance in the church by dropping to a slower shutter speed so that the wall sconces in the rear of the church become more prominent.

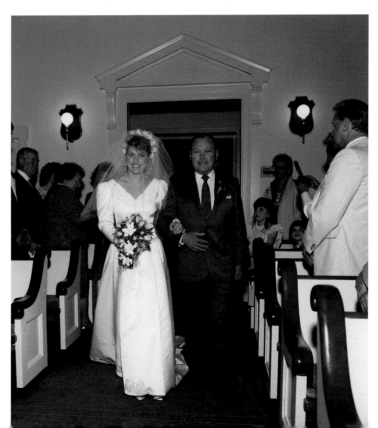

Candids on the dance floor often give the impression that the main subject is standing in a black hole. It gets worse when catering hall designers paint the walls or ceilings black or midnight blue to make the room more mysterious and romantic. By dragging your shutter a little (using a longish shutter speed) you expose the background and add a sense of motion to a scene in which activity is important. Alternatively, you could add a second or third light to such scenes, which would help open up the background a bit, making the subjects appear more three-dimensional. © Three Star Photography

all its azure glory will be overexposed (looking very bland and white). In this example, an incident reading of the subject might call for an exposure of 1/30 second at f/5.6, while a reflected reading of the sky might call for an exposure of 1/125 second at f/11. What do we do?

Because we want the sky to register deep blue, set the camera to 1/125 second at f/16. Then move the flash unit so that it is about 5 feet from the subject. Remember from our discussion about guide numbers (see page 115) that flash exposure from 5 feet calls for

an exposure of f/16. Therefore we are ready to shoot the portrait.

This picture will produce a properly exposed bride in front of a deep blue sky. You might want to take a second photograph without the flash, with the camera set to 1/30 second at f/5.6 (meter for an incident light exposure of the subject in the shade). The two pictures will appear wildly different, and you might get two sales from these two frames. The one (with flash) will be richly colored, while the other (ambient light only) will appear high key and airy (see photos on page 123).

Even under conditions that many photographers consider perfect, such as an overcast sky, you can to use a small puff of light to brighten the subject's eye sockets. For these situations I carry a white handkerchief and drape it over my flash head. The white cotton cloth cuts the flash output by about 1 stop. I use this technique when the ambient light intensity is low so that light from the flash is not unnaturally harsh.

The mixing of flash and ambient light is not limited to use out of doors. Many shooters, in reception halls with great crystal chandeliers and wall sconces, shoot their dance-floor images at 1/30 second (instead of 1/60 or 1/125) to pick up some of the "flavor" of the room. Just remember not to do this when working under strong video lights or the images will have a yellow cast.

The Double Light and You

After you've mastered how to use a single light, the next step in portable flash work is called "double lighting." In addition to the camera-mounted flash unit, the photographer uses a second slave-triggered flash on a pole. To get the most out of a portable second light, you need an assistant to hold and aim it.

Remote Flash Triggers

To make your second (or remote) light fire in synchronization with your camera's main light, you need a piece of equipment called a remote trigger or flash slave. There are three categories of remote triggers, classified by their actuation method:

1. Light (from a flash unit)
2. Radio signal
3. Infrared pulse

Let's look at the three types of remote triggers available:

LIGHT-ACTUATED REMOTE FLASH TRIGGERS

Light-actuated slaves are the simplest and probably the most reliable of the three. By reacting to a burst of light (your on-camera flash), they fire the second flash. They have no moving parts and generally require no power supply, although some contain battery-powered amplification circuits. Their Achilles' heel is that light from any flash unit will cause them to fire. While this may not seem like a problem, just think for a moment of all the point-and-shoot cameras brought by those in attendance at the average wedding. All those flashes may well drain the battery supply that powers your

second light! To make matters worse, if your exposure calculations are based on illumination from that remote light, you and your clients will be out of luck when the remote is recycling after being tripped by Uncle Otto's WonderFlex and WonderBlatz, just as you have snapped what would undoubtedly be the perfect shot.

In today's world of wedding photography, video lights pose an additional problem for light-actuated remote triggers. They can blind a light-actuated trigger, making it useless. I have often defeated this bugaboo by covering my remote trigger's receiver with translucent strapping tape, which reduces the amount of ambient light falling on it. However, considering these limitations, light-actuated slaves are reliable, lightweight, relatively inexpensive, and easy to use.

RADIO REMOTE FLASH TRIGGERS

Radio remote triggers use the same basic technology as electric garage door openers. The transmitter sends out a radio signal. The dedicated receiver picks up the signal and fires the remote flash unit that is attached to it. They are preferable to light-actuated flash slaves for weddings because they don't react to the flashes of all the point-and-shoot

There are two models of radio slaves in the PocketWizard line. For wedding work, many photographers will find the simpler, less expensive PLUS model to be more than sufficient. I find the PLUS easier to use in the trenches than the MultiMax model. © MAC Group

Getting a Good Assistant

A good assistant is one of the most valuable tools in a wedding photographer's arsenal. A photographer and a good assistant become a team. The best assistants know what the photographer is trying to accomplish and act to achieve that goal.

Finding an assistant is not easy, but there are some likely places to look. Trade schools as well as the photography department in your local high school or college are obvious sources. If you work in a city with multiple-room catering halls, your next assistant could be working for the photographer at the other reception! Or, you might look for a young person in your neighborhood who is interested in photography.

Good assistants are to be treasured. They can organize the families and touch up a pose. A good assistant can keep track of your materials and equipment, hand you filters, or even shoot another view from the choir loft while you work on the lower level.

To get this kind of performance from an assistant requires that you communicate what you want. I never criticize an assistant in front of a customer, but on the way home from an assignment my assistant and I discuss how things could be improved. This helps them feel like a teammate.

I teach by example. If you want your assistant to get you a cold drink during a break, first offer to get him or her one yourself. Treat them as you would like to be treated. I give my assistants a few extra bucks after a heavy June season and around the winter holidays, and usually I give them a share of any tips I get. It's amazing what kind of loyalty and effort you receive when you treat them well. You are trying to establish a team, and a good team means better pictures and a smoother assignment.

cameras. However, they aren't perfect either. Most require two cords connected to the transmitter, which is mounted on the camera: a sync cord from the camera to the transmitter and a second cord from the transmitter to the on-camera flash. Some radio slave transmitters come equipped with a foot that allows them to be mounted to a camera's hot shoe. This eliminates the need for a sync cord between the transmitter and the camera. Also, a third sync cord is needed between the receiver box and the second light, which is mounted on the pole. To further complicate things, radio remote triggers require batteries in both the transmitter and receiver. The transmitter box draws power only when you fire the camera, so its power supply seems to last forever. The receiver, on the other hand, must always be in a state of readiness to receive the transmitter's signal. Because its circuitry is always up and running, it eats batteries for breakfast, lunch, and dinner! While the newest radio remote triggers have cut back on their power-hungry ways with improved circuitry, they still require frequent battery replacement.

Many photographers report good luck using rechargeable batteries to power their radio slaves, but I have had problems charging them and having them hold a charge. On the other hand, I have had good luck using lithium batteries instead of alkalines. They are more expensive than the alkalines, but are lighter and last much longer. If you use "AA" batteries to power your radio slave system, it is worth considering a switch to lithium cells. Also on the plus side (and it is a big plus), many of today's AC (studio-type, plug-into-the-wall) strobes come equipped with radio slave receivers, so you'll have the beginnings of a radio slave system if you choose lights with this feature included.

Seeing all these point-and-shoots is the best advertisement I can think of for using radio or infrared slaves! Though a posed photograph of the bride with her attendants is a surefire seller, sometimes an "arranged candid" can give the whole album a different, fun look. While some might balk at the idea of arranging a candid, a situation like this begs for the photographer's direction. Any single bridesmaid with her camera would make an interesting image but it would rarely sell. However, squeeze them all into one frame, and it'll probably make the album! If you add into the mix the modeling created by two flash units (with the main light off-camera), you can greatly increase your chances for a sale.
© Franklin Square Photographers

INFRARED REMOTE FLASH TRIGGERS

Instead of responding to a radio signal, infrared receivers are triggered by a coded pulse of infrared light from a transmitter, so they too are unaffected by flash-happy point-and-shooters. The transmitter is battery dependent, but the receivers require no batteries. However, the transmitter must recycle between pictures, and as the transmitter's batteries near the end of their useful lives, the transmitter's recycling time increases. On the plus side (and this, again, is a big plus), some AC strobes come equipped with infrared receivers, so all you'll need is a compatible transmitter.

Using the Second Light

Currently I use radio remote triggers, but my gear cases include multiple replacement sync cords, multiple spare batteries, and multiple back-up light-actuated slaves for use when everything else fails. Once again, like the debate surrounding the use of manual or auto flash, the type of remote trigger you use is not the real issue. What you can do with a second light and how you use it are much more important than simple hardware preferences. That's what makes a difference in your photographs, and that's what can increase your potential picture sales.

In my opinion there are four different ways a candidman can use a second light on a pole. (Actually, there is a fifth, but it is really a combination of two of the first four.)

1. You can use a second light as the main light to illuminate the primary subject you are shooting.

2. You can use a second light as a hair light to separate the primary subjects from the background.

3. You can use a second light to light up the background, which won't improve the lighting quality on your primary subjects but will eliminate the light-in-a-tunnel, dark-background look.

4. You can use a second light to create a special effect for a highly salable picture.

5. As a last effort, and with help from a good assistant, you can use a second light to provide a hair light and light up the background at the same time.

One neat technique stems from a second light's potential to make the subject appear three-dimensional. The remote light should be placed closer to the subject than the camera-mounted light, and at an angle 45° to 60° to the lens axis, and 2 or 3 feet above the subject. In this approach, the second light (on the light pole) becomes the main light, and the flash on the camera becomes the fill light. Making the second light the main light means that it is stronger than the on-camera light. This diminishes the feeling that your subject was lit with a coal miner's helmet light.

I have heard some photographers claim that when they are double lighting, they make the camera light the main light and the second, pole-mounted light the fill. Without meaning any disrespect to my colleagues, I think they are wrong! If you think about this practice you will realize it is impossible. If the camera light is the main light in the traditional miner's-helmet style (coming directly from the camera lens axis), what shadows does it create? There are no shadows to fill in!

A much more interesting question is, how strong should the second (main) light be in comparison to the camera-mounted fill light? Although I might answer the question by saying it depends (actually, it does!), many photographers would like a simple rule that governs most situations. I have found that if the main light is twice as strong as the fill light (that, by the way, is 1 f/stop), the resulting pictures feature shadows that are "open." The idea isn't to make all the pictures overly dramatic by creating inky black shadows, but instead to create well-lit three-dimensional looking images. Here's the trick: If you are working with two flash units of equal power, and the fill light is mounted on the camera, then the main light should be located two-thirds the distance from the subject as compared to the camera-mounted fill. If you do the guide number math, you will find that the two-thirds rule equals about a 1-stop difference in exposure between the two flash units. If I'm taking my photograph 10 feet (3 meters) from the subject, then the main light should be about 7 feet (2 meters) from the subject. If I'm 15 feet (approximately 5 meters) from the

An Important Hardware Note

If you decide to work with two lights, one of the most important accessories you can own is a pair of Wein TeleFlash Monitors. These little boxes (about 1 x 1/2 x 2 inches) sense the electromagnetic pulse that's emitted when your flash goes off and they blink red to confirm that the flash has fired. I have one mounted on each of my on- and off-camera flash heads with a piece of Velcro. If you use radio or infrared slaves, it is all too easy to accidentally throw a sliding switch in the heat of battle and shut off your assistant's flash (or even worse, your on-camera flash). I train my assistants to constantly glance at both sensors to make sure everything is working as planned. And even though my assistants are checking the sensors, I check them too. It's that important.

subject, the main light is 1 stop "hotter" if it is 10 feet away from the subject. Because it is based upon mathematics, this rule always holds true.

How does one expose for this type of two-light setup? Some might think that you should expose for the main light and let the shadows fall where they may, but I disagree. The problem with following that rule is that you cannot be 100% certain that the second light will fire. You can test your slaved flash a thousand times, but when you need it most, it may not work. The radio or infrared slave's batteries may be too pooped to pop, the light-actuated slave might be blinded by a video light, the batteries that power the flash itself may decide to be exhausted at that moment, or someone else's flash may trip your slaved unit a nanosecond before you shoot . . . or, . . . or, . . . ad nauseam. Being aware of Murphy's Law comes with a candidman's territory!

Considering the fact that it is difficult to get good photos when you underexpose by a full stop, I split the difference between the exposures required for each individual light. Therefore, if my main light calls for f/11 and my fill light calls for f/8, I set my aperture scale between f/11 and f/8. That way, when the second light doesn't fire (and it won't sometimes), I end up with an image that is only 1/2-stop underexposed. When my second light does fire, the highlights are a little "hot," but with the latitude that's built into either color negative film or digital post processing, it is a situation that both my printer and I can deal with.

With your assistant's help you can place a second light above your subjects so that the beam skims the tops of their heads. This separates the subject from the background. It may not seem important, but in the murkiness of a dim catering hall with dark-haired people wearing dark suits, the edges of your subject can sometimes disappear as they merge with the unlit background. However,

there are a few notes of caution worth considering. If the light above the subject hits the face, it will illuminate the top of the nose, which I can say from sad experience is very unattractive. Also, if your subject has thinning hair (or is just plain bald) and you accentuate that feature for the whole world to see, you could have a very unhappy customer. Worse still, often the cue ball you've exposed is the person who's paying your bill, and that is definitely not a pleasant situation to be in!

Many photographers work alone, and although I'm not often in that situation (anymore), when necessary, I put my second light on a light stand equipped with wheels. To stabilize the rig, I hang the flash unit's battery pack from a lower section of the light stand so that it is less apt to tip over. Working with two lights in this fashion isn't easy, and because of that I change my plan of attack. I do not use my second light as a main light or as a hair light on my primary subject. Instead, I place it so that it illuminates the area behind my subject. This is called lighting the background, and although my prime subject is bathed in miner's helmet light once again, now it's acceptable because the background isn't unbearably dark. I have watched couples add pictures to their album at the proof return because they could see Uncle Louie in the background of a photograph . . . lit by my background light.

Another situation in which a background light is worth its weight in gold is during the bouquet and garter toss. I use it to illuminate the crowd diving for the bouquet or garter that is frozen in mid-air by my on-camera flash. This is almost always a winner. Although you might not like these pagan rituals yourself, your job is to create photographs that sell, not to make value judgments about a client's tastes. These photos almost always find their way into a wedding album.

Special Effects with Two Lights

Using a second light to create a special effect offers unlimited possibilities. If a subject has a winning profile, simply putting the second light on the floor behind him or her aimed at a wall can create a silhouette. If you decide to go this route, you must block most of the light from the camera-mounted flash so that the front of the subject remains dark (unlit). This can be achieved by bouncing the on-camera light or by blocking most of its reflector with your hand. If you are using a radio or infrared slave, there is usually a provision for shutting off the light mounted on the camera. If that's your plan of attack however, you MUST remember to turn the camera-mounted light back on after you've made your magic. You Must! You MUST! YOU MUST!

A second flash can also be used to rimlight a kiss. Instead of aiming the second flash unit at the wall behind the subject (as you would for a silhouette), you can turn it around towards your subjects for a beautiful, glowing effect. Trying this is often a hit-or-miss proposition, but sometimes even the mistakes are outstanding.

There's a time and a place for the perfection of posing and, conversely, a time to set up the scene and then let the action happen without your further interference. Once you ask the groom to kiss his bride there's no need for more direction on your part . . . just watch and push the button. © In-Sync Ltd.

Your imagination is the only limit to the different ways you can use a second light for a special photograph—a sure-seller. Many candidmen I know put their cameras on a tripod and make time exposures with a second light fired into the background. You might try placing your second light up a stairway and aim it down at the bride and groom's faces as they climb "the ladder of success" (a little hokey, to be sure, but pretty nonetheless). I knew a photographer who always carried a small piece of reddish-orange gel with him. Whenever he saw an unlit fireplace, in went his gelled second light. Brides and grooms appeared to gaze longingly at the roaring fire, when actually they were only looking at a 50 watt-second pop!

Adding a Third, Fourth, or More to the Mix

If you want to use your portable double lights to illuminate the main subject (which I feel is the most flattering method), the backgrounds go dark. This means that the whole background mélange of the wedding goes unrecorded; not always a good thing since the presence of guests, and the decor lend ambiance to your photographs, often leading additional sales. A third (or fourth) flash unit lighting the background can open up new possibilities. To some candidmen these lights are called room lights, or picks, and most often they are slaved 1,000 watt-second AC strobes on 10-foot stands, bouncing off or skimming the ceiling. They aren't aimed at the crowd on the dance floor, but instead they flood the background jumble with light. If the room is large enough to require room lights, I try to place them inconspicuously (if 1,000 watt-seconds can ever be considered inconspicuous!) along the sides of a room. Near an electrical outlet and away from waiter and guest traffic is a perfect location.

If you decide to set up a room light, you have to be aware of where it is placed, and you must position yourself in such a way that the room light doesn't appear in your picture or flash into your lens. Most importantly, you and the room light must be positioned so that the room light is illuminating the background of the picture you are taking. When I explain this to green assistants (or photographers not used to exploiting room lights), I employ the analogy of setting a pick in a basketball game. The pick (the room light) remains stationary, and the play develops around its position.

Many times at multiple-photographer weddings, another crew is responsible for setting up the room lights. After taking portraits in another location, you may find yourself dashing into the ballroom (or ceremony room) with just a few seconds to orient yourself and discover where the room lights are positioned and aimed. When I'm faced with this situation just moments before the action starts, as I enter the room I'll pop the room lights with my radio-slave trigger just to see where they are. Once I see them, I choose my position. This may seem far-fetched if you are used to smallish weddings with 100 to 200 guests. However if you are photographing in the grand ballroom of the New York Hilton (which is the size of a football field, has 40-foot ceilings, and a wrap-around balcony) with 700 guests milling about, finding the room lights is no easy task.

Special Effects with a Third Light

A third light, like the second, can be used to create interesting effects. If used as a carefully placed room light, a third light can make a small church look like a cathedral. And you can use it not only to open up backgrounds at the reception, but to open them up for formal portraits as well. This frees you from having to work against a wall or a drape. If you use a third light as a room light, you can set up a portrait location in the middle of a fairly large room without fear that a dark background will detract from your image. Another advantage to using a third light is that the background lit by it will be quite far away from your subject and will be slightly out of focus. It's another way to make your subject "pop" off the page.

But if an artificial background is required for more formal portraiture, a third light opens up all sorts of possibilities. Whenever the background comes out of its bag, my third light really starts to shine. I place the stand behind the background, with the flash head peeking over the top. When I put a 20° honeycomb grid over the head, it becomes a studio-type hair light.

One thing that usually sets studio portraiture apart from wedding portraits is the use of a hair light. With a background and a 20° grid, I can make my location portraiture look more like studio work. Many shooters set the hair light's output so it is 1/2 stop more powerful than the foreground lights. Personally, I've found that an exposure for hair light exposure equal to the foreground exposure is about right, but this is a matter of taste and also depends on the subject's hair color. With black-haired subjects, the hair light can be 1 stop stronger than the foreground exposure, with lighter brown-haired subjects I set my hair light 1/2 stop stronger than my main light exposure, and with blond or white-haired subjects I make the hair light of equal intensity to the main lights.

The Balcony from Heaven

As an aside, whenever you look up at a ceiling to decide if you can use bounce lighting, also look for high vantage points. Choir lofts, projection booths, and balconies offer many creative possibilities. Not only can you place lights up there, but from there you can also make gorgeous photographs! Just remember that, like fine perfume, a little goes a long way. Customers will always buy one or two unique views, but rarely will they buy two dozen. A few frames are all that's required.

Some photographers may like the look of this photo because the subject seems to be lit by a spotlight. But that has more to do with luck because the rear wall of this particular church is stark white. If the aisle was longer or the rear wall was dark, the models would appear to be frozen against the background.

Room Lights

Want to make sure you don't cast dark shadows behind your subjects, as though you are lighting them with a coal miner's helmet lamp? Room lights are the answer!

While a flash on your camera is the easiest and most compact way to insure properly exposed photographs when shooting moving subjects in dark rooms (like at a wedding), it is also true that the quality of such lighting leaves much to be desired. The blast from a camera-mounted flash does nothing to make your subject look three-dimensional and it often results in photographs with dark backgrounds (because light intensity falls off rapidly over distance).

I set up a demonstration of this concept at the Maine Photographic Workshop where I instruct each summer, using models to shoot with room lights both on and off. I used Kodak Portra roll film (the ISO 160, NC flavor) and two AC-powered 1000 watt-second Dynalite flash units, each throttled down to less than 250 watt-seconds. While I used two battery-powered lights to illuminate my subject's on the aisle (the second one attached to a pole held by my assistant), you can get similar results by using your camera-mounted flash with room lights that light only the background.

Properly using room lights will always give you an advantage, separating your photographs from the huddled masses using point and shoot cameras (film or digital) and their pop-up flashes.

In this photo, with my room lights firing, the rear of the church is open and bright.

If you are going to use a hair light, here are a few suggestions:

1. Put a small piece of tape on the floor where your subject must stand in order to be bathed in the hair light. That way, you'll know that the subject is the proper distance from the hair light, ensuring proper exposure.

2. Hair lights are notorious for causing lens flare. If you use a hair light, investigate purchasing a compendium lens hood for your portrait lens. Short hoods will not do the job!

3. If your subject has thinning hair or is bald, turn the hair light off. This is a feature most subjects don't want you to accentuate.

Sometimes in rooms with a low ceiling I will give up on the idea of using a hair light because it isn't worth trifling with the possibility of lens flare. It's better not to have hair light than it is to have lens flare. In that case I carry a special short light stand and put my third light (complete with 20° grid) behind my subject and aim at the muslin. Nothing makes a subject appear more angelic than a gridded background light.

When I first started to shoot wedding photographs I carried two battery-powered flash units. Today, counting backup equipment, I carry three or four battery-powered flash units and three or four AC-powered studio strobes. I have also added an assistant to my list of essentials. If you think this is the antithesis of reportage-style wedding coverage, I agree. But I have seen what National Geographic and LIFE photographers include in their kits in order to be prepared for anything. In the world of wedding photography, the real players (i.e., the busiest, highest paid candidmen) are always willing to go the extra step and carry an extra light.

Winter and rainy-day weddings test a photographer's flash technique. After the main and fill lights are placed to illuminate the subject, some photographers run out of gas when it comes to using a third light. In both these examples a boom-mounted light with a 20° grid is positioned behind the subjects.

In the photo at left, the light is directed toward the models' heads, and the resulting hair light separates their heads from the background. Alternatively, you can forgo the hair light and position the third light so that it illuminates the background as was done in the photo at right.

Chapter Six

EQUIPMENT

I finally scraped together enough money to get my first wedding camera—an old baby Linhof Technika. It was gorgeous! I brought the camera to my mentor's studio to show it off. Joe's response was, "Get insurance." I told him it would take awhile to save the money for that and shifted the conversation to my real purpose. Could I bring my camera to the job he was shooting the next weekend? Could I shoot a few pictures? The answer was yes!

The following Sunday I set up my camera, put it aside, and started to assist. Two hours later Joe told me to pose one of the last family pictures. When I was finished with my pose he told me to go shoot some photos of the buffet table while he finished the family groups. Oh joy! Oh rapture unbounded! I was going to shoot! I ran to where I had left my camera and . . . it wasn't there! I ran back to Joe who was posing the last group. "Joe, my camera is gone," I told him. Without skipping a beat he replied, "Not now, I've got to finish this family group." I searched and searched and still couldn't find my camera. My heart was fluttering . . . I felt dizzy. I had put all my money into that Linhof, and now it was gone. For two hours I was a miserable lump of human flesh. Finally, when my misery became unbearable, Joe took pity and produced my Linhof. He had hidden it in his camera case. I was livid . . . absolutely crazed! Joe just looked at me deadpan and said, "Get insurance." Monday morning I called an insurance agent.

Fifty years ago, roll film was in its infancy in the wedding world. Two important developments for wedding photographers occurred when sheet film was replaced by film packaged in rolls and color film was offered in addition to black and white. Both roll film and color wedding coverage were making their presence felt by the late 1950s. As the move away from the 4 x 5-inch format progressed, 6 x 7cm cameras such as the Koni Omega, Graflex XL, and Mamiya Press came into production. This resulted in the end of folding, bellows-equipped press cameras being used for wedding work. In addition, as film quality improved, the 6 x 6cm camera, in both twin-lens-reflex (TLR) and single-lens-reflex (SLR) designs, started to come into favor. Finally, the smallest of the roll-film formats, 6 x 4.5cm, was introduced in the 1970s.

While advances in film and cameras continued, a separate fork branched off the time line with the creation of 35mm cameras, and in 1959 the Nikon F was introduced. These technologies developed over a 75-year span, so it is important to realize that the quality available from today's film cameras didn't happen overnight.

When I wrote the first edition of this book, equipment options for wedding photographers hadn't changed much in the previous 15 to 20 years. Sure, there were improvements in film emulsions, camera automation, and flash technology. But the basic choices—format, manufacturer, zoom lens or prime, etc.—were the same choices photographers had been making for many years. Digital photography has changed all of this and suddenly this chapter has become as important for seasoned shooters as it is for those just getting started. Because of this, I wrestled with it for a long time. While I know that digital photography will even-

tually replace film in nearly all applications, as of today there are pros and cons in the film vs. digital debate. Accordingly, some shooters have decided that they are staying with film for the present. There are many reasons for this, not the least of which are the cost of buying new gear (not only new cameras, but computers, storage media, and other devices), the necessity to change old habits of working and shooting, getting used to lens conversion factors, quality issues, new workflow and post processing practices, etc. And while, on the surface, the cost of shooting digital may appear to be much cheaper—no film to buy is certainly the

photographer's ultimate dream—there are still many costs in the digital process. Profit is measured by the price your product can command in relation to how much you spend on equipment and materials—and importantly, how much time it takes to produce the product. An old joke that has some truth says that being on the cutting edge makes you bleed, and the purpose of this section on digital photography is to keep bloodshed to a minimum.

Even without the digital debate, writing about equipment choices to shoot weddings can be a nightmare. Every photographer has favorite brands, and battles rage about which camera or flash system to use. Every time a name photographer endorses a specific brand, photographers rush to buy it. This is the same in many fields—from cola to cars—and it is what drives the endorsement game.

There is a gag about photographers that goes like this: How many photographers does it take to change a light bulb? The answer: 100: one to change the bulb and 99 to tell him how they would have done it differently! Although I offer specific recommendations in this chapter, I also include general ideas that should interest you. Keep in mind that no matter what suggestions I make, you or other photographers may disagree. In the end it is the images that are important, not the equipment that's used to make them. On the flip side, many of our customers have been influenced by photo industry advertising, so it may add to your credibility to use a well-known brand that has a sterling reputation.

The Camera

Many photographers think that the camera is the most important of your hardware choices (though I think lighting equipment is of equal or greater importance). The type of camera format in which to invest is still a critical decision whether you are considering digital's many options or deciding between the two key film formats—35mm and 120/220 roll film (medium format). These basic alternatives and some others will have an impact on how you work, how you are perceived by your customers, what options you can offer, and the quality you deliver.

THE SLR

Whether you shoot roll film, 35mm film, or digital images, the most popular camera design for today's professional is the SLR (the Single Lens Reflex). Because today's photographers want automation (both focusing and exposure control) and are rushing to embrace digital imaging, there has been a decrease in the demand for roll-film SLRs. Consequently, two major players in this arena have either disappeared or have drastically reduced their product offerings. Bronica (in both the 645 and the 6 x 6 formats) has gone out of production, and Hasselblad has made overtures about eliminating their venerable 500 and 2000 cameras. This will limit their line up to the autoexposure, autofocus 645 SLR—the H1—and its digital counterpart, the H1D. Mamiya, the other player in the roll-film arena, has introduced their Mamiya ZD, which is a 22 megapixel digital SLR that looks like a 35mm camera on steroids. The ZD joins the Mamiya 645 AFD, which can be used as either a 6 x 4.5cm roll-film camera or a 22 megapixel digital camera depending on which back (film or digital) you use. There are also high-resolution digital backs now available for almost all new and used roll-film cameras.

THE DIGITAL SLR

Digital technology is still in its infancy and digital cameras have just recently achieved the resolution of 35mm film. However, the technology is improving rapidly. New cameras with higher resolutions, better noise

Classic pictures such as this one of a ceremony from the rear of the venue (this time it's a tent wedding) are always popular. In this instance, the photographer considered the light source behind the subjects and exposed the image so it would be a semi-silhouette.
© *Frank Rosenstein*

reduction, and full-frame sensors are on the scene. In fact, it is nearly a full-time job to keep up with all the options! Plus, this means staying current not only on cameras, but also on file types, memory cards, lens conversion factors, and even flash units. To make matters worse, the list of necessary digital photography tools (computer gear, software, file storage, etc.) needs to be updated so often that it seems as if digital manufacturers are becoming a partners sharing in the photographer's profits.

The current changeover to digital imaging has been accompanied by a tremendous amount of hype in the photographic press, huge advertising budgets (which in turn create more hype in the press), and photographers wooed by film savings ("maybe there is a free lunch!"). If it sounds too good to be true, it may be. So let's look at the issues surrounding digital photograhy.

The Megapixel Myth

Photographers often rush to sell their 5-megapixel camera when a 6-megapixel model becomes available but, in terms of resolution, there is hardly any difference between the two. In fact, to double the resolution of a 5-megapixel camera you need a camera that contains a 20-megapixel sensor! What, you might ask?

To better understand this, forget about the prefix "mega" for a moment and look at a simplified example with just a few pixels. Let's say you buy a brand new 'DigiFlex' SLR and its imaging chip is 2 x 3 pixels. Multiplying the two pixels by the three pixels means that your hot new DigiFlex has a total of 6 pixels. When the next generation—the DigiFlex 2—is introduced, it has an imaging chip that is 4 x 6 pixels. The new camera offers twice the resolution of the original DigiFlex because you have twice the number

of pixels in both the vertical and horizontal dimensions of the chip. But, when you multiply the 4 pixels by the 6 pixels you have 24 pixels on the imaging chip. Now, substitute the word "megapixel" for the word "pixel" to get a grip on the reality of digital resolution. Here's the rub; no camera manufacturer will tell you this because they are very interested in selling you their new incrementally increased megapixel replacement for your older, last generation, digital camera. To make this even more complicated, resolution isn't the only determinate of image quality. Other things such as sensor size, pixel size, noise, lens quality, and compression are just as important.

Camera manufacturers are very interested in having you upgrade to the next generation, so each advance of one or two megapixels is touted as if it's the ultimate improvement. It's true, however, that there is a certain amount of logic in the argument to purchase as many pixels as possible in order to approach the resolution found in a piece of 35mm film, which, according to Kodak contains approximately 50 megapixels of data. Adjusted for limitations of the human eye, which for example cannot see infrared or ultraviolet light, 35mm film actually delivers about 16 megapixels of useful information. Since a medium format (6 x 6 cm) negative cropped to produce prints of 8 x 10 inches (or a 6 x 4.5 uncropped negative) is about 3 times the size of a 35mm frame, the roll film represents about 48 megapixels of useful information.

It's possible that you (and your clients) might be satisfied with the resolution of a 6-megapixel camera if you don't need prints larger than 8 x 10 inches. That's because (in my opinion, anyway) the image quality of a digital file becomes indistinguishable from a silver-based image at normal viewing distances when sized at 300 ppi (pixels per inch) and printed at of approximately

8 x 10 inches. And at 300 ppi, a 2000 x 3000-pixel chip (the basic dimensions of most sensors in a 6-megapixel camera) will record enough information to make 6.7 x 10-inch prints. But note, to increase print dimensions up to 8 x 10 inches, the resolution must fall to 2000 x 2500 pixels, which limits the print size to 250 ppi. Now, even if the quality at 250 ppi is acceptable to you (and it is to some photographers), cropping becomes a key issue at this point. Because the original 6-megapixel file (call it a digital negative) has just enough resolution to produce an 8 x 10-inch print (at 250 ppi) there is very little cropping that can be done before you run out of pixels.

Further, imagine cropping a vertical 8 x 10 image out of the horizontal frame that is 2000 x 3000 pixels. To do the math, convert 2000 pixels to height of 10 inches, which yields 200 ppi. Then your width, 8 inches, must also be 200 ppi, or 1600 total pixels. You have had to crop your 6-megapixel file down to less than 2 megapixels. Forgive the pun, but at a print size of 8 x 10 inches, a 1600 x 2000-pixel file will not result in a pretty picture.

In the last few years a number of friends and associates have called me with what amounts to the same question each time: Why, they wonder, are they unhappy with

Inside the Mamiya ZD medium format camera is a CCD sensor with 22 megapixels! This digital camera is fully compatible with all Mamiya 645AF lenses. © MAC Group

the sharpness from 6-megapixel cameras when they shoot large groups. This situation never rears its ugly head in the all those examples shown at trade shows that present beautiful close-ups of a model's face or a flower. Consider this: Let's say you have a row of 30 people standing side by side across the frame. The distance between each person's head is about 1.5 times the width of a single head so the 30 people's faces represent about 30/75 of your image (30 plus 30 x 1.5 = 75). Remember that a 6 x 4.5 cm negative contains eight times the amount of information (48 megapixels) as a 6-megapixel sensor. Also, remember that the horizontal pixel count of six megapixels sized to print an 8 x 10 is 2500. Now, 30/75 of 2500 pixels is 1000 pixels, and those pixels have to be divided over all 30 faces. This means that each face is represented by only 33 pixels, so there is no way the detail in this digital photo will be as sharp as the print made from the 645 negative.

In the search for getting every pixel out of the digital format, some photographers, labs, and binderies are producing prints (and albums) for the full dimensions of the 2 x 3 ratio these cameras produce (which is also the ratio of 35mm cameras).

No Film Costs...But

The current business model for digital camera manufacturers (and retail stores) requires these companies to constantly clear out old models to make way for the new. Consequently, a camera that was first a closely guarded secret and then last year's "MVP" may well find itself steeply discounted this year. Instead of becoming an investment that will appreciate in value, digital cameras are upgraded nearly every other year, which means that cameras only a few generations old are barely worthy of being paper weights. Just as with old computers, their resale value is nil because ever advancing technology has stripped them of their

usefulness. As proof, check out the resale prices of used cameras that were introduced just a few years ago. Camera manufacturers are no longer happy when you merely add a new lens or flash to your system; they want you to buy a new camera every few years!

Try this on for size. If you spent $10,000 on the highest-end roll-film camera system, it will be usable for 30 years. If you were to shoot 100 weddings per year for 30 years, your equipment costs would be less than $4 per assignment ($350 per year). In addition, keep in mind that there is a thriving used market for roll-film cameras that contains plenty of examples in pristine condition at outstanding value.

Conversely, if you spend $30,000 today on the highest-end digital system available, you'll be lucky if you get 5 years from the system before it needs major upgrading. If you shot the same 100 assignments per year, your equipment costs would be $60 per assignment ($6000 per year!). Before you disagree with my $30,000 figure, remember that digital photography includes so much more than just the camera and lenses to make the system work. Laptops, memory, hard drive upgrades, software, CD or DVD burners, and backups are all part of the upgrade costs that must be considered. And given these costs, woe unto you if you shoot less than 100 assignments per year! We're talking crazy numbers here. Don't believe me? If you shoot only 20 weddings per year with a typical digital system, the cost ends up being about $300 per wedding assignment, while the roll film system's per assignment cost (over 30 years at 20 weddings per year) will be less than $17.

To be fair, there are less expensive ways to get into the digital world, and these should not be overlooked. The vast majority of photographers aren't going to buy two 16 megapixel bodies (at $8000 each!) and many photographers making the switch to digital already have a set of lenses that can be

mounted on their new digital SLR bodies. There are 6- and 8-megapixel cameras in the $1000 to $2500 range that offer fine performance. And as the technology takes hold, resolution and performance will only increase as prices decrease. But the cost of constant updates (to cameras, lenses, computers, and software) is still an important consideration.

What About Time?

In the chapter on pricing and packages, I point out that for every hour spent shooting with a digital camera, it takes an additional hour of computer time to download, organize, color correct, and archive your pictures. If you shoot for 6 hours on each of 100 assignments a year, it will take 600 hours (or 15 working weeks) of your time. You have to either charge your customer for this time or eat it yourself. Eating this time without charging the client can be costly.

Is Shooting RAW the Answer?

Some photographers try to speed up the downloading and postproduction process by shooting in the JPEG format. However, I have found that the exposure accuracy required to shoot quality JPEGs is equivalent to shooting with transparency film, which is fine for a commercial or portrait assignment when there's time for careful light reading and exposure refinement. However, for wedding photographers used to the forgiving nature of color print film, it is difficult to get good JPEG files in the fast

While not full frame, the sensor in the Canon EOS-1D Mark II is larger than those offered in many digital SLR cameras. Thus it captures a wider field of view than cameras with smaller sensors. Sensor size in digital cameras is an important buying consideration for wedding photographers who need to maximize the coverage of their wide-angle lenses for group photography. © Canon USA, Inc.

paced world of the dance floor! The result is often blown highlights on the bridal gown or lack of detail in the groom's tuxedo. One friend working with JPEG has told me that his digital shooting style is shoot, shoot, shoot, delete, delete, delete, then shoot, shoot, shoot, ad nauseum.

Many photographers have found that using RAW format (which contains all of the file's unprocessed data) gives them the ability to make exposure and white balance corrections in the postproduction process. Others use cameras that offer the option of shooting both RAW and JPEG files simultaneously. Since JPEG is used for proofing, the photographer only has to process the RAW files for the pictures that the customer has ordered as prints. This results in a huge saving of computer processing time, but RAW files require more space on memory cards than JPEGs.

Digital Camera Choices

While the coming years will no doubt see the introduction of new medium format digital cameras and backs, most of the digital cameras used by professional wedding

photographers are based on the 35mm SLR. For 35mm shooters, this offers the advantage of being able to use lenses they already own. However, some cameras feature different sized sensors, from chips that are physically smaller than a 35mm film frame (which changes the view seen by the lens) to those in cameras that are the same size as a frame of 35mm film. The view through these is exactly the same as a 35mm camera. Compared to 35mm film SLRs and digital SLRs with full-frame sensors, digital SLRs with smaller than full-frame sensors make lenses perform as if they had longer focal lengths than they actually do. In order to appreciate this change in view or magnification, a multiplier (or lens conversion factor) must be used at a given focal length. For example, a small sensor might feature a conversion factor of 1.5x. Thus, the view or field coverage of a 50mm (normal) lens will be equivalent to that of a 75mm lens on a 35mm camera.

Telephoto focal lengths get a boost in magnification power, but more importantly, so do wide-angle lenses. This means the field of view for wide angles is narrower than with a full-sized frame, and this "cropping effect" is significant in wedding photography. For example, a digital SLR with a multiplier of 1.5 makes a 20mm lens perform as if a full-frame camera had a 30mm lens mounted on it. It is important to consider this when shopping for a digital camera to be used with a bag full of lenses from a 35mm system that you already own. Your old tried-and-true favorite portrait lens will suddenly offer a very different view of the bride when mounted on a camera with a sensor that is less than full frame. More importantly, the wide-angle lens that you used for group shots will no longer include the four cousins on either side of the family!

Living in Interesting Times

It is extremely important to realize that digital technology is improving daily. Rapid changes are occurring not only with cameras, but also with computers, software, and both in-camera and archiving storage media.

When the "revolution" started, a digital back on a roll-film camera was one of the first ways many pros got into the digital scene. Then came 35mm-based digital SLRs with ever-improving sensor and processing technology, all at ever-decreasing price points. Lately, digital medium-format cameras like the Mamiya ZD and the Hasselblad H1D (both possessing 22 megapixels), along with the newer Pentax 645 Digital (with a Kodak 18.6-megapixel chip) have been introduced to the market. These cameras, with larger than full-frame 35mm-sized chips, feature higher resolution and physically bigger pixels. Bigger pixels mean less noise in addition to the high resolution, so it may be true that the death of medium format has been greatly exaggerated (to paraphrase Mark Twain).

Likewise, the Fuji S3 with its two differently sized pixels at each photo site on the chip is an advancement that may help prevent blown highlights and blocked shadow detail. Meanwhile, both Canon and Nikon continue to produce improved, higher resolution cameras that, along with their fast zoom lenses, may cement the 35mm-based digital SLR as the camera of choice.

There is an old Chinese toast that doesn't wish for health and wealth, but instead hopes that the person being toasted "lives in interesting times." The switch to digital imaging from film has set the photo world on fire and, without a doubt, we are living in interesting times!

SHOOTING FILM

Despite the advances in digital technology, many wedding photographers still rely on film for some or all of the assignment. If you decide on film, I believe that roll-film is superior to 35mm for wedding coverage. There are many reasons for my opinion; some are based on practical, mechanical concerns, and others are based on customer perceptions. Both are valid. Here's the real nitty gritty of it: Over the years 35mm has made great inroads into the field of professional photography. We've all seen nature and sports photographers toting humongous telephoto lenses attached to Nikon or Canon bodies. Shooters festooned with 35mm cameras in war zones around the world appear on TV news. However, before we assume that these cameras are equally suited to wedding work, we must consider three things:

1. Weddings are shot on color negative film.
2. The images are going to be viewed as original prints, not generations later as the product of a printing press.
3. It is more profitable to sell large prints than small ones.

Although 35mm truly has become the "everything" format, its main weakness is in the area of enlargements. I know, I know. You can get excellent results from 35mm color negative films. I agree, but can 35mm color negatives consistently produce prints that are 8 x 10 or larger with saturated color, creamy smooth skin tones, and excellent sharpness? The fact is that when the 24 x 36mm frame of a 35mm negative is enlarged to 8 x 10-inch proportions, only a 24 x 30mm section is used. More importantly, the negative effectively becomes even smaller if the client asks you to crop out "the lady in the red dress" or asks (heaven help us) that the final print be a vertical instead of a horizontal. In the greater New

With a format size of 6 x 4.5cm, Mamiya's 645 Pro TL can fit more images on a roll of film than 6 x 6 cameras. Compatible digital backs are also available. © MAC Group

York area, 5 x 7-inch prints are sold for $12 to $30, 8 x 10s bring $20 to $50, 10 x 10s range in price from $30 to $60, 11 x 14s are priced from $50 to $150, and 16 x 20s can run the gamut from $75 to $300. For larger prints the prices are even higher. When these prints are produced by a professional wedding lab, the price difference in your costs between the finished sizes is minimal. Thus, you can't afford not to provide the larger sizes to your customers! If the size of your negative doesn't allow it to be blown up to a high quality 16 x 20 print, you are missing an opportunity to sell the highest profit maker on a wedding photographer's price list.

Still, there are photographers who swear by 35mm. In fact, I have more than a few 35's in my equipment locker, though I don't use them for color negative wedding photography. There are photographers who will tell you that the quality of 35mm is equal to that of medium-format, but I find that's not exactly true.

Whenever someone shows you a stunningly sharp 11 x 14 print from a 35mm color negative, remember that you are *not*

The Hasselblad H medium-format system offers both roll film (H1) and digital options (H1D) in medium format. © Hasselblad USA Inc.

seeing *all* the hundreds of photographs from that assignment. Roll film offers consistently higher overall quality than 35mm. Taking this a step further–larger negatives require less enlargement, making it much easier to produce top-quality prints from negatives that are slightly under or overexposed.

Usually I've found that the photographers who say roll film isn't necessary fit into one of these categories:

1. They don't want to carry a heavier roll-film camera.
2. They have a 35mm system and don't have the funds to start building a roll-film system.
3. They use the automated systems available in 35mm as a crutch and don't have the technical knowledge to cope with the demands that roll film places on a photographer.
4. They think that what they can accomplish in 35mm cannot be done in medium format.
5. They are intimidated by large, manual cameras.

The public's perceptions of the differences between roll-film and 35mm cameras are also worth considering. If you shoot a wedding with a 35mm camera, chances are good that some guest at the wedding will have a camera that is equal to or "better" than yours. Professionals know that it is the person behind the camera that makes the picture and not the camera, but if Uncle Louie has the latest Whizflex G5, and you are 'only' shooting with the Whizflex G4, your abilities may be questioned. It doesn't matter that Uncle Louie's pictures never come out. He has a better camera, and therefore to the casual observer he is a better photographer. By extension, the perception is that if his pictures don't come out and he has a better camera than you, then… well … you couldn't possibly be very good!

On the other hand, if you are shooting with a highly respected roll-film camera, a Hasselblad as an example, most knowledgeable amateurs will be in awe of your equipment. Photography teachers often talk about the camera's "presence," and the more professional your equipment's "presence," the more you look like a professional. This isn't necessarily true of course, but if you're just starting out in the wedding business, every little thing that can add credence to your professionalism is helpful.

In William Golding's book *Lord of the Flies*, a group of schoolboys become stranded on a desert island with no adult supervision. They set up a rudimentary form of government that revolves around a conch shell. Only the boy who holds the conch shell can speak; without it, the others must listen. A roll-film camera is the wedding photographer's "conch shell." If you shoot 35mm there is a good chance there will be more than one "conch shell" at the wedding. With these thoughts in mind, let's start the section about cameras by looking at the professional wedding mainstay, roll-film cameras.

Roll Film Formats

Depending on how a 220 roll of film (or the shorter 120 roll) is divided into frames, it produces three different negative formats. There's the 6 x 7cm format that provides an embarrassment of riches in terms of image quality and enlarges directly to 8 x 10 with little or no cropping. There is the 6 x 6cm format that offers two interesting features that I will detail a bit later, and the 6 x 4.5cm format that can be looked at as either a shrunken 6 x 7 format or a blown up 35mm. These three formats fit onto a 220 roll of film in such a way that they provide either 20, 24, or 30 frames per roll, or half of these frame counts on a 120 roll.

Advantages and Disadvantages

While the 6 x 7cm format camera is the darling of professional commercial and portrait shooters, it has limited applications in wedding work. The primary examples of this breed, the 6 x 7 Mamiya RB and RZ series SLRs, are big, heavy, and cumbersome. Adding to this is a long time parallax (the time it takes after the shutter button is pressed for the picture to be taken) caused by the inertia of the massive mirror as it accelerates to flip out of the way to expose the film.

The 6 x 6cm format is represented by Bronica, Hasselblad, and Rollei (as well as some inexpensive new and used-market twin-lens reflexes, which are very serviceable picture takers). This format is my choice for wedding work for two reasons. First and foremost is speed of operation. I'm not talking about time parallax here, but the time required to position the camera and flash before making an exposure. Here's the scoop. When working with a direct, single, on-camera flash, the best possible lighting you can get is when the flash is located above the lens. Savvy rectangular-format shooters know this and use a swing bracket to keep the flash over the lens for both vertical and horizontal compositions. However, before the exposure is made, the camera must be physically positioned for each type of composition. If the photographer is using a swing bracket that allows the flash to be swung over the lens for both horizontal and vertical compositions, that too must be physically manipulated before the exposure is made. While one of these decisions is made mentally (the vertical/horizontal composition choice) the other two—positioning the camera and then the flash—have to be done manually. This takes time. Using a square format camera means you don't have to decide ahead of time whether to compose vertically or horizontally, so flipping the camera and flash is not a consideration. This is also true when working without flash while using the camera on a tripod. In addition, the 6 x 6cm format allows the photographer to upgrade the customer to a larger and more impressive square album that is more profitable.

The 6 x 4.5cm format is the last format used by roll film SLRs for wedding work and it is also the most recent. Its primary claim to fame is the added pictures that can be squeezed onto a roll of film (hence lowering film costs). I find the savings to be a less than a fair trade compared to the 6 x 6, considering the speed of operation and the ability to more easily upgrade an album to a square format. Importantly, I work in a big city environment with big budget weddings where a visually educated clientele is often less concerned with price than quality. If the competition in your area offers only 5 x 7-inch photographs and the clientele is satisfied with that, you might skip roll film and use 35mm film because it offers as much quality as your customer needs or can afford. As they say on the web, ymmv—your mileage may vary!

CAMERA EVOLUTION

Though there are a number of camera brands that offer fine performance, most of today's 35mm shooters choose either the Canon or Nikon SLRs. Both offer multiple camera and lens systems that are up to the rigors of the work and have the required panache.

These cameras offer bells and whistles that are advantageous to the wedding photographer as well as other features that probably won't be used for wedding work. For example, while a camera manufacturer will crow that their model can sync with their flash at 1/8000 of a second, they neglect to mention that this feature can be accomplished only by making their flash unit act in a stroboscopic mode that greatly limits its power and does little to freeze action! Excuse me, but I need to shoot at f/8 (not f/2.8!) and I have to get to that aperture in one flash pop so my other flash units (both my assistant's light on a pole and the room lights I use) work in sync with my camera.

In fact, although all of the photographers I hang with make use of the autofocus features of these cameras, we mostly set the exposure manually because auto exposure systems are too easily tricked by white bridal gowns, black tuxedos, and cavernous, dark wedding venues. Neither I nor my customers find it acceptable to blow out the detail in a lace overlay on a $ 3000 wedding dress, and that can happen all too easily when using automatic flash. Furthermore, pre-flash exposure systems limit the ability to light up a room using room lights and, in reality, dialing in exposure compensation (and remembering to dial it out in the next scene!) takes more time than setting the f/stop manually.

Lastly, while it is important to get a digital SLR with the highest resolution you can afford, all of the models in 35mm film systems yield the same resolution because they all use the same high-resolution film.

Further, the same latest and greatest lens you can bayonet onto a top-of-the-line Canon or Nikon can also be mounted on a lower priced model within the product line. Because of this, while your first camera should be chosen from the top of a brand's line (the customer's perception again) your back-up equipment can be further down in the same system in terms of features and price point.

Granted that the SLR is the primary tool of today's professional, it is certainly not the only type of camera that can do the job. Photographers who think the SLR is the be all and end all are limited in their understanding of what other camera types can do. But, because the SLR is today's most popular design, lets look at some of the advantages and disadvantages.

Viewing Through the Taking Lens

Regardless of the imaging medium (film or digital) or format (roll film, 35mm film, or sensor-size), viewing the image through the taking lens has its advantages. Shooting through things such as doorways, cake decorations, and limo windows is easy because there is no parallax between the taking lens and the viewing lens. Parallax is the difference between what the lens sees and what the viewfinder sees, and its limitations are exemplified by both the rangefinder and twin-lens-reflex (TLR) camera designs.

Seeing Your Depth of Field.

SLRs let the photographer preview the depth of field at the taking aperture. By putting the stop-down lever to use, a practiced eye can tell how much depth of field is available. This really helps when you want to do a selective focus image or if you want to know just how sharp an out-of-focus background will appear. In the viewfinder of a rangefinder, everything is in focus all the time; while the viewing lens is always wide open in a TLR. The former design gives you

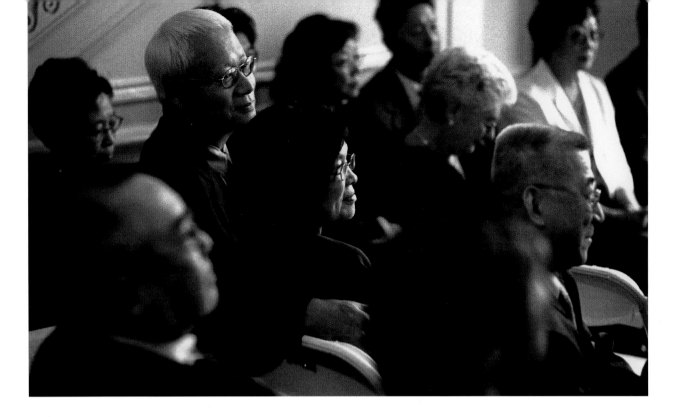

Sometimes the best picture is behind the photographer! In wedding parlance, turning from the primary action to see what else is happening in the room is called a "reaction shot," and these sometimes yield interesting results. In this example, the photographer used available light and limited the plane of sharp focus to just one guest by using a large aperture. It was captured as he turned from the ceremony to survey the guest's reactions. © George Weir

a false sense of security to the extent that some photographers actually forget to focus their rangefinder cameras (!), while the wide open viewing system of the TLR makes it hard to determine if soft, background trees behind the groom's head will actually end up being in focus, appearing to sprout out of the top of his head due to the greater depth of field at the taking aperture.

Not Viewing Through Camera at the Moment of Exposure.

There is one aspect of the SLR design that I find disturbing. You don't get to see the subject at the exact moment of exposure. When the shutter release is pressed, the reflex mirror behind the lens flips up out of the path of the incoming light, which exposes the film. Whether the SLR has an instant-return mirror like a 35mm SLR or a mirror that doesn't reset itself until the camera is recocked, like some Hasselblads, doesn't really matter. At the moment the flash fires,

the instant the film is exposed, the eyepiece view is a black hole.

Because wedding photographers depend on flash, you should want to see it fire; you should want to see it hit your subjects. Camera companies (and even photographers) will tell you that their SLR offers continuous viewing, but you can't see the subject at the exact moment you need to.

However, one way around this is to not look through the camera! SLRs with normal or wide-angle lenses are possibly the second-best way to view a scene being photographed. I say second best because people are the squirmiest, wiggliest, blinkingest things the universe has to offer. Therefore, in most "people-picture" circumstances using an SLR, the "best" way to shoot pictures is by viewing the moment of exposure with your naked eye, without a camera in the way. When you're shooting a formal pose with the camera mounted firmly on a tripod, this technique is easy. The camera is

held firmly in place; it isn't going anywhere so it isn't necessary to be peering through it when you push the shutter release. When you're working hand-held shooting flash, it's not as easy but can also be accomplished. The easiest way to explain the technique is to say I feel like a turtle. First I view through the camera and frame my picture. I then freeze my arms and body. Next, without moving my body I crane my neck and peer over the eyepiece of the camera. I view the real scene as I push the button. The first advantage is obvious: You can see if your flash fired! But with a little practice you can see blinks, smiles that died or crested perfectly, and a zillion other little details that are frozen by the flash.

If you use wide-angle lenses (in 35mm format: 20, 24, 28, or 35mm; or in roll-film format: 40, 50, or 60mm) regularly, the body-freezing trick is even less critical if you frame your photograph with a little "air." When you use normal and longer lenses your framing accuracy becomes more important, so you have to be very careful about holding everything still while you do your craning. Still, if you do weddings and use flash, this is the way to go!

Difficulty in Focusing Wide Angle Lenses

Wide-angle lenses "minify" the image on an SLR ground glass, and this makes it difficult to focusing them manually because the details you want to focus on are smaller and harder to see. The wider the lens, the worse it gets. For most of my work with wide-angle lenses on an SLR, I focus by guesstimation. As a test, in a dim catering hall, I used a 50mm lens on a 6 x 6cm camera and focused three times on the same subject. Each time the distance scale ended up at a different setting. With a wide-angle lens I have found that the best chance for focusing success is to estimate my distance from the subject, set my distance scale accordingly,

and shoot away. Estimating distances accurately takes practice, but it is a worthwhile skill for a candidman to master. From experience I have become very good at estimating distances between 6 and 25 feet. Shorter and longer distances give me much more difficulty. If I'm shooting a large group with my wide-angle lens, I even go so far as to bracket my focusing. If I think the group is 20 feet from me, I shoot a frame with my distance scale set to 15 feet, another frame with the scale set at 20 feet, and a third frame with it set to 25 feet, just to be sure. A candidman I know once watched me shoot a wide-angle group shot. After I was done, he came over to me and told me he did it just like I did. First he focused his camera, then he looked at his distance scale, then he reset the distance scale to what he estimated the distance to be, then he shot. In other words, he didn't trust his distance scale either! And we both ended up with sharp images.

Long Time Parallax

Sadly, SLRs have a long time parallax. When you push the shutter release on a roll-film SLR with a leaf shutter, the following things happen: The lens stops down to the taking aperture; the leaf shutter closes; the mirror flips up out of the way; and finally, the shutter fires. Although this takes only a fraction of a second, it can seem like forever. If you're shooting with a leaf shutter Hasselblad, there is also a second auxiliary back shutter that must open. If you're shooting with a Mamiya RB or RZ, or a Pentax 67 (although it has a focal plane shutter), the mass of the mirror makes the flip-up procedure agonizingly slow. Many times subjects react to the sound of the mirror flipping up, inadvertently timing an eye-blink to coincide perfectly with the flash. Often just the motion of the shutter closing is enough to make subjects react with a blink. And while the time parallax of a digital or 35mm SLR is less than that of a larger, roll-film camera,

it is still worth your consideration.

Some of you are saying, "So what?" The time parallax is only a tenth of a second." It just so happens that one of the fastest human reflexes is the blink. It protects the eyes from dust and other stuff (like flying bugs), and its speed can create havoc for photographers. You end up with a set of wedding pictures no pro wants to show. Thankfully, there are a few solutions.

As a first line of defense, some roll-film cameras have a way of pre-releasing the mirror. This feature also closes the shutter and stops the lens down. Once all this happens, the SLR's time parallax shortens dramatically. It should, because once you've released the mirror you no longer are using an SLR, therefore this solution works best when your camera is tripod mounted. With the camera mounted on a tripod another trick is to cover the finger resting on the shutter release with your free hand. Some subjects react to your finger's movement. In the worst cases, you can ask your subject to close his or her eyes and open them when you count to three. At the exact same instant, on three, you push the shutter release. Sometimes none of the above solutions work and you are just out of luck. It happens. If you find yourself in this situation, shoot a lot of extra film and hope that something works. Most times it does. But even when it doesn't, at least you can say you tried your best and have the photos to prove it! It is also worth noting that both rangefinder and TLR cameras have a relatively short time parallax because there's no reflex mirror that must be moved out of the way.

As an aside, sometimes nervous subjects tell me to take a second shot because they blinked during the first picture. Although I always comply, if it happens more than a couple times, I always ask them if they saw the flash. If they say yes, I explain that once they've seen the flash the picture has already been taken and although they are blinking, it's after the fact. This usually relaxes them, and a relaxed subject usually results in a better picture . . . even if they do blink some of the time!

SLR Design Creates Complex Construction

With all the things moving around in an SLR, something's bound to break sometime. Last year I completed about 100 wedding assignments, shooting approximately 20 rolls of 220 film for each one. Every roll had 24 images on it, meaning that last year my cameras made approximately 50,000 exposures. Camera mechanisms are only metal, and metal eventually breaks (but it takes longer than plastic!). The complexity of the SLR exacerbates this situation as does the knockabout way wedding cameras are used. One solution is to have a few spares in your equipment locker (not counting the two you carry with you) and to rotate your equipment. Keep records on each camera, and have your repair person perform CLAs (Clean, Lubricate, and Adjust) on them regularly. Even when you do this religiously, they'll still break. When it happens, don't fret. Just change to your spare and keep going. By the way, check your spare cameras regularly to make sure they're working properly. Note again that both rangefinder and TLR designs have fewer moving parts and many find these more robust.

Noisy Operation

Another downside to having so many things moving around in an SLR is that they can be a bit noisy. On the dance floor with the orchestra playing, nobody notices the "thwuck" or "clang" your camera makes every time you release the shutter. But that same thwuck or clang becomes very loud during the hush of a nuptial mass. You can't do much about it, but it's worth noting that rangefinder and TLR designs are quieter.

Zip-A-Line is a thin plastic tape that can be used on your viewing screen to remind you of the actual proportions on the proof size.

Even considering these shortcomings and after careful consideration, my choice is still the SLR.

USED CAMERAS

Sometimes a used film camera can serve you just as well as a new one. Sometimes the latest incarnation of a specific camera has additional features that are of no real interest to you. The latest Hasselblads, for example, all offer TTL auto flash, and if manual flash is your cup of tea (as it is mine), then spending extra bucks on electronics you won't use is not cost effective. Even Hasselblad is aware of this, and they have reintroduced earlier designs. In the roll-film camera arena, old is not necessarily bad.

Older cameras can still produce great results, so it can be a good idea to search for a source of used bodies, magazines, or lenses that fit your brand. You might begin by scouring the ads in photographic magazines. Shutterbug, for one, runs a tremendous number of ads from dealers who specialize in older equipment.

Retailers that specialize in used equipment often use a rating system. For example, one used equipment mail-order advertiser rates their equipment as NEW (self-explanatory) through various classes such as LN (like new) and UG (ugly). UG cameras are in rough shape. They may exhibit dents, dings, mars, and brassing on the camera body. UG lenses have surface wear and may have dam-

age to optical glass that will affect the image. Up one notch from UG is BGN (bargain). Bargain equipment is often rated as 70–79% of its original condition with more than average wear. Bargain equipment will probably have surface scars, but will still be in useful condition. Lenses may have more than average wear, but picture quality is not affected. While I stay away from UG equipment, I don't have anything against "more than average wear." If you feel your camera is a reflection of your ego and need the latest on the market, that's fine. But if the flaws on a used piece are just cosmetic and won't affect picture quality, I don't care. If you love (and must have) new equipment, consider buying a new first camera and find used models for back-ups.

Some photographers like to jump to the latest camera model whenever it comes on the market. These neophytes will then sell their older equipment whenever the next latest and greatest arrives on their dealers' shelves. But this is often long before their older equipment has outlived its usefulness. Furthermore, there's always some hobbyist who buys the biggest and the best only to find that lugging it around is more like work than fun. I look for those guys and in fact very rarely do I buy new equipment. The only caveat here is that digital camera quality is changing so fast that it is often imperative to buy the latest offering to get the features or resolution you need.

If you are fortunate to have a photo shop in your area that specializes in pro equipment, by all means, check out the used equipment that is available. Wherever you shop, if you see something you need, do not waste time. Jump on it. Who knows, you might decide to trade in something I have been looking for! In the world of the hardcore professional, new and shiny camera equipment is not something to lust after . . . it's just an extra expense!

Lastly, remember that every camera, whether roll-film SLR, TLR, rangefinder, 35mm SLR, or digital SLR, has peculiarities. Keep in mind that nothing is perfect, so if you find a camera system that suits your needs, don't discount it because of a minor idiosyncrasy. I feel that my camera's advantages far outweigh any minor quirks in its design, but the same quirks I find easy to work around could prove to be impenetrable obstacles for you. As with anything, if a camera's advantages outweigh its disadvantages, it could be the right one for you.

PROOF PROPORTIONS VERSUS FORMAT PROPORTIONS

It is worthwhile to consider the proportions of your proof size versus your camera's format proportions. Young photographers often can't grasp that a full-frame 35mm (with a 2:3 proportion) doesn't fit onto an 8 x 10 piece of paper (which has a 2:2.5 proportion). To make things easier to visualize, many labs and binderies now offer prints and albums designed to fit the proportions of 35mm and digital sensors. The reasons I don't care for the 2:3 proportion are because I find it too long for its height and I like the final print sizes of my work to be different from mass produced amateur prints. Whether these reasons are important to you is not the real issue. What is important, however, is that your proof proportions match your finished print proportions. To do this it's important that you mask the viewing screen in your camera to the finished proportions of your proofs so you don't accidentally cut Aunt Charlotte from the family photograph. Even though you can explain until you are blue in the face that a particular person really does appear on your negative even though he or she doesn't appear on the proof, it won't matter. If customers can't see it on the proof, they won't buy it. Even worse, when the customers review the proofs with their families, you are not there to explain that although Aunt Charlotte isn't on the proof, sure as shootin' she's on the negative. If they don't see Aunt Charlotte on the proof, you probably bumped her off . . . on purpose!

Therefore, to eliminate customer wrath and sell more pictures, mask your screen so you can frame and shoot for your proof size. The masking should be subtle so that you can ignore it when you want to use the full frame. Taping a viewing screen is easy. Your local art supply store can come to the rescue. Most of them carry a graphic arts product called Zip-A-Line, which is thin colored tape that's used to create graphs and borders. Zip-A-Line comes in a variety of widths and colors. The thinner versions are perfect for masking a viewing screen, and the color doesn't matter at all. I use 1/32-inch width, but you can use any size that works for you. But just remember, thinner is better.

Here's what I do: I carefully remove the viewing screen from my camera and cut pieces of Zip-A-Line tape to fit the screen. Once they are positioned correctly on my screen, I reinstall the screen, put my prism back on (that's the way my camera works) and start to take pictures. On the 2-1/4 square viewing screen I use the four pieces of tape (two vertical and two horizontal) to define vertical and horizontal compositions. When I shoot a vertical, I ignore the horizontal tape and vice versa. By the way, if you're using Zip-A-Line on a 35mm camera, take about 1/8 inch off the right and left of the screen's long dimension to define an 8 x 10 crop.

Mamiya's 80mm f/1.9 lens serves as a normal lens on a 6 x 4.5 format camera. © MAC Group

LENSES

Whether you choose a roll film, 35mm, or a digital SLR camera, your next decision is what focal length lenses to choose. For most wedding work, you'll need three different focal lengths: a wide, a normal, and a short telephoto. These can be fixed focal length or zooms and both have their adherents. Fixed focal lengths are often faster (with a larger maximum f/stop), are sometimes sharper, but are less convenient than zooms. However, whichever is your choice you still need the wide, normal, and telephoto parts of the equation. So, when using an interchangeable lens camera you've got some decisions to make.

Some photographers believe in stuffing their camera bags with every lens available for their camera. They end up toting so much weight that after a hot weekend in June shooting four weddings they look like little old men walking stooped over. For me it is more important to be light and mobile than it is to have every lens available. When I work alone I use a small shoulder bag to carry a 50mm wide-angle on my 6 x 6cm camera (equivalent to a 28mm lens on a 35mm camera or an 18 to 20mm lens on a digital SLR with less than full size sensor). My 100mm lens (50-60mm on a 35mm camera and approximately 35-40mm on a small-sensor digital SLR—the sensor is smaller than the size of a 35mm film frame) rides on my camera. Using these two lenses

I can cover a wedding. If I had to choose only one lens for the assignment I would pick a 60mm (equivalent to a 35mm on the 35mm camera or a 24mm on a small-sensor digital SLR) or 80mm (equivalent to a 50mm on a 35mm camera and approximately a 35mm lens on a small-sensor digital SLR). Either of these could be used for full-length, groups, and with careful framing, bust-length portraits. Importantly, if I had only that one lens to work with, I would forget about taking the close-up head shots of the bride and groom.

When I work with an assistant, we can carry more lens choices. My full wedding case includes a 50mm wide (a 28 on a 35mm camera or an 18-20mm on a small-sensor digital SLR), a 60mm wide (a 35 on a 35mm camera or a 24mm on a small-sensor digital SLR), an 80mm normal (a 50 on a 35mm camera or an 35 on a small-sensor digital SLR), a 100mm long normal (a 60 to 85 mm on a 35mm camera or a 28 to 35 on a small-sensor digital SLR), and a 150mm telephoto (a 105 on a 35mm camera or a 60 to 80 on a small-sensor digital SLR). In a case of spare equipment (often left in the trunk of my car), I carry a second 50mm wide, a second 80mm normal, and a 2x teleconverter. Although my 60mm lens can pinch hit for the 50mm wide, I feel the 50mm focal length is so important that I want two of them available. The same holds true for the second 80mm lens in the spare equipment case. Lastly, the 2x teleconverter, when used with an 80mm normal, can replace the 150mm tele in an emergency. By combining my 150mm prime tele lens with the 2x converter, I have a 300mm lens available for those occasional long shots.

The Nikkor DX 17-55mm f/2.8G ED-IF AF-S zoom is designed exclusively for Nikon digital SLRs that have smaller than full-frame sized imaging chips. It is the approximate equivalent of 26–83mm zoom on a 35mm camera. Both its constant aperture and its zoom range are ideal for wedding photographs. ©Nikon USA, Inc.

Lens Choice Is a Funny Thing

New photographers often want the widest or longest lens available. They don't understand that most photographs are shot with lenses that bracket a normal lens. In my 35mm system, I have lenses from 15mm to 400mm, but if I had to choose only three, they would be a 28mm, a 50mm, and a 105mm (these convert approximately to 50mm, 80mm, and 150mm respectively in the 6 x 6 or 6 x 4.5cm formats). Over the years I've realized that while I can take a "show-stopper" with an ultra-wide or an ultra-long lens, 99% of my photographs are taken with these three "money lenses" (when the money is on the line I want these three in my camera bag).

In olden times, the three lenses that 35mm photojournalists all carried were a 35mm wide, a 50mm normal, and a 90mm telephoto. These focal lengths didn't impress their optical signature on the picture, and the viewer understood the photo because the picture angle appeared normal. In that era, the 35mm rangefinder was king of the hill. With time and the advent of the 35mm SLR, the picture-viewing public became more sophisticated and the parameters of the wide and telephoto parts of the troika were pushed outward. The three standards became a 28mm wide, a 50mm normal, and a 105mm tele. Standards have a way of changing, and today (at last count) many 35mm pros consider money lenses to range from 18 mm to 210 mm. A good part of this stretching of the standard is because of the great optical qualities found today in such lenses as the 18–35mm, 24–70mm, and 80–200mm fast zooms.

The real lesson here is that you get much greater use from the lenses that closely surround your choice of a normal lens. In 35mm format photography, a 28mm or 105mm lens will see more action than a 15mm or 300mm. In medium format, a 50mm wide and a 150mm telephoto will give you more picture opportunities than a fisheye or 250mm lens. This doesn't mean that a 250mm lens on a roll-film SLR (or a 300 on a 35mm) should be overlooked entirely. Realize what your priorities are for the job you're going to shoot (in this case, a wedding).

One of the biggest advantages to using a 35mm system is the zoom lens. While there are zoom lenses available for roll-film cameras, there is no roll film zoom that covers the medium wide-angle to medium telephoto focal lengths. Mamiya does make a 55-110mm f/4.5 zoom for their 645 cameras that might be considered an "everything" lens, but it is big and heavy compared to carrying two prime lenses. Although a newcomer might be interested in a tele zoom for wedding work, the assignment calls for a type of picture, specifically groups and tight candids on a dance floor, that is the territory of wide-angle lenses. Both Nikon and Canon make wide-angle zooms that start and end in wide-angle focal lengths, but the truth is that a medium tele and a normal lens are also required on the job. Therefore, some of the best zoom lenses for wedding work using 35mm cameras have a range from about 28mm to about 80mm. An important factor to note is, the longer the zoom range of the lens, the bigger and heavier it becomes. Likewise a fixed-aperture zoom is always bigger and heavier than a variable-aperture zoom. Lastly, note that the bigger the zoom's range (i.e., a 50-100mm zoom has a 2 to 1 range, while a 30-90mm zoom has a 3 to 1 range), the harder it is for the lens manufacturer to design. While we've all read about 28-300mm zoom lenses, the simple fact is that they aren't stellar performers compared to shorter-range zooms. As a hobbyist you might be willing to trade quality for convenience, but that decision is harder to accept for professionals who have to satisfy their customers.

Lens weight, speed, and sharpness are of vital importance to a wedding photographer. Although zoom lenses are very convenient, they require you to make certain sacrifices. Zoom lenses are usually heavier, slower (having a smaller maximum aperture), and less sharp than their fixed focal length cousins. In addition, a zoom with a variable aperture can create nightmares for photographers working with manual flash.

There are two different types of zooms available that you must consider. One has a variable aperture—the effective maximum aperture changes as you change the focal length. You might have a 28-70mm f/3.5-4.5 that starts at 28mm as f/3.5 and becomes an f/4.5 lens when zoomed to 70mm. It is very difficult to use manual flash with this type of lens. If you're willing to commit to TTL auto flash, Nikon has a 24-120mm variable-aperture (f/3.5-5.6) and a 24-85 (f/2.8-4) zoom lenses that offer excellent optical performance. I have both of these lenses in my system—they are important because one backs up the other. These are zoom ranges that smart candidmen would be willing to die for. Canon has similar lenses in its lineup. These variable-aperture zooms enable you to create an outstanding one-lens system.

The second type of zoom is a fixed-aperture lens, and both Nikon and Canon offer this kind at the top of their lines. These are designed for professionals, and as a wedding photographer, that's what you are. Both Canon and Nikon produce fixed-aperture zooms in the "money" range, including a 24 or 28-70mm fixed-aperture zoom that performs excellently.

Cheaper is Not Always Worse

Interestingly, many photographers shooting with small-sensor digital SLRs have found that less expensive fixed-aperture zooms by Sigma and Tokina offer equal performance to camera manufacturers' lenses at prices that are sometimes half of the big brand names. This may be true of other independent lens brands also, but I only have witnessed this on those two brands. Here's the inside track on this phenomenon. Almost all of today's lenses are very sharp and offer great performance in the center of their circular pattern. Conversely, edge performance is not as easy to achieve but (big but) all of the small-sensor digital SLRs use only the central portion of the lens' pattern. Thus even if the edge performance of an inexpensive lens is somewhat lacking, the small-sensor digital SLR will never see it. Check out the info on lens hoods below for a similar story.

Lens Accessories

LENS HOODS

Number one on the list of important lens accessories has got to be a lens hood. Lens hoods offer protection from stray light rays that can cause flare, and they can protect the front element of the lens from oily fingertips. They can also absorb some of the impact when you drop a lens . . . yes, accept it . . . eventually you will! Whenever possible, I prefer to use bayonet-mounted, rigid lens hoods instead of bellows-style compendium hoods. Some shooters I know successfully use collapsible rubber hoods. Although compendium lens hoods have their place (such as when shooting portraits using a hair light or working outdoors in soft backlight) the rigid ones are smaller and, if they bayonet into place, they can be removed quickly so you can easily add a filter.

Attention Small-Sensor Digital SLR Shooters!

As with some lenses when used with a small-chip digital SLR, there is another interesting point worth mentioning when discussing lens hoods. Here's the scoop. The one I'm using on my 50mm f/1.4 is from an ancient 105mm f/2.5 Nikkor. Although this combination is "vignette-ville" on a full-frame 35, it doesn't vignette on my Nikon D100 because the smaller-than 35mm-sized sensor only sees the center of the lens' circle of coverage. Likewise, my 24mm f/2.8 Nikkor is sporting the lens hood from an 85mm f/1.8 Nikkor without a trace of vignetting. If you're shooting with a camera sensor that is smaller than a 35mm film frame (full frame), investigate hoods designed for longer lenses on 35mm cameras. You might be pleasantly surprised at how much extra protection you can get from lens flare without vignetting woes.

Filters

There are some filters I cannot live without when shooting weddings. Whether on film or digital cameras, today's lenses are very sharp . . . sometimes too sharp! They can record with great clarity every pore and blemish that is part of the complexion of all normal people. Sometimes this level of detail is not what I have in mind! For this reason my camera case contains three different types of diffusion filters, and each has a specific purpose. While a touch of diffusion can cover the ravages of time on a grandma's face, a great big blob of diffusion may take a mundane picture and elevate it to a romantic, pictorial event that can become the centerpiece of the newlyweds' living room.

For just a touch of diffusion there are a few ways to go. Of the methods I use, one just cuts sharpness while another cuts sharpness and also makes the highlights in the scene glow (they have a halo).

To simply cut sharpness, as I might want to do in a portrait of an older woman, I use a piece of very fine black netting (called tulle, pronounced tool) stretched over my lens. I hold this in front of the lens by attaching my lens hood over the material. This eventually tears and shreds the fine netting, but the material costs less than a nickel per 5 x 5-inch square (that I cut from a bigger piece of fabric). So when it shreds, it shreds. I just throw it away and cut another piece! If this seems like too much trouble, you could use a softnet black filter. Because black veil doesn't make the highlights glow,

On the left my 4-cent piece of tulle makes a great diffusion filter, but if you want a more permanent filter, you can buy a ready-made net filter, like those on the right (of course you won't be able to fold the store-bought filter and stuff it in your shirt pocket!) Since all you usually want is just a 'whisper' of diffusion, I suggest using the least amount of diffusion you can find. Photo on right © Joseph Meehan

it doesn't impress its signature on the picture. The only trick to using this filter is remembering to open the lens 1/2 f/stop when it is in place. Depending on how coarse it is, the black veil prevents about 1/3 to 2/3 stop of light from reaching the medium.

The second type of diffusion filter I use has small lens-like elements on the filter's surface. They scatter light and selectively defocus details while maintaining an overall appearance of sharpness. These filters are available in varying degrees of diffusion. Tiffen's Soft/FX and Warm Soft/FX filters are both available in five densities. Zeiss makes its version, the Softar, in three levels of intensity. Of the three, the Softar I is my first choice (although I also carry the more diffuse Softar II). When used in sunlight, a Softar I creates highlights with an angelic glow. Unlike the black veil, however, filters of this type do impress their signature on the picture. In other words, once you've seen the effect these filters produce, you'll recognize it when you see it again. Diffusion filters of this type are expensive, but their sophisticated design maintains image clarity while creating soft, luminous highlights—perfect for wedding photographs.

The last type of soft-focus filter I use is a homemade variety. Commercial photographers often use Vaseline streaked, smeared, and/or dabbed on a UV filter or sheet of glass to make a soft-focus filter that is soft only where they want soft focus and sharp in other areas of the composition. Although the idea is a great one, while shooting a wedding there is no time to clean the filter and reapply the Vaseline for each shot. I buy old, scratched, ratty skylight filters from the junk boxes at photo shops and swirl on clear nail polish in various patterns. My favorites have a dime-sized clear area slightly off-center, and when I put it on my lens I orient the clear spot so that the part of my composition that I want to be sharp is aligned with the clear area of the filter. I might put the clear spot straight up for a portrait and straight down for an altar picture. Although my diffusion filters work for me, there are dozens of other soft-focus devices that I have seen photographers use over the years. From translucent plastic cups riddled with holes to very expensive Imagon soft-focus lenses, each candidman has favorites. Over the years I've tried many softening devices, from crumpled cellophane with holes burned in it to breathing on my lens in cool weather. Although I have listed the ones I'm currently using, if you ask me to list my favorites next year they would probably be different. Whether you try my ideas or are creative and think up some of your own, diffusion is a useful tool in the wedding equipment arsenal.

Tripods

If some wicked witch were to cast a spell over me that would allow me to carry only one accessory other than my camera and flash (she's not totally wicked . . . she let me start with my camera and flash!), I would be hard-pressed to choose between my tripod and my light meter. If I was using a 35mm with a built-in meter, my choice would be easier. In fact, my camera doesn't have a built-in meter, and my choice is still easy: Give me my tripod! Sure, tripods create a presence for the camera, but what's more important, they make a new range of shutter speeds available, which in turn makes more apertures available, which gives the candidman more tools to work with. Picking the right tripod isn't easy, but before I get specific there are some generalities to consider.

Taking pictures of people quickly with a tripod-mounted camera requires a specific set of criteria. The choice of features one needs should be made with speed foremost in mind. Consider the following:

1. Although leg bracing (i.e., rods, either adjustable or fixed, that attach between the tripod's center column and its legs) makes for a sturdy tripod, it is not conducive to fast tripod-shooting technique.

2. The tripod's ability to be extended or collapsed quickly is important. Tripods with quick-release leg locks can be operated much faster than those without them. There is a way to avoid having to change leg length constantly. This method only requires slight adjustments to be made to assure that the film plane of the camera is parallel to the subject plane (which is your goal for an accurate rendition of the subject).

To accomplish this I open the tripod's legs to a length that allows me to shoot a close-up portrait at eye level with the center column fully extended and a full-length portrait with the column at its lowest point. I open the tripod's legs so its height, not counting the center column, is 41 inches (65 minus 24 is 41) because the height of my fully extended center column plus the height of the tripod head is about 24 inches. Considering that the eye level of an average person is about 65 inches, this means that with my center column collapsed all the way down, the height of the tripod is 18 inches lower than the 65 inches with the column at full extension. The tripod head-height (approximately 6 inches) still exists whether the column is extended or not, so it doesn't count in this instance. 65 minus 18 is 47 inches, which is the height of my tripod's legs and the tripod head. But be aware, all this mathematical exactitude should really be considered as approximations, and it ultimately depends upon the subject's eye level and the length of your tripod's center column and tripod head.

Professional tripods are usually sold without a head. This allows photographers to choose whichever head they like best. When it comes to wedding photography, the primary consideration is speed of operation. © RTS Inc.

Now that we have that figured out, note that the height for a full-length portrait, established above, is approximately nine inches higher than the recommended camera height for shooting a full-length portrait. Many of you are now saying: "Whoa . . . why is 38 inches the approximate optimum height for a full-length portrait?" Well, if we go back to the idea that I want the image plane to be parallel to the subject for an accurate rendition, you'll find that belly button height is the correct height for this. The average person's belly button height is about 38 inches (measure it on a few friends using a yardstick if you don't believe me!). Ten inches over the optimal camera height is a reasonable compromise made in my quest for speed of operation. I often see neophyte photographers shooting full-length portraits with their camera set at eye level and that makes the subject look foreshortened (their heads are disproportionately large compared to their bodies). Photographers committing this mistake often do it because they are lazy

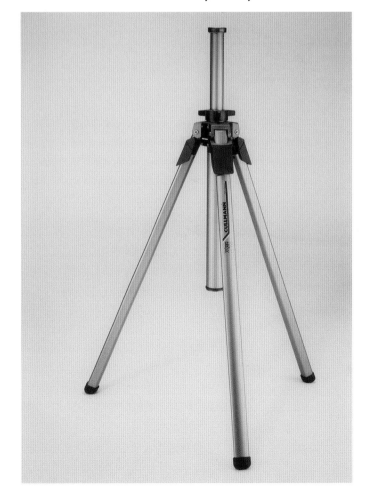

or they just don't know any better. Well, you now know better and if you want to be the best you can be, there's no place for laziness! With all this being said, it also pays to remember that an extreme low angle shot (or an extreme high angle shot for that matter) should be thrown into your mix from time to time because a single such image can occasionally be brilliant!

Continuing our list of general tripod features:

3. Ballheads or speed-grip tripod heads are much faster than pan/tilt heads for taking people pictures (which is what wedding photography is all about).

4. A geared center column not only slows you down, but also makes you carry unnecessary weight. The kind of tripod with a sliding, friction-locking center column is lighter and faster.

5. Weight and sturdiness also must be factored into your choice. Strong used to mean heavy, but with the advent of carbon fiber tripods that's no longer always true.

6. Spike-tipped tripod feet might be great for shooting in the muck and mire, but you'll regret it if your tripod scratches up a caterer's parquet floor. Avoid spiked feet.

7. Your height plays a role. Many of your shots will top out at eye level. For this kind of shooting, it doesn't make sense to carry a 10-foot-tall tripod if the highest camera position you'll be shooting at is eye level.

From looking around at the 30 or so candidman I associate with regularly, I can say that the favorite 'pod among my peers is the Cullmann Titan. This German tripod's claim to fame is a two-section leg that is both released and locked in position by a lever at the top of each leg near the tripod yoke (where the three legs meet). This makes for lightning fast leg operation. On the neg-

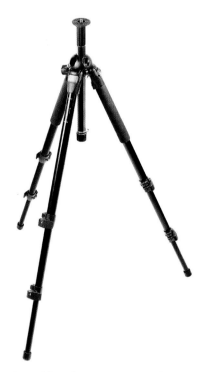

The Manfrotto 3265 Grip Action Ball Head (above) is the uncontested champ when it comes to speed of operation. It can be used with any tripod, such as the Manfrotto 3021 BPRO (below). © Bogen Imaging Inc.

ative side, the two-section leg means the Cullmann doesn't collapse compactly, but this is not a big concern in wedding work. The tripod is also heavy and requires a special Allen wrench to keep the tripod screw tight.

On the other hand, a few of us swear by our Gitzo tripods (imported by Bogen), and the first one I bought over 30 years ago still works well. Gitzo's latest tripods are made from carbon fiber (although they still make metal ones), which is lighter and stronger than the aluminum it replaces. However, the 40% reduction in weight and the increase in strength offered by carbon fiber are quite expensive. Other contenders for the tripod throne include models manufactured by Manfrotto (also distributed by Bogen in the U.S.).

No matter which tripod you decide upon, the head is another choice you've got to make. Serious shooters mix and match different brands to suit their needs. Pan/Tilt heads are slow compared to ballheads when used for people pictures. The Bogen 3265 Grip Action Ballhead has a spring-loaded release lever. By squeezing the head and the release lever together, the camera can be positioned as you like; by releasing your hand pressure, the head is locked. Very nifty. My choice is an older model Linhof ballhead that is almost as quick and basically indestructible. Whatever head you decide upon, look into a quick-release camera coupling between the tripod head and your camera. The same type of coupling should be on your flash bracket so you can switch the camera back and forth quickly between bracket and tripod. Some candidmen add another quick-release coupling plate beneath their flash bracket so they can quickly mount it onto the tripod. Once again, speed is of the essence, and anything you can do to make the flash bracket-to-tripod switch happen quickly is advantageous.

Light Meters

Even if you use an automatic flash and a TTL (through-the-lens) metered 35mm camera, a light meter is a worthwhile accessory. If you decide to shoot with manual roll-film cameras and manual flash units, it is a necessity! With brides dressed in masses of white and grooms and ushers dressed in masses of black, the light meter you choose should be able to measure incident light. Reflected light meters are calibrated to read anything they are pointed at as a middle gray. Therefore, brides (masses of white) are underexposed and recorded as middle gray, while ushers (masses of black) are overexposed and recorded as middle gray. Although you will be able to record detail in the bridal gown and tuxedos this way, it will play havoc with the rendition of skin tones. When shot using a reflected light meter's suggested exposure, brides look perpetually sunburned and grooms always look pasty.

On the other hand, incident light meters read the light BEFORE it is reflected off the subject and, therefore, the reading isn't affected by the color of your subject.

In addition to making sure a meter can read incident light, make sure it can also handle flash readings. Currently, again using my circle of colleagues as a sample, Minolta Flashmeters are the favorite choice.

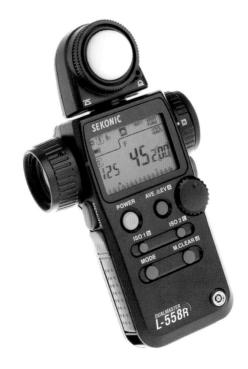

The Sekonic L-558R DualMaster light meter.
© *MAC Group*

Specifically, the Minolta Autometer IVF or newer VF, which is simpler and less expensive than other Minolta models, has all the features a candidman needs. Some candidmen choose from the Sekonic line (imported by MAC Group—the M stands for Mamiya), which has smaller, more compact models available. If you use PocketWizard radio slaves (also distributed by Mamiya), there are two Sekonic meters that have built-in radio slave transmitters that make it a breeze to take flash readings. Truth be told, I carry both Minolta and Sekonic meters because I prefer the handling of the Minolta meter and use it for available light readings. I also use the Sekonic (with it's built-in PocketWizard radio slave transmitter) for my flash readings because it's so convenient when used with my PocketWizard radio slave system.

Even if you know your guide numbers like the back of your hand and can read available light very accurately by eye, a flash/ambient incident light meter can be used to check out a manual flash unit's output or your exposure guesstimate of a sunlit scene. I carry two nearly identical meters with me and check one against the other (and both against a known, manual flash) at the beginning of each assignment. For me, peace of mind is worth carrying two flash meters! Additionally, I have a third flash meter at the studio that never goes on the road. This meter, which lives a life of ease in its foam-lined box, is used as the standard against which I test all my other meters.

Flash

Battery-Powered Flash

Although young photographers think of their flash unit as an afterthought, seasoned candidmen consider it to be one of their most important tools. That's the reason why I've devoted a whole chapter to shooting with flash. Before I give specific recommen-

dations about the brands that have withstood the test of time, there are some general features that you should look for. Let's examine portable, battery-powered flash units first because they are the cornerstone of your flash equipment.

The first question that must be answered is how much flash power you need. That depends on other factors. Format, film speed, lens (wide or tele), and size of the reception hall are all contributing factors in your choice of flash. An 80mm lens (normal) on a roll-film camera has less depth of field than a 50mm lens on a 35mm camera when both are set to the same aperture. Consequently you might need an aperture of f/11 on the 80mm to get the equivalent depth of field as the 50mm set to f/8. This in turn means that to get equivalent depth of field from a roll-film camera you might need twice the flash power as that required using a 35mm counterpart. Let's generalize for a minute, and then you can tailor these generalities to your requirements. Consider the following criteria:

1. You need at least three or four different levels of flash output from your flash unit. Ideally, each power setting should be one stop more or less powerful than the adjacent setting.

2. For best lens performance, you should be able to work at an aperture at least 3 stops down from wide open, and you probably want to shoot group pictures at 15 feet at about f/8 to gain enough depth of field to cover focusing errors. Thus, you should check the guide number of the flash to make sure it will deliver this combination at the ISO you are shooting.

3. Use rechargeable batteries. You don't want to empty your wallet each weekend for fresh, disposable batteries. It's expensive, and it's bad for the environment.

4. You need to be able to get 200 to 500 flashes (at mixed power settings) from a

battery before you need to recharge it. While you may make it through a June lawn wedding with only 50 to 200 flash pictures, there will be a January evening wedding that starts and ends with flash photos, so be prepared. However, you might look into having a few smaller batteries with smaller capacity (the advantage being their reduced size and weight), but expect to change batteries during a break in the wedding action.

5. You need to be able to change to a freshly charged battery quickly and easily.

6. Balance your lust for power (both from the flash and the size of the batteries) with the consequences of size and weight.

7. The reflector on your flash unit should more than cover the widest lens you'll be using and provide even illumination. That way, if your flash unit becomes misaligned on your bracket, its coverage will still be adequate for what the lens sees.

8. You might be interested in having bare bulb capability for working in small white rooms (such as the bride's house) or for putting out just a small puff of fill light.

9. Although it can be handled by your flash bracket, your flash unit's ability to bounce can also be helpful.

10. A fast recycle time is very important in the wedding business. You can't tell the bride and groom to stop on the aisle for 10 seconds while your flash unit cranks up to power. In that instance, 10 seconds might as well be a year! Think in terms of a one to two-second recycle time and you'll be on the right track.

11. Some manual flash units that satisfy criteria one through 10 also have auto flash capability. Therefore, if you think you might ever use auto flash, this could be important to making your decision.

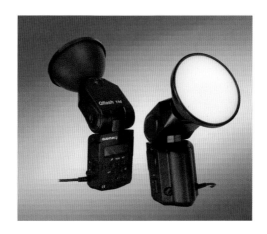

Quantum Qflash T4d. © Quantum Instruments Inc.

Some photographers like self-contained units (with batteries in the flash head itself), and others prefer a separate battery pack that's worn on the belt or shoulder. Personally I prefer a shoulder pack because I like my camera-flash head combination to be light and whippy. Because my flash head is 6 to 8 inches over the lens, each extra ounce puts extra stress on my wrists. Eight extra ounces in the flash head might not seem like much, but it can really add up after a three-wedding weekend.

When the first edition of this book was written in 1995, the most popular flash unit by far seemed to be the Lumedyne, which satisfies all eleven criteria listed above (all but two of my entire circle of candidmen coworkers used Lumedynes!). Almost all used the 200-watt-second 065X packs, which have a faster recycle time than Lumedyne regular (non-"X") packs. Today, it's a different story. Now most of my associates use either the Quantum Qflash or the Sunpak Auto Pro 120J. However all of us still use our old Lumedynes for our second light, attached to a pole that is held by an assistant. Oddly, we also have not forsaken the bulletproof reliability record that Lumedyne enjoys. All the Quantum and Sunpak users (me included) are using Lumedyne packs or batteries to power our Qflashes or 120J's! Both Lumedyne and Quantum even make

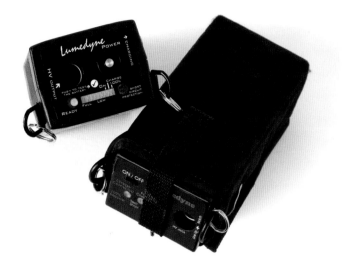

Lumedyne UltraMegaCycler batteries work well with my shooting style. Perfected Photo Products offers many custom cases for batteries and other accessories.

adapters to attach a "Q" head to a Lumedyne pack, and Lumedyne has added a special pack to their line called the Quadramatic pack designed specifically to power the Qflash head. For smaller shoe-mount flash units, Quantum produces the Turbo Battery, and Lumedyne has a series of batteries, all of which increase the number of flashes available because they have greater capacity than the batteries contained in the flash unit itself.

With external batteries, you have to choose between how fast your flash can recycle and how heavy the battery is. Sadly, there's no free lunch and you have to select one or the other! Lumedyne has a series of lightweight, low-voltage batteries that are no bigger than a cigarette pack. These small batteries have limited capacity but, more importantly because they are low-voltage designs, you are saddled with 5-6 second recycle times. Conversely, high-voltage packs, which require a special cable between the flash and the battery, are heavier and offer recycle times in the .5 to 1.5 second range (depending upon the output power selected on the flash). Without a doubt, I think the faster recycle is more important!

My associates and I choose Lumedyne packs and batteries for reasons that may not be important to you. This brand's power, reliability, and features are compatible with our style of shooting. If you are shooting with 35mm or using ISO 400 film, you might get by with a less-powerful flash. In addition, some 35mm brands have accessory flash units with features that you might find important. If you do go this route, realize that, 1) you'll still need an accessory battery pack with its larger capacity, and 2) many popular 35mm accessory flash units aren't designed to take the strain placed on the unit by 200 to 500 manual flashes in 5 to 6 hours.

Some of these shoe-mount flash units are designed to be used as fill flash in the automatic mode, which creates less heat in the flash head and uses less battery power. Furthermore, my associates and I avoid TTL automatic flashes that use a preflash for exposure measurement because of our desire to use additional flash units (see the chapter on working with flash for more info on this point). Of the aftermarket shoe mount flash units available, the Vivitar 283/285 series has proven to be particularly reliable and adaptable, as are some Sunpak flash units. If TTL work is your plan, it is worthwhile to consider using a flash designed to work with your camera's electronics. Both Nikon and Canon have finally gotten on the band wagon and are now offering flash units powerful enough to use for wedding work but, importantly, all the automation they offer is expensive and, in my view, it often limits creativity.

In the New York area, various strobe shops that cater to candidmen modify flash units often by replacing the fragile hot shoe with an aluminum plate that's been drilled and tapped for a 1/4"-20 screw or by adding small, external gel cell battery packs to increase their capacity. If you can find a local strobe shop (or an adventurous

camera repair person) in your area, it pays to establish a good rapport with them and find out what they can do to satisfy your special needs.

Sadly, just like cameras, all flash units break, and a candidman without a flash is hopeless! With that thought in mind you should plan for this calamity beforehand. If you're shooting double light (with an assistant holding a second strobe on a pole), you have to be ready in the event that the second flash unit breaks as well. Batteries die or refuse to hold a charge, flash tubes blow, pack switches burn out, cables fray, and so on. My battery powered flash case includes two Lumedynes and two Sunpak 120Js with enough spare batteries and cables to make sure I can finish every assignment I start! More extra packs and flash heads are also part of my system (but they are spares and stay back at my studio) and they are rotated into my traveling equipment regularly.

FLASH BRACKETS

The union between your flash and your camera is the flash bracket, and for many candidmen it is an expression of individuality. While there are some excellent ready-made brackets on the market, many serious players customize a store-bought item to better suit their needs. Since each candidman's bracket is different, it pays to look at some of these weird beasts to get a better idea of what each shooter considers important.

For my 6 x 6cm camera, I use a modified 35mm bracket with a few interesting wrinkles. The ability to hold my camera securely with either hand is important to me. So, the bracket's long base, designed to hold a 35mm camera, was cut down considerably, but I left a stub of it sticking out on the right side (opposite the hand grip) to help stabilize my grip on the camera with my right hand. The stub is short enough that it doesn't interfere with my hand when I advance the film, but long enough that I can hook my right thumb over it and still have my index finger reach the shutter release button. This stub allows me to hold the camera and release the shutter with one hand. The stub's proper length (for me) was found by trial and error (and a lot of skinned knuckles along the way!).

My next modification involved removing the large, knurled camera-mounting screw on the bottom of the bracket and countersinking the hole so a flathead 1/4"-20 screw

The MultiMax unit from PocketWizard offers a variety of options, including the ability to be used as either a transmitter or receiver, dozens of channels, and the ability to turn off flashes individually.
© MAC Group

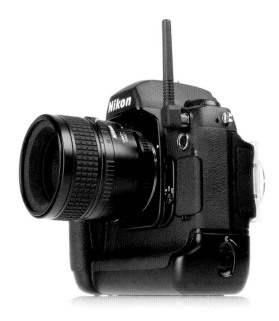
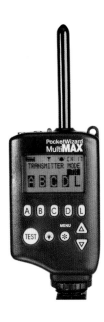

could be used to mount a quick-release camera coupling. That way, the bottom of my bracket is flat, so I can rest the camera on any flat surface.

Next, butted right up against the quick-release coupling used with my bracket is a short brass bar that has been drilled, tapped, and screwed to the bracket. This bar stops the quick-release coupling from rotating on the bracket. There is also a groove cut into the wooden handle on the left side, which acts as a thumb rest when I hold the camera-bracket combo in my left hand.

While there are many readymade flash brackets on the market, don't feel intimidated if you want to file a notch or add a threaded hole in one if it makes it better suited to your shooting style. Remember that your bracket is a personal thing, and if it's comfortable for you (you'll be holding it a lot) and does what you want it to, then it's right.

Getting Multiple Flashes to Sync Up

You will find that nearly every wedding guest with a camera will be taking flash pictures. In this environment, a radio slave system is an essential requirement (see also page 127). There's no sense in setting up multiple flash units if every amateur shooting their own flash can steal the lighting you have painstakingly set up, which is what happens if you use the less expensive light-actuated type of slaves.

There are two brands of radio slaves that I find valuable. They are the FreeXwire made by Quantum and the PocketWizard distributed by MAC Group. The PocketWizard's primary claim to fame (aside from being an excellent radio slave!) is the brilliant marketing ploy of putting the transmitters into several Sekonic flash meters (also distributed by MAC Group) and getting various flash camera and flash companies to build PocketWizard receivers into their products.

At last count Dynalite, Norman, and Profoto AC flash units offered models with a PocketWizard receiver included. Of the two models available from PocketWizard, I find the basic (and less expensive) PocketWizard Plus model to be more than adequate for wedding work. FreeXWire is also a fine radio slave with a feature set worthy of note and, if I were using Quantum's Qflash, my brand of choice might well be different.

AC-Powered Flash

While many candidmen don't use AC-powered (wall outlet) strobe units, I find that this type of flash unit can add a new dimension to wedding work. I use them as room lights to open up backgrounds during the reception. With them I can avoid the "coal miner's helmet" look so common in wedding photography. When I'm part of a team photographing a wedding in a large hotel ballroom, it isn't uncommon to see three or four 1,000-watt-second strobes positioned in the balconies. If there is time, and an available wall outlet, they can change a large church from a dark cavern into an ornate castle. To perform this kind of lighting magic requires a team approach, and with the help of a good assistant (not to mention the 1,000-watt strobe), I can be shooting single-light pictures of the bride getting out of the limo while my assistant is setting up room lights in the church. But these bruisers shouldn't be limited to just illuminating backgrounds.

Using two portable flash units for taking candids is the obvious way to go, but once you settle into a location where you intend to shoot a number of photographs (think portraits), you might explore the advantages offered by AC-powered flash units. While there are disadvantages to carrying extra equipment and being tethered to a wall outlet, AC units offer more power, modeling lamps (to preview the strobe's effect), and

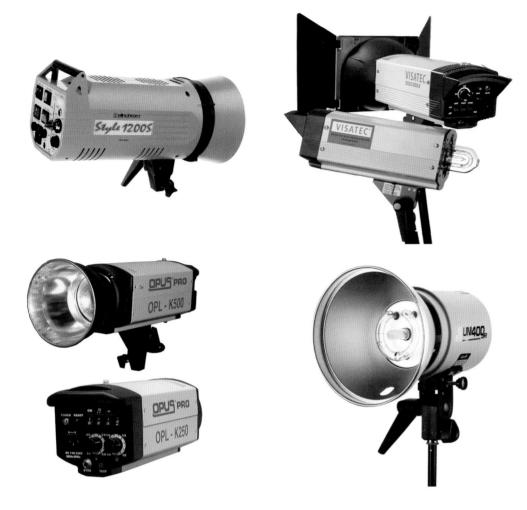

Monolights come in several different sizes and powers:
Elinchrom Style 1200S(1200 watt second). © Bogen Imaging Inc.
Hasselblad Visatec SOLO 800B (300 watt second). © Hasselblad USA Inc.
Opus Pro OPL-K500 (500 watt second) and OPL-K250 (250 watt second). © Nadel Enterprises Inc.
Dyna-Lite Uni400JRg (400 watt second). © Dyna-Lite Inc.

the luxury of never having to worry that the battery will be too spent to recycle the unit. No matter how much battery pack weight you're willing to lug about, a battery-powered strobe is easily outpowered by an AC flash unit. AC strobes offer faster recycle times, also. This power, along with the modeling lamps, allows the candidman the luxury of working with umbrellas or softboxes that offer superior light quality when compared with direct flash. While Lumedyne, a battery-powered flash, offers a special head with a modeling light, I have found that the modeling lamp draws so much of your battery power that the tradeoff in lost flashes

isn't worth the luxury of the modeling lamp. Because AC units use wall current, the modeling lamps are not a liability.

Without being brand-specific, I'll offer a few criteria to consider. The first should be small size and light weight. I have found that AC units used for portraiture or as room lights need at least 1,000-watt-seconds of output. Today's 1,000-watt-second strobes are small compared to the units of a few years ago, and while it's easy to throttle down a big pack, you can't increase the power of a small pack. A 1000 watt-second AC flash unit is a good compromise between portability and output.

An AC pack can be hung on a light stand with a loop of nylon rope secured by a square knot. This makes the light stand more stable and less likely to be knocked over.

Where you live and work might make a large difference in which brand of flash unit you buy because you'll want a brand of strobe that is sold and serviced by a local supplier. There once was a truism that shooters on the West Coast of the U.S. used Normans (made on the West Coast), Midwest shooters used Speedotrons (made in the middle of the U.S.), and East Coast photographers used Dyna-Lites (made on the East Coast). This was not because any of these flash units were necessarily superior, but because the photographers were closer to sales and service facilities, a very important factor. Today, with flash units being manufactured internationally (Comet, Broncolor, Elinchrom, Profoto, etc.), and the existence of national distributors who ship equipment everywhere, this old truism isn't as absolute as it once was, but my choice of flash system is still strongly influenced by what I can buy and have repaired locally. Today, with a choice of express delivery services, the world has shrunk considerably, but there is something to be said for whatever brand a local, reliable dealer displays, stocks, and repairs. The practice of dealing locally must be tempered by what you actually require, but many brands of strobe units can satisfy your needs.

The next thing on your want list is low power consumption, and with this there are a lot of considerations. Power consumption means how many amps the flash draws from the power supply when it recycles (with AC units, it's the wall outlet). Today's AC strobes designed for location work draw about 7 amps of power, and since most outlets have 20-amp circuit breakers, you might think all is well. In fact, it is and it isn't. If there is a video crew at the wedding, they also might place a load on the circuit you are plugged into. A 1,000-watt quartz video light uses 7.5 amps of power. If the video crew is using three lights (as many do), they require two 20-amp circuits to themselves. The band or orchestra is another amp-hungry beastie. Without going into their requirements (which vary wildly), let me point out that while many ballrooms have an entire 100-foot wall festooned with outlets, frequently all of them are on the same 20-amp circuit breaker! Between you, the videographer, and the musicians, 20 amps don't go very far! In a perfect world a still photographer would always find the power he or she needs. Too bad the world isn't perfect! Finally, consider that while an AC flash might only draw 7 amps, each 250-watt modeling lamp is going to add another 1.5 to 2 amps of draw to your requirements. Therefore, sometimes, by turning off the modeling lamps on room lights you can get your amp draw back down to an acceptable level.

In the world of AC strobe systems there is a battle raging between two camps: self-contained flash units and separate flash head and power pack designs. Both designs are worth considering. Self-contained strobes are smaller, and if you are using multiple units and one breaks, the rest of the system is still up and working. On the other hand, self-contained strobes are usually less powerful than their separate head and pack cousins.

The separate head and pack units have features all their own. In the first place, you can very often substitute a more powerful pack from the same system and use it with a head you already have. For example, some Dyna-Lite flash heads can work with 500, 1,000, or 2,000-watt-second packs. If you are using more than one AC strobe unit in your system, and you blow a head or a pack (and you will eventually), the remaining pieces are still useful while the blown piece is being repaired.

One reason that I use separate head and pack designs has to do with liability. Liability? Let me explain. When I use an AC flash unit as a room light, I put the flash head on a 10-foot stand, making it an easy target for someone to knock over. Self-contained units are usually heavier than equivalent separate-pack flash heads, making the light stand even more top-heavy and easier to topple. For added stability, I have tied a short rope loop on the handle of each of my 7-pound AC packs and use the loop to hang the pack from the base of the stand to help stabilize the entire thing. While I carry a substantial liability insurance policy as a safeguard, I prefer never to have to use it!

PACKING TIPS FOR AC STROBES

My normal complement of AC strobes includes three 1,000-watt-second packs and four flash heads. The whole system packs into three different-sized hard cases, which double as posing aids once I have the lights set up. My three-case system for my AC strobes nestles into the trunk of my car. The first case, which is medium sized, carries one pack and two heads. My second case, the largest, carries two packs and two heads. My third case, the smallest, is used for spare equipment. Each case has all the cables and connectors necessary to make the equipment in that case usable. This is called "stand-alone packing," which means that each case has all the bits and pieces needed

to make all the things in it work. It's worthless to drag in a case that's loaded with equipment but missing an integral part (such as a power cable) that is stored in another bag in the trunk of the car.

If you decide to travel the AC strobe route, include some grounded extension cords on your equipment list. You'll always find that the perfect position for your room light is two feet further from the wall outlet than the length of the power cable that comes with the strobe. I carry three 10-foot and three 25-foot extension cords in addition to the three 15-foot power cables that come with my three AC strobes because, hey . . . you never know.

In addition to the extension cords, my spare equipment case includes an extra modeling lamp or two, a set of grids (in case I want a spotlight effect or a hair light), some extra batteries for my light meters, a few extra soft-focus filters, a small roll of gaffer tape, and a larger roll of duct tape. (Duct tape is less expensive than gaffer tape but it's not as well-suited to every situation as gaffer tape because it melts under heat and its adhesive comes off on everything.) I use the duct tape to tape down any extension

There are all kinds, shapes, and sizes of packing cases. Some have wheels, and others don't, but the Porter Case can be converted into an equipment dolly too, which makes it special. © Porter Case

cords I'm using to lessen the chance of someone tripping on my cables. I have all this equipment available just in case it's needed. You might say my third case is the "just-in-case" case!

If you're going to have all this equipment available, you have to find a way to cart it all around easily. For me this means piling my cases on a very sturdy luggage cart and rolling it into the reception hall. I recommend carts with large wheels and a sturdy steel wire construction. While I don't always bring all five cases (the two additional ones are for my battery powered flashes and my cameras) in to every assignment, I always wheel in at least three.

Accessories

Sync Cords

Without a sync cord between your camera and flash, all your other preparations are worthless. Within every sync cord is a multi-stranded wire whose filaments are each almost as thin as a human hair. Consequently, sync cords are extremely fragile. They break just as surely as night follows day. To add insult to injury, if the wire doesn't break, the PC tip becomes deformed and can't make good contact. Over the years, the flash industry has been lambasted for settling on the PC tip as the standard. I personally consider the debate to be a waste of time. The fact is, the PC tip is the standard, whether it is a weak link or not. The real question pros must face is how to deal with the situation.

My solution is simply to carry a half-dozen spares on every assignment. Some may think that six extra cords is overkill, but frequently when a cord breaks, a photographer will replace it but never add a new spare to the case. Eventually, usually in the middle of a hot June wedding, a cord breaks, and the photographer finds that the cup-

board is bare . . . a very sad tale. I once got an emergency phone call from one of my associates asking me to please bring a sync cord to the church for him. Talk about not being prepared. Many photographers can't bring themselves to throw away bad cords, and instead they tie a knot in them (to signify it's no good) and put it back into their case. I think they secretly hope the knot-tying game will magically repair the bad cord. Eventually, the bottom of their case is filled with a rat's nest of knotted cords, and not a one is in working order. Forewarned is forearmed. So always carry spares, and throw out the bad ones!

Banks and Umbrellas

If you're set up to take portraits, one of the easiest things you can do to improve the look of a subject's skin tone is to increase the size of your light source by using a light modifier of some kind. This is most easily accomplished by using a bank light or umbrella accessory. Without such accessories, flash can produce large, hard-edged shadows on a subject's face, accentuating every imperfection. However, with a light modifier, the size of the light source is increased, producing smaller, soft-edged shadows and minimizing skin imperfections.

Umbrellas come in a variety of colors, each of which affects the tone of the light reflected on the subject. I have found that the soft white variety (I use Photek) creates a more pleasant skin tone than those with silver or gold reflective segments.

Although I have found that banks and umbrellas produce similar effects when used in large dark rooms, when used in smaller light-colored rooms, bank lights create a more directional, contrasty light quality than umbrellas. I have also found that umbrellas are quicker to set up and more compact to tote than banks.

Light Stands and Ways to Tote Them

Some might say that a stand is a stand is a stand, and to a certain extent they are right, but even when it comes to light stands, thinking of your equipment as a system has advantages. No matter what kind or how many light stands you carry with you (it depends on your lighting choices), make sure that all of them have the same diameter mounting stud. It is too frustrating to try to remember that one light stand requires a bushing to mount a specific light and another doesn't. You'll probably misplace the darn bushing anyway, and then you'll be sticking stuff together with gaffer tape, which only works in a pinch. The mounting studs on all my light stands are 5/8-inch diameter, and all my flash equipment fits this size mount. Just make sure all your lighting equipment works with all your stands and you'll be okay.

I carry four 10-foot Bogen stands, one 7-foot RedWing (no longer made), a tiny PIC stand (for a back light), and four soft white Photek umbrellas. All of this fits into a soft Tenba light stand case that is slung over one of our shoulders when we walk into the catering hall. When I work "light" (with only two battery-powered lights), I pull the RedWing pole out of the case and leave the rest of the system in my car's trunk.

Backgrounds

By carrying a background along, I can shoot formal portraits on location by setting up a small studio wherever I am. It's great not to worry about ratty wood paneling in a VFW hall and to not shudder when you see the painted cinder block walls of a basement meeting room! So into the trunk of my car I tuck a 10 x 20-foot muslin background. It is stuffed into a second Tenba pole bag, which contains another, smaller bag that has all the clips needed to set it up along with the two

stands and two-piece PhotoTek crossbar used to support the muslin. Remember, as mentioned earlier . . . Stand-Alone Packing.

How the background is stuffed into the bag deserves a brief comment. Many novice photographers who buy a background notice that it always comes to them neatly folded. They dutifully continue to fold it up every time they pack it away. After a while the creases in the background show up as a checkerboard pattern in their pictures. A better alternative is to stuff the muslin into its case willy-nilly. This way, you end up with a random pattern that, when thrown out of focus, doesn't distract from the subject.

Posing Drapes

One accessory that rides in every equipment case of mine is a posing drape—a piece of nice material that can be used for a variety of things. I carry black ones that are about 45 inches square, but gray, white, and other colors can also be used (I even carry a white one in my just-in-case case). The cut ends are folded under and sewn with a simple line of stitching. The stitching keeps the material from fraying and makes the drape look neater and more professional.

What do I use a posing drape for? Here are just a few suggestions: My black drape can be used as a quickie background for a head shot. I either tape it or safety-pin it to a wall or curtain but, in a pinch, I've even had an assistant or casual bystander hold it behind the subject. Often I use a hard camera case as a posing prop, and I can hide it by throwing a drape over it. My black drapes can also do double duty as a scrim (or flag) to block light from hitting some part of the subject or background that I want to stay in shadow. Finally, I've even rolled one up and used it for a pillow when I needed a nap!

Tool Kit and Emergency Kit

Two things that might save your day are tool and emergency kits. What you include in

yours is very personal and should be tailored to meet your needs and equipment system. My tool kit includes the normal complement of pliers, jeweler's and regular screwdrivers, a Leatherman Wave tool, and a Swiss Army knife, but along with those staples I've added three Allen wrenches that fit my light stand locking screws, the hinge screws on my stepladder, and the Allen-type locking screw on my Dyna-Lite variator knobs. My kit also includes an open-ended metric wrench that fits the leg bolts on my Gitzo tripod yoke. But these tools fit my system and your tools should fit yours.

My emergency kit includes adhesive bandages (the flexible fabric kind the doctor gives you), acetaminophen, antihistamine (sometimes pollinating roses give me sneezing fits!), safety pins, bobby pins, pearl-topped hat pins (for CAREFULLY pinning down a train on a windy day), and rubber bands all stored in a plastic 35mm slide box that I've covered with gaffer tape. While these small things seem insignificant, if the groom pops a suspender button and his pants keep falling down and looking schlumpy, my safety pins can save the day! Once again, the stuff I include (although it is chosen with the eyes of experience) should only be a jumping-off point for your kit. You might not need the antihistamine, and you may want to double up on the headache medicine!

Ladder

I've saved this for last because it is one of my most important accessories. In the trunk of my car, beneath all my cases, is a 30-inch stepladder. The more photographs I take, the more I use my stepladder. If I want a high view to shoot over the crowd, my stepladder is ready to lend a boost. If I need a place to seat a subject to make a more

A ladder is one of the most important tools you can own. You can use the steps as seats for posing people and then stand on it when shooting to see over the crowd. My choice, made by Wing Enterprises, is more like a portable staircase that a stepladder.

interesting pose, I use my ladder. If I need to get an equipment case off the ground for easy access, my stepladder is with me. In fact, once all my equipment is tucked away in the catering hall or church, the equipment that stays with my assistant and me includes the camera, our two lights, my camera case, and the ladder. My ladder is one of my best friends on a job.

My ladder of choice is the Little Jumbo made by Wing Enterprises. More like a portable staircase than a ladder, the Little Jumbo is very sturdy and heavy and, for me, it is the way to go. I use all three of its steps for posing people, and it can change a line-up into a grouping in the blink of an eye. One modification I've made to my Little Jumbo has to do with the spacer plate that is riveted between the legs on the non-step side. I've found the rivets loosen over time, and the thing becomes rickety. To combat this, a local welding shop welded my spacer plate in place for $20, which was worth the expense.

While I shoot weddings with multiple photographers and several hundreds of guests on the New York City hotel circuit, you may be shooting smaller weddings in a less demanding and less competitive market where less equipment is needed. That's fine, but I get a warm relaxed feeling from knowing I'm prepared for anything that wedding assignment from hell is going to throw my way.

RELATING AND SELLING

I'm at a posh wedding photographing a big circle dance. As the bride and groom swirl past my camera, the battery pack for my flash unit dies. I call my assistant over and plug my sync cord into his pole-mounted light. I grasp the light pole and my bracket in my left hand, throw his battery pack onto my shoulder, and continue to soldier on shooting with this unwieldy setup. The dance set ends, and the crowd begins to reseat itself, while the second photographer, who has been shooting from the balcony, makes his way over to me. I'm standing there, a battery pack on each shoulder, straining to hold my camera, bracket, light pole, and flash head all in one hand. With my eyes popping out of my head, I say, "Did you see what happened to me during the dance?!" He says, "Yeah, you looked busy . . . Let's go shoot the tables."

I consider this chapter to be the most important in this book! When I first started to outline this work, I discussed a few of my ideas with one of my mentors. When I got to the chapter about relating, he told me that if I could teach the reader this skill, I would be doing a great service—both to bridal couples and to photographers. While many will argue that it is the final picture or album that really counts, I have found that, in wedding photography, making your subject feel comfortable is just as important in creating the final photograph as your lighting technique or camera equipment. We candidmen are working with stressed-out subjects who may have unrealistic expectations of perfection, which only add to their stress. In this situation, it is as important to be nice as it is to be creative. Your compassion can actually improve the demeanors and appearances of your subjects. And from a business perspective, as many job recommendations (if not more) are generated by a photographer's pleasant personality as are generated by good wedding pictures.

Relating

If you think about the complexities involved in taking wedding photos, there are some simple truths worth noting. Everyone involved strives to look her or his absolute best. On their wedding day, brides (and to a lesser extent, grooms) make a tremendous investment in this effort. Professional hair arrangements and makeup applications are the rule rather than the exception. Much thought is put into the choice of wedding dress as well as the formal attire for the groom, and an almost equal amount of effort is put into the attire of the bridal party and members of the immediate family. Every aspect of the day, from invitations to the dessert table, is planned and re-planned with an eye toward perfection. Because your clients are doing all they can to make everything look flawless, delivering good photos of your 'perfect' subjects becomes an easier proposition.

If perfect subjects make it easy to create beautiful pictures, what about the interpersonal, relationship side of the equation? Without rewriting the Dale Carnegie book, *How to Win Friends and Influence People* (although it is valuable reading for all who want to shoot any kind of people pictures), there are some things I've noticed that can enhance your interpersonal skills and make or break your relationships with clients. Knowing which of your actions to cultivate and which to avoid can lead to success as a candidman or studio owner.

Six Secrets of Relating Well to Your Customers

Here are some concrete things you can do to make yourself a pleasure to work with. Remember, if every wedding you shoot generates three recommendations, you will soon be a very busy photographer! So these ideas are well worth the effort.

1. DEVELOP A POSITIVE ATTITUDE

Practicing the Golden Rule is one thing that helps you become a great people-person. There is a reason that "Do unto others as you would have them do unto you" is a cornerstone of the Judeo-Christian philosophy! If you can apply this prin-

What mother of the bride could pass up this picture of the bride's teenage brother trying to be so cool and nonchalant that he is eating a peanut butter sandwich while holding her train? Shots like this are not only guaranteed to find a place in the mother's album, but they will also be treasured in years to come and may even land you the job when baby brother finally ties the knot. ©Mark Romine

ciple to your business, you'll be on the right track. Always try to put yourself in your subject's shoes.

I can't understand why some photographers feel it is necessary to point out physical "flaws" in their subjects (after all, they are the customers!). How a photographer can look a fragile bride in the eye and say, "What are you going to do with that pimple on your nose?" is totally beyond me. Likewise, I don't see any point in telling a bride how tired I am, that I have a headache, that she's late, or that her dress is soiled. I think photographers who get some perverse pleasure in saying these types of things are overly concerned about their own insecurities and want to drag other people into their pit of misery.

It would be better for those photographers (and their businesses) if they could climb out of their dark pit and up to the sunny hilltop. In this business, a negative attitude is totally counterproductive. Without being saccharine, you can make it part of your style to always see the bright side and be positive. Of course, underlying this is the assumption that you like people. And if you don't like people, you should question your career choice!

Positive energy is contagious. For example, I once shot a wedding the day of a huge snowstorm where 150 (of the 200) guests, along with the band and photographer (me), marched through hell to get there. I made sure to get a few pictures of the couple in the snow, pointing out that the snow made their wedding unique—in twenty years it would be a great memory. I also pointed out that the 150 guests who made it had to love them dearly to come, and that they were lucky to be surrounded by such supportive friends and family. It was a great party and the band played "Let It Snow! Let It Snow! Let It Snow!" more than once that afternoon.

Every situation has both negative and positive components. At almost every wedding something will happen that can be looked at in two ways, be it a summer squall or an inebriated guest! Don't ever let a minor quirk of nature or human behavior

get you or your subjects down. Instead of saying, "Oh *#@%*!, this ruins everything," it is better to say, "Boy, this will be very funny . . . next week. But right now let's make beautiful pictures!" You are acknowledging that whatever happened is a drag, but you are also pointing out that the joy of the day overshadows the snafu.

You can even generate enough positive energy to navigate around a tragedy and finish the job. At one wedding I was shooting, the bride's grandfather dropped dead . . . face down . . . right into his soup! I know many photographers who would have stopped shooting, and that would have been the end of the wedding. Instead, soon after the paramedics left with the gurney, I walked right up to the bride, looked her in the eye and said, "Your grandfather wouldn't want to ruin your wedding day. Go into the bridal room, fix your makeup, and let's keep going." Mind you, I didn't say, "Let's Parteee," but rather my comment pointed out that, 1) life goes on; and 2) her grandfather loved her. The bride stared at me for a second and then got up to go fix her make-

up! Believe me, I felt like I was walking on thin ice, but I had good rapport with the bride, and I didn't want to let anything totally ruin the day. Sometimes we have to walk a fine line, but if you have sincere compassion for your subjects (I mean, you really care about them), you can get over almost any bump in the road.

Make it your goal to accentuate the positive and eliminate the negative, not only in wedding photography, but in everything you do! While this might sound simplistic, it does work and you can apply an optimistic outlook to almost all aspects of life. Winners (in both life and wedding photography) see the roses, not the thorns. This doesn't mean you are oblivious to the thorns, but you are more interested in the roses.

2. GAIN CONTROL

During my early days as a wedding shooter, the first wedding photographer I assisted told me repeatedly that great wedding photography was a matter of control. I would say, "Yeah, yeah. I understand . . . " but I really didn't. Later, when I moved into commercial photography (though I continued to shoot weddings), I learned that most advertising pictures are rigidly controlled. A photographer in the studio, sweating over a still life, must examine everything in the frame. Even if something in the frame is not central to the composition, the photographer must examine it and make a conscious decision about whether it does or doesn't matter.

Almost anything little kids do is cute, but sometimes getting them to smile on command can be difficult. Many times when kids are making faces, I offer to trade them one funny face for one smile. Sometimes the funny face is the better picture! © Jerry Meyer Studio

This extreme type of control is not always possible at a wedding. Most novices, when first trying to exercise control over their subjects, can be rather heavy-handed. They raise their hand and demand that the world stop for them. If you can get past that rigidity, you realize that while you might think you want total control, what you're really after is a controlled situation in which the subjects are free to express themselves.

Let me draw an analogy. Imagine a bird, softly enclosed in a hand. At the right moment the hand relaxes its grip, and the bird is free to fly. But the softly enclosed hand was so comfortable that, after the bird does its soaring, it chooses to return to the hand. In the same manner, you want to gain control of your subjects in a way that is comfortable to them. You want to release your control, allowing their natural expressions to be recorded, and then regain control of the situation once again. While all this sounds very Zen-like (and it is), it does make for successful pictures and happy subjects.

3. Know the Important Players

Before every wedding I make it a point to find out from the bride and groom or their parents who the important players are. I like to know how many siblings the bride and groom have. I also ask about grandparents, godparents, and important aunts, uncles, and cousins. In fact, I want to know about anyone who is important to the couple or their parents–a best friend, a boss, or even people from the office. Once I have the information, I make it a point to act upon it. If "Mom" mentions that she has a favorite brother, I'll go up to her sometime during the party and say, "Is now a good time to get a picture of you with your brother?"

Mom beams; after all, I listened and remembered (!), and chances are good that when her next child gets married she'll remember me!

4. Remember Names

One thing you can do to make your customers feel at ease is to remember their names! If you say to the bride, "Bride, take a step to your left," she is not going to feel special! I make it a point of remembering peoples names, an act that I consider a sign of respect. If the parents (whom I always initially call Mom or Dad or Mrs. Smith or Mr. Smith) tell me to call them by their first names, I always say thank you because they have let me move "inside" to a more intimate relationship. In fact, whenever I do a portrait of someone (or a couple) the first thing I say is, "What is your name?" From that moment on, any direction I give to them is always personalized: "Mary, snuggle into John." I even try to remember names of siblings and the bridal party members.

5. Attend to the Trouble Spots

Sometimes there is one member of the bridal party who is a troublemaker (and it is almost always a guy). This person is never interested in being photographed or doing what the bride and groom want. Usually his goal is to get to the bar at the reception as quickly as possible. If left unchallenged, he tries to become a ringleader intent on reducing the day to a drunken, bleary-eyed non-memory. Controlling him (or her) is difficult, but it is easier if you know his name. I make it a point to direct some of my comments to him while I'm shooting pictures that he's in. Very often I'll say, "Let's do a picture of all the ushers. I promise to make it quick, Louie!" Although I want to isolate him from the crowd, I don't want to antagonize him, so everything I say is done with a smile, and I never attack him personally. As a last resort, if Louie is a problem child whom I just can't control, no matter how hard I try, I do the pictures that include him first and then let him go drink his beer in the limo while I finish the portraits.

Often before starting the formal pictures, I'll call a bridal party huddle so that everyone knows my plan. I actually say, "Let's have a quick meeting." Once I have everyone's attention, I lay out a game plan. I say things like, "The sun is going down so we have to work quickly," or "I want to get these pictures done quickly so we can get to the reception," or "I want to do these pictures now so that when we get to the reception I won't have to bother you." Notice that I mention that I will work quickly, we will all get to the reception soon, and I won't bother them after this. My game plan always includes (1) the reason why I'm subjecting them to this and (2) the resultant reward (in this case, a no-hassles reception). Usually most bridal parties understand that by helping to meet my goal they will meet theirs, and they get their acts together pretty quickly.

6. AVOID SAYING "NO"

It would be ideal if the word "no" was eliminated from wedding photographers' vocabularies on the day of the wedding. On that day, "no" is the last word any bride wants to hear. Given budgetary constraints and supplier limitations, she's probably heard "no" enough during the planning stages: "No, we can't make a German nut cake for your wedding cake," or "No, we can't serve the lobster tail entree and stay within your budget," or "No, we can't get yellow roses in February." No is a powerful word, and it puts an end to almost any further communication from the moment it is uttered.

Even if the couple (or a parent) asks you to do something impossible at an inopportune moment, you still shouldn't use that word! You might say, "That's a great idea, I'll fit it in later," or "Absolutely, I'll remember to get that," or just say anything else that will keep the lines of communication open. Even though your clients have hired you for your expertise, they are still the ones paying

the bill, and almost any request of theirs deserves to be honored. Besides, if a bridal couple makes a specific request, it is almost always destined to become a sale (they want it!), and selling is the real bottom line in the wedding photography biz. Even if you think an idea is ridiculous, the cost of time and material to try it once is well worth the goodwill it creates.

Selling

Selling is another place where your interpersonal skills are put to the test. Selling the job is really a two-pronged effort. First you have to sell your potential customer on the work you do so they will agree to utilize your services and make an initial order; and then when the proofs are returned you have to sell your customer on purchasing extra pictures. Since the second sale will never happen if you're not successful at the first, let's start with landing the job. (This doesn't mean that the second sell is unimportant, because without it the wedding business, seasonal as it is, is not very profitable.)

The First Sale: Selling the Job

Success at the selling game is not easy, but there are some rules that can help you. If you have a natural "gift for gab" (which is almost a requirement for being a successful wedding photographer) the battle is almost won, but here are some other ideas to improve your percentages. Obviously, you should be dressed neatly and have clean, well-organized samples to show, but also consider the following.

SIT AT THE KITCHEN TABLE

When you visit a prospective customer, try to describe your services and display your work at the kitchen table. Although this may seem like an odd suggestion, I have found that most important family decisions are made at the kitchen table. While the living

By getting to know your clients and listening to their comments before the wedding, you can be sure to get pictures that are important to them. Maybe you pick up on the special relationship within the family between the groom and his only niece, for example. © The Photographer's Gallery

room is reserved for more formal meetings, people let their hair down in the kitchen, and it is easier for the customer to treat you as a friend (instead of an adversary) there. The table allows you to sit opposite the customer and look them straight in the eye as you make your pitch. However, you must be careful, because with you sitting on one side of the table and the customer's family on the opposite side, the table becomes a barrier between you. I circumvent this by always bringing two sample books with me, and while one side of the table looks at one book, I invite a family member to my side so we can view the second book together. My invitation is usually made to the mother because I try not to break up the bride and groom and, quite frankly, I've found that most fathers are more interested in the bottom line (how much?) than the quality of my work. Besides, if mom likes you and your work, she will often cajole dad into spending a little more than he planned.

LISTEN CAREFULLY

Many times in the course of a sales meeting the customer will tell you what they are looking for. They say things like, "I don't want a pushy photographer," or "Family pictures mean everything to me," or "I don't want to miss the cocktail hour." Remember those words, and sometime later in your pitch throw them back to the customer. As you describe what will happen at what time on the wedding day, you might say, "I would like the immediate family to come to the park with us for the family pictures so I don't have to act like a pushy photographer at the reception," or "Tell me who is in the immediate family so I'm sure not to miss anyone," or "Let's plan on doing the family pictures after the main course so we won't have to spend valuable time doing them during the cocktail hour." Although this might seem insincere, in reality it is not. It simply acknowledges that you are listening to them and are willing to meet their needs. All wedding coverage should be tailored to the customer, and you're just saying, "If you want it, it's yours!"

TAKE NOTES

When my potential customers outline what they want, I make a mini-big deal about writing it down. I want them to see me doing it, and I question them about what I've written down so they can make sure I've got it right. I tell them that I'm going to attach the information sheet to their contract so I'll be sure I won't forget. This has a few added benefits. My information sheet assures the customers that I'm catering to their individuality and that I care about their desires. A second benefit is that by saying I'll keep it with their contract (notice it's their contract, not mine), I've broached the subject that there will be a contract. Once they start giving me specific information, we are both beginning to work on the assumption that I am their photographer, and this assumption will make closing the deal easier.

DON'T BELABOR THE TECHNICAL SIDE

When showing your samples, don't dwell on how you got the shots. Other than another photographer (or an avid amateur), no one is really interested in what f/stop you used to take a picture. Forget about most of the techno jargon that you could throw at your customer because most of it goes over their heads and, besides, it gets very boring very quickly! Instead, ask about the day, the gown, the flowers, the church, the park, the reception (anything they can relate to) and only mention technical considerations in passing.

If you've done one of their friends' weddings (and that's how you might have gotten the lead anyway), talk about that instead. Find out what they liked and didn't like about it, and be sure to write it down (in front of your prospective customer) on the information sheet you've been working up. Let your pictures, not your mouth, prove your professionalism.

ASK FOR THE ORDER

It is amazing to me how many photographers never tell their prospective customers that they want the job! You have to ask them to give you the assignment. People hardly ever say, "I'm sold!" So, at some time near the end of your pitch you have to say, "Look, you seem happy with me and my work. I did Sally's wedding. Can we wrap this up now? I would love to be your photographer!" Now comes the tricky part. They'll probably say that they have to check with other photographers, or maybe even say "no." Do not get discouraged. Many great salespeople will tell you that the real sell doesn't start until your prospective customer says "no."

OFFER INCENTIVES

Sometimes after the customer says "no," you can snatch victory from the jaws of defeat by offering an incentive. Look your customer right in the eye and say, "I really want to shoot your wedding. If you're happy with my work, what would it take to close the deal right now?" Sometimes, lo and behold, the customer will say, "Well, XYZ Studios offered us two extra 8 x 10-inch portraits and 100 photo thank-you cards in their package, and because we're on a tight budget, that may become important to our decision." If you know what it takes to get the job, then you can decide if the incentive is worth offering. If this prospective customer is talking about three albums and a video (which have a high profit margin), two 8 x 10s and 100 thank yous are a cheap price to pay for their signed contract. If they're considering a minimal package (without much profit), you might say you're willing to split the difference and offer the 8 x 10s but not the thank-you cards. That might work anyway because some customers aren't always truthful about how much they are offered by your competition.

Whatever happens, be aware that the last photographer a prospective customer sees is usually the one he or she signs with, so you want to do everything in your power to close the deal when you are there. There are other incentives worth offering, such as giving all the proofs in a slip album or allowing the first hour of overtime at no charge. Just be aware that if you give away too much, your generosity may come back to haunt you. Other recommendations that come from this job might ask for the same deal that you gave them, and you must remember that doing wedding photography is a business, not a charity.

GET A DEPOSIT

No matter what you think, until you have a deposit in hand to reserve the date, you haven't completed the sale. You can be absolutely sure the customer is yours, but without a deposit, it just ain't so. Some customers will tell you that their word is their bond, and no deposit is necessary once you have their handshake on the deal. Forget it!! Even a first-year law student will tell you that without an exchange of something of value, your contract, even though it is signed by the customer, is nothing but a piece of paper. If the customer decides to renege on their commitment to you (and hire another photographer–one who probably got a deposit!), it won't be worth the time, the energy, or the expense of taking them to court to force them to pay for the job they agreed to. Besides, you'll lose anyway. The judge will look at you sympathetically (because he'll know you are a naive businessperson), point out that you never produced a single wedding picture for these people, and throw it out of court.

In accepting a job, you are giving the customer a guarantee that you won't accept another job on the day of their wedding. The customer is giving you a guarantee (in the form of the signed contract . . . AND A DEPOSIT) that they have chosen you to be their photographer. Many photographers just starting out are afraid to ask for money. They must get over it. Some think money is crass and evil, and they trust the word of their fellow man. I also trust the word of my fellow man, but business is business. Get a deposit! No exceptions! Well, maybe, if the client is your mom . . . but . . . come to think of it . . . even then . . . GET A DEPOSIT!

If the bride's parents are hiring you, they are most likely paying for precious memories. Parents are usually an easier sell than brides themselves, who as clients are often budget-concious and strictly looking for the "best deal." © Frank Rosenstein

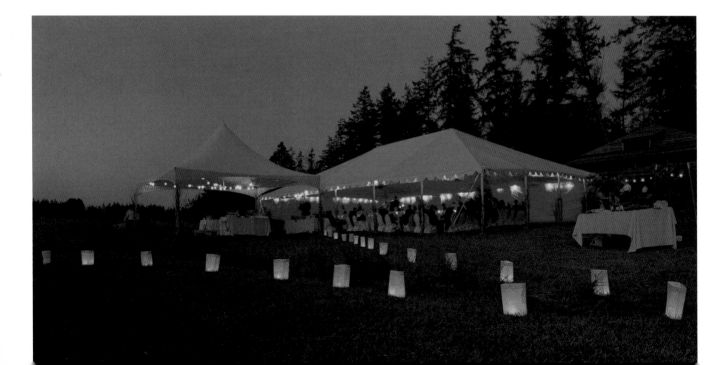

Who Is Buying the Pictures?

Generally, at any wedding there are two possibilities as to who will be paying your bill. Either one of the sets of parents could be laying out the money, or the newlywed couple might be buying their photographs. While it doesn't really matter who is paying the tab, there is a difference about how each of the prospective customers sees the result. Let's look at each one separately. Parents first.

For a moment, let's look at the bride through her parents' eyes. Put yourself in the father or mother's place. Here is your child getting married. She is dressed and quaffed to the nines, and you love her. Parents don't really see the bride (or groom) in the harsh light of reality. Instead they see their toddler's first steps, school graduations, happy family dinners and holidays, sports team victories, and a raft of other fond memories. They also see the beginning of the end of responsibilities, a feeling of freedom on the horizon, and a continuation of their bloodline. These are easy people to please! In fact, other than your bill, you are giving these people nothing less than the best memories of their lives. Now, step back into your shoes as the photographer. If you present pictures that are sharp and centered, chances are good that the parents are going to love them; after all they already love the subject. These people are an easy sell.

Now for the couple. Brides (for the most part, the groom just goes along for the ride) can be a much more difficult sell. Often it is the first chance for a bride to show that she is a smart shopper. This may cause her to go overboard in looking for the photographer who can give her the most value. Another point to consider is that her pockets may not be as deep as her parents', and any suggestions you can make to ease the financial burden will be appreciated.

You might suggest that she ask her parents to pay for their own albums, or offer to start her out with a minimum package so that she sees you're interested in saving her money.

If she is young and inexperienced and if you come across as someone she can trust, she may be willing to follow your lead. Mentioning that you are creating an heirloom that will have great value in future years sometimes helps, but often it isn't enough. What does work, in my experience, is the idea that you are producing a very personal thing for her and that you are working as a team. As I pointed out earlier, your information sheet can be the dealmaker. The bride has to feel that you are extremely interested in her unique needs and that you will work tirelessly towards that goal.

Finally, never overlook the fact that you've done weddings for her friends (if you have). Peer pressure can be used to your advantage. Overall, I feel that brides are more difficult to sell to than the parents, but it is still possible!

The Second Sell: Building Your Order

Unlike the first sell, the proof return has a different set of sales goals. During the first sales opportunity, where you initially sold your services, you may have offered incentives to secure the job. However, at this point when the proofs are returned, your object is to maximize your profit. An analogy might be a builder who throws in the kitchen sink to get a signed contract but then charges the customer for the plumbing and hardware required to make the sink functional.

Building up an order is as much an art as getting the assignment in the first place. Realize that your customers have already paid for the caterer, flowers, band, clothing, limousines, and invitations, so the cupboard might seem bare to them. On the

other hand, you should have pictures of everything they spent their money on, because most people like to see where their dollars went.

The proof return is the time for you to enjoy the fruits of your labors. I usually let the customers show me their choices of what to include in the album before I make any suggestions. Once they've shown me, I arrange their selections in a loose, chronological order and then start to look for holes. It's amazing but true that very often couples leave out entire sections of their wedding day. These are some of the easiest sales to make. For instance, the bride might select a picture of her Dad walking her down the aisle and then her next choice is a picture of the newlyweds getting into the limousine. All we have to do is look at the two images and usually we both just laugh out loud. Sliding in a few photos of the ceremony is an easy sell!

On my next go-through I pick out all the single images for which I shot a matching second image. Sometimes the bride forgets to include a picture of the groom's parents alongside the picture of her parents. I point out the political implications of this folly and, "Ker-ching!" . . . the cash register rings! Look back through the repertoire chapter for other similar sets, such as the bride dancing with her father as a match for the groom dancing with his mom, or the selective focus shots of the bride and her parents mated with the same shot of the groom with his parents. Any album order can be built up nicely.

Finally, check to see if she has included a photo of one sibling and not another. It is an easy step to have most couples include photos of the other siblings once they've included one. Review my repertoire and note every place I claimed something was a sure-seller. If the bridal couple hasn't included most of them, you should suggest they be included in the album.

After you've done this, take a last spin through the unselected proofs and pull out any images that you feel look great and ask the couple if they might be interested in those. You might point out that while the food has been eaten, the band has gone home, and the flowers are wilted, your pictures remain as the only permanent memory of the great day, and your product is the only one they are purchasing that will become more valuable as the years pass.

While you are at it, remember to suggest a picture of the bridal party for each bridal party member. If the proof return happens at an opportune time of the year, the idea of pictures as Christmas gifts for family members is another idea worth mentioning. Some photographers also offer framing services for the gift prints, and that is another way to maximize profits.

As in the entire wedding game, presentation is important. Because big prints are very profitable, some studios work with an overhead projector and project huge images into blank frames so the customer can get an idea of how the photograph will look on the wall at home. Obviously, if you go this route, framing can be a very lucrative sideline worth investigating.

GET ANOTHER DEPOSIT!

The last part of the proof return requires you to total the remaining bill and get at least half of it as a deposit. You should not start to produce the wedding albums without this final deposit. Some couples will rush to give you the print order and then disappear for a year as the finished albums languish on your shelf. The whole idea of getting deposits as the job progresses is this: All production costs should be paid with the customer's money. You are their photographer, not their banker.

Find a Partner for Sales

Selling is so important that it can make or break a wedding studio's success. Oddly enough, many excellent photographers are terrible salespeople. Whether it's because their egos are easily bruised when a customer doesn't fall in love with their work or they are just more comfortable with the technical side, the reason is really not important. What is important is that they realize that selling is not their (or perhaps your) strong point. Some of the most successful studios in my area comprise a partnership: one individual is an excellent salesperson and the other is the photographer.

If you find that selling is not your cup of tea, you can still be a studio owner. Photographers who are not great salespeople can actively look for an exceptional salesperson to handle that side of the business for them. If you find that person, consider forming a working relationship with him or her. Many novice photographers first build a wedding studio business to 100 weddings per year (about $200,000 to $500,000 gross) and find a salesperson at that point. That then allows the business to grow to more than 300 weddings a year (up to about $1,500,000 gross).

Find Work and Generate Leads

Without an ongoing source of new clients, your budding wedding photography business will wither and die. On the flip side, a growing wedding photography business is usually operated by a photographer who is always on the lookout for new customers.

BUILD A PORTFOLIO

Getting your very first assignment will be the most difficult because you have limited samples to show, and without samples it is hard to demonstrate to a stranger the quality of your work. Therefore, for most young photographers, the first few assignments will probably come from family and friends. On these assignments it is imperative to do your best because these photos will become the basis of the samples you need to establish and expand your business.

Remember also that every bridal party is brimming with potential customers. When I suggested in the repertoire that you include pictures of unmarried couples in the bridal party, I had an ulterior motive. These people can become future assignments. If you do a good, conscientious job, each wedding can produce more leads for future business. Growth by word of mouth is a very slow process. While these assignments and the leads they generate can slowly build your reputation and your client base, there are additional things you can do to help accelerate the growth of your business. There are also other good ways to generate new work.

BECOME ACTIVE IN THE COMMUNITY

In all likelihood your local clergy are the first people in the community to know about upcoming weddings. Although you can't turn them into your sales force, you can meet with them and introduce yourself. You might be willing to offer your photo-

Caterers and other wedding suppliers can always use good photographs of their work. When you see excellent examples of such things as food presentations, hall set-ups, floral arrangements, hair styling, and the like, take a couple of photos of them. The caterer or florist will appreciate our thoughtfulness and keep a sample of your work, which could result in referrals later on.
© *Freed Photography*

graphic services (gratis . . . of course) for a local church function. You might participate in community bazaars or even donate your services (providing a family portrait, for example) as a prize in a raffle.

MAKE FRIENDS WITH CATERERS

Caterers are the big fish in the wedding business pond. All the other suppliers, including photographers, are the pilot fish that swim around these behemoths. They are always in need of photographs that show off their talents. Not only do they need pictures of their food presentations, but they also need pictures of their facilities to show prospective clients. Some upscale caterers create beautiful individual dishes (or ice and fruit carvings) that are worth a picture. So while at a reception, shoot some pictures; then make some prints, dress neatly, bring your business cards, and pay a visit to the caterer. It pays to remember that there are many ways to form symbiotic relationships within the industry that can help insure success for all concerned.

MAKE FRIENDS WITH OTHER WEDDING SUPPLIERS

Florists, dressmakers, bands, makeup artists, hair stylists, and classic car limousine companies also need pictures to advertise and develop their own businesses. And, coincidentally, pictures are what you do! Therefore, providing these people with free samples of your work, which shows off their work, is always a good idea. Very often these businesses don't have sample pictures of some of their best work. If you make a point of seeking them out and giving them an 8 x 10 that shows off their artistry, you've made a friend—a friend who can recommend other customers to you. Without being heavy-handed, explain that you are also looking for wedding customers and that you would be appreciate any leads. Offer to

I make a point of shooting a picture of makeup artists and hair stylists if they come onto the "set" for a quick touch-up. Make sure to give them a copy of the touch-up picture and an image that shows off their finished work. Make an effort to build good relationships with caterers, makeup artists, hair stylists, and florists. By helping them with examples of their work, they'll be more likely to help you with referrals. It's a symbiotic relationship.

shoot pictures for them from time to time, and ask if they could pass around your business cards when appropriate.

As I said earlier, success in the wedding photography business requires relating and selling skills that are at least equal to your photographic skills. Some think (and I tend to agree) that relating and selling skills are more important than photographic technique. Most photographers like to take pictures and shy away from the relating and selling side of the business. This is too bad, because it's the relating and selling that can guarantee your success!

PRICING AND PACKAGES

As a salesman I was green. I promised my customers everything. The bride's father looked at my lacquer-sprayed prints in their leather binding and asked if these pictures were as well protected as his long-ago wedding pictures that were in plastic-covered pages in a plastic binding. I said, "My photographs are absolutely waterproof!" The father looked at me, picked up my sample book, placed it in the sink, and turned on the faucet!

Only in New York.

From that day on I always told prospective customers that due to the protective lacquer spray I used, my pictures wouldn't be damaged by a few drops of water . . . but they weren't meant for viewing underwater!

The goal of any business is to make a profit, which is the difference between the price charged for a product and all the expenses involved in producing it. Wedding photography is not just an enjoyable pastime, but a business endeavor that must generate a profit. With that profit you can eat, pay rent, buy a car (or a house), or pay for a child's college education. Some newbies at the game think their expenses are limited to the cost of film and processing, memory cards, making prints, and binding albums. These photographers are doomed to failure . . . or at least to a life of eating gruel. Since gruel is not too tasty, it pays to take the time needed to define your expenses in order to maximize your profit.

Time Is Money

Before I get into the absolute costs of producing photographs for weddings, it is important to realize that one of the items you are selling is your time. And because time is finite, it is expensive. How much should you charge for your time? That depends on how much do you want to make? Everyone always answers, "A LOT of money!" Obviously. But for a more concrete answer, you first must figure out some other things. How many hours can you work at wedding photography in a week? How many in a year? Before you answer, consider these facts:

1. Booking, shooting, selling, and producing a set of wedding photographs takes 3 to 4 times longer than the six hours you spend shooting during the typical wedding day.
2. About the same amount of this "non-shooting" time is required whether you spend two hours or six hours shooting an assignment.
3. You can't shoot wedding photographs 40 hours per week, 50 weeks a year.

Let's look at each statement individually.

Time Frame to Complete an Average Assignment

Here are the tasks involved in delivering (i.e., booking, shooting, selling, and producing) a set of wedding photographs and approximately how much time each task takes:

Book the job (selling)	3 hours
Preparation on the shoot day	1 hour
Travel to the shoot	1 hour
Set-up time	0.5 hour
Shooting time	6 hours
Breakdown time	0.5 hour
Travel from the shoot	1 hour
Deliver images to lab and pick up	1 hour
Sort proofs (cull rejects)	1 hour
Review proofs with customer (selling)	3 hours
Pull negatives	1 hour
Deliver negs to lab and pick up	1 hour
Check prints	1 hour
Deliver prints to bindery and pick up	1 hour
Deliver albums and prints to customer	2 hours
Estimated Total Time	24 hours

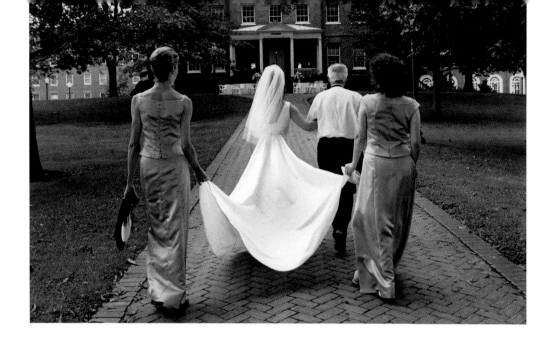

Your time is valuable! And I'm not just talking about the time you are actually shooting the wedding and reception. You have to price your services in such a way that you make a profit even for the time when you are not on location. Remember, it also takes time to sell, prepare, travel, set-up, review proofs, deal with binderies, and keep yourself up to date on techniques and advancements in the profession.
© Freed Photography

When shooting digital, you can eliminate some of the time dealing with film, but you must replace with time spent processing and editing the files you have recorded.

As you can see from this estimate, the time needed to produce the entire assignment is quadruple the time it takes to shoot the pictures. I have heard some photographers claim that they can book an assignment in 15 minutes (sometimes that's true) or that they mail their media to their lab, which only takes 15 minutes (sometimes that's true also), but I have found the length of time for each task cited to be accurate for most assignments. Every photographer has their own system and their own special set of circumstances, so make up your own time sheet and see what you come up with. You might also consider the time it takes to buy, test, repair, and organize equipment; clean tuxedos (not to mention buying them); test films; choose samples of your work; make those samples; and do your paperwork.

The Minimal Option

In order to break into their area's market, some photographers offer minimal wedding coverage at minimal prices. This creates two problems. No matter how short the actual shooting time, the selling and production work remain about the same. Because of this, when you contract for short assignments at low prices, you end up using a disproportional percentage of time on non-shooting responsibilities. This lowers your profit. Short shooting assignments have other pitfalls as well. By offering the short, low-priced option to your customers, you run the risk of committing to a small (low-profit) job on a day when you might get a big (lucrative) assignment. Furthermore, if you offer the low-priced alternative, you leave the bigger assignments for your competitors . . . and in wedding photography, bigger is better, or at least more profitable.

Feast or Famine

Assignments are numerous in the spring and early fall, and sparse through the dead of winter and the dog days of July and August.

This might set the gold standard for bread-and-butter pictures. Normally, every bridal couple wants a shot of the wedding party for their album, and the more people in that type of photo, the bigger the potential to sell additional copies of prints to those in the picture. Who knows, a good salesperson might be able to get 35 orders out of this single shot. © Jan Press Photomedia

Bread and Butter

Many wedding photographs aren't necessarily creative, but do provide an accurate record of the event. In candidman parlance, these are often called "bread-and-butter" pictures, and without them, all the creative effort in the world won't fill out a fat (and profitable) wedding album. Whether you decide to shoot weddings for yourself or as a candidman, it pays to understand what the customers might buy. If you shoot 96 drop-dead gorgeous, bust-length portraits of the bride, the maximum number that you are going to sell is two! OK, OK, maybe four. If, on the other hand, you shoot 96 frames, but only 24 are drop-dead gorgeous, bust-length portraits of the bride and the other 72 are of the couple with friends and family, you could sell many more. You would still have shot 96 frames, but the second strategy can yield a whole lot more profit, both in primary (the bridal album) and secondary sales (other albums or extra prints). In either scenario, you'll still sell the two (or four) drop-dead gorgeous portraits of the bride, so you decide.

It seems that nobody living in the snowbelt wants to risk having their wedding canceled on account of a blizzard. Others, living in warmer climates, may choose not to wed during the steamy heat of summer. You will find that you need 48 hours in a day just to stay even during "the wedding season," and you are bored to tears in the dead of winter or the peak of summer.

A top candidman who shoots for a number of different studios in a large population center can find enough work to stay busy year round. But even candidmen in this enviable position are less busy in midwinter and midsummer than in the spring and early fall. For a studio owner with a big staff to support, keeping everyone working during the off-season is difficult. To make matters worse, you'll find that while you can get six jobs on Valentine's Day or a Saturday in June, you can shoot only one or maybe two of them (and even then, only if the timing is right).

Shooting weddings, for the most part, is weekend work, and even considering all the preparation and post-production that's required, it is hard to milk a 40-hour week out of two days and one evening year round.

Concrete Costs

Many who are just starting out think that their only expenses are the cost of media, processing, proofs, prints, folders, and albums. These people are taking a very simplistic view of the expenses involved. Without belaboring the point, here is a list of only some of the other expenses that contribute to your costs:

1. The cost of camera and flash equipment (including spares); equipment also needs to be updated from time to time, so this is a never-ending expense, especially so in the current digital environment.
2. The repair of that equipment when it breaks (and it will)
3. All-peril insurance in case your equipment is stolen or damaged
4. Liability insurance—a must-have for both the studio and candidman
5. A reliable car
6. Car repairs
7. Car insurance
8. A tuxedo (busy shooters need multiples)
9. Tuxedo cleaning
10. Phone service
11. Fax and answering machines
12. Studio rental
13. Stationery and office supplies
14. An accountant
15. Legal advice
16. Studio staff (even if it's only part-time help)
17. Medical insurance
18. A retirement plan
19. A SALARY FOR YOURSELF

If you decide that any of these (except maybe staffing, which might not apply) are irrelevant, you are setting yourself up for failure. Furthermore, your specific needs may add other expenses to the list—some hard work with a pencil, paper, and calculator is required. If you think that you can't be bothered with all this accounting-type work,

and you live in a major population center, investigate the idea of being a candidman as opposed to a studio owner. But being a success even as a candidman requires you to know the costs involved, and many of the costs listed apply to both studio owner and candidman.

"But How Much Should I Charge?"

Figuring out how much to charge and how to collect your money are the most difficult and most important parts of the wedding photography game. Putting aside the collection aspect for a moment, let's start by looking at the smallest unit of your product—the print. Some photographers discover that an 8 x 10-inch machine print can be purchased for anywhere between $2 and $5. They, rightly so, double the price of the print and

Don't sell yourself short when it comes to charging for your services. You are a skilled professional who must invest not only your time, but also your cash for concrete costs, in order to deliver prints, albums, and lasting memories. In most parts of the country, wedding photography is seasonal, which further limits your ability to make a profit. You won't be able to get outdoor shots like this in the Midwest during January. © Freed Photography

sell their prints for between $4 and $10. But I feel there are other costs that must be reflected in your print prices.

You should include the cost of media, the processing, and the proofing in your print prices, but even this adds up to less than meets the eye. For example, you might shoot six images of the bride and groom cutting the wedding cake. Check the Repertoire chapter, but for a quick recap, the pictures would include two cake-cutting shots (looking at the cake and looking at the camera) the bride feeding the groom, the groom feeding the bride, a kiss, and possibly their hands, complete with shiny wedding rings, clasped together in front of the cake. When the couple returns the proofs, you find that they've chosen one cake-cutting picture and no amount of your cajoling or salesmanship will make them include other cake pictures in their album. In this instance, the actual cost of the one cake print that sold is the cost of the print plus the media for six frames and their processing and proofing. Another even more horrid (from a profit standpoint) example is when you shoot 30 portraits of the bride and she narrows her selection down to her two favorite pictures, one full-length and one close-up.

After 30 years of shooting, I have found that the ratio between pictures taken and pictures included in an order is approximately 5 to 1. While there are instances (such as a family group or the entire bridal party) where one negative will yield an order of six or more prints, these images are few and far between. Taking all this into account, I think you should include the cost of shooting five images in the price of one final print. This consists of the cost of your medium—film or memory—plus processing and proofing. Using 220 film (24 exposures) and having a numbered proof made of each

True, there are no film costs when shooting digital. But digital is not necessarily less expensive than film photography. Not only is there extra equipment to buy and technology to keep updated, but now you have to spend time in front of the computer as well as behind the camera.

negative will result in a price of about $1 per picture. This, in itself, should be a sobering thought—every time you push the shutter button it costs you a buck!

Learn to think before you push! Let's say for argument's sake that you have shopped labs wisely, and you determine that an 8 x 10-inch print costs you $3. If you add the cost of five shots to the mix, at $1 each, you will see that your final print really costs approximately $8. Some of you will argue that, because you are already figuring the cost of the media, processing, and proofing into your wedding package expenses, you shouldn't include these costs a second time when determining the price for a print.

Although I can understand this, it can complicate things when you are pricing other types of assignments. Imagine, for instance, you are pricing a portrait sitting instead of a wedding. In that case, you must include all the material and processing costs required to produce a print in your pricing structure. An alternative would be that you could make two print price lists (one for weddings and one for portraits), but I find that this is confusing to the customer. It seems to be easier on everyone if there is only one set price for an 8 x 10 (or any other print size). From a profit standpoint, if you can include your costs twice, so much the better for you!

The Digital Myth

There are photographers committed to digital photography who will look at the cost figures I've delineated and gleefully point out that they have no film and processing expenses when working digitally. I feel these souls are misguided because they have bought into an advertising sales pitch! They should read a few pages of the *EP Digital Manifesto* from the Editorial Photographers (EP) website (editorialphoto.com)

I will both quote from and paraphrase portions of it here:

"A basic digital set of two professional SLRs, several lenses, dedicated flashes, laptop, card reader, memory cards, desktop computer, software, monitor, printer, and CD/DVD burner, will cost approximately $20,000 to $60,000. That equipment, in order to remain technically current and keep you competitive, will need to be replaced every 3-5 years, some much sooner. Comparatively, a basic film system for editorial work would likely cost under $20,000 and would likely remain current and functional for 10 years or longer."

So here is the comparison based on costs outlined by EP:
$20,000/10 years = $2,000/year average cost if you're shooting film.
$40,000/5 years = $8,000/year average cost for digital.

Though I think EP's research is valuable and interesting, I feel they over-estimated the expenses for film equipment while underestimating for digital expenses! In fact, although I find the dollar figures for the cost of the equipment to be in the ballpark, I find the useful life expectancy figures for digital equipment to be less so. In the wedding photography world, many film shooters I know have been shooting with the same camera (or camera system) for over 30 years! Conversely, in just the last five years, digital SLRs have gone from 3 to 16 or more megapixels with three to four separate generations within this timeline.

But there's much more involved here than simply the cost of that shiny new digital SLR. As digital resolution has increased, the required capacity (and cost) of memory cards has also increased. Worse still, if a photographer has switched to a higher resolution camera and then, to further increase image quality, switched from working with JPEG to RAW format, file sizes have exploded and even larger memory cards are required. (Ask any digital photographer how often he or she uses their old 256-megabyte cards in the current age of the multigigabyte memory!) Computers, hard drives, and required software are also on the upgrade schedule. This problem becomes exacerbated because photographers (thinking the "film and processing" part of the digital equation is free) now shoot more exposures when working digitally. I find it a scary thought to consider how long it takes a two-year old computer to convert 1000 raw files into viewable images. A few years ago I bought my first one-gigabyte hard drive and was tickled at the idea of having "a gig". Today I have several drives of 160 gigabytes each stacked next to my Mac, and they aren't even used for my wedding images (I only shoot digital for my non-wedding assignments!).

As usual, however, it is time rather than hardware that becomes the important factor when considering costs and profits. Even without the added costs of digital equipment (from cameras, to computers, to software, to peripherals), I need at least an hour of work in front of my computer for every hour spent shooting with a digital camera. While some may say this is no big deal, if

Carry Insurance

No matter how careful you are with equipment there is always the possibility of someone (a guest, waiter, musician, or member of the bridal party) getting hurt by something that you're responsible for. With this in mind, it is imperative that you carry liability insurance. You cannot afford to be without it. Forgo a vacation, eat gruel, drive a jalopy, but carry liability insurance. This is true whether you set up room lights or not. It's like carrying a second camera—there are absolutely no exceptions!

you shoot 100 six-hour assignments per year, you need approximately 600 hours of computer time to process and correct all these images. For those of you not well versed in math, that is equal to 15 working weeks of 40 hours each. That's almost three extra months of work each year!

The *EP Digital Manifesto* reaches the following conclusion:

> "It is clear that we are being pressured by clients who are insisting on digital while resisting paying for our added work and investment. It is also clear that if we are to survive, we must make a stand by insisting on added payment for our added services and expenses."

> "Our suggested pricing . . . follows . . . These figures need to be increased over time to reflect both inflation and rising equipment and production costs. Once again, note that these are for editorial projects."

> "Digital production charge:
> $300-$1000/day
> CD burning: $30 -$50/disk
> DVD burning: $50 -$75/disk
> FTP uploading: $75 -$150
> Digital (inkjet) contact sheets:
> $20-$50/contact sheet
> Inkjet reference prints: $15-30/print
> Digital post-production: $15-$200/hour"

> " . . . Simply because we are now charging our clients for the higher production costs of digital does not make the charges less valid . . . If we fail to assert reasonable compensation structures, we will soon find ourselves unable to afford to practice our craft."

Before you brand me as being hopelessly attached to the past (yes, I still use film to shoot weddings), I strongly believe the future of wedding photography is in the use of the digital medium. That being said however, to think that the ongoing digital revolution means less work and lower expenses is sophomoric and based on hype perpetuated by manufacturers more interested in their profits than yours.

Size and Format Affect Price

While most photographers sell rectangular prints, from a profit standpoint you might look into selling square prints. Most wedding labs will make a 10 x 10-inch print for slightly more than an 8 x 10, but a photographer can sell a 10 x 10 print in an album for 50% more than an 8 x 10. While this may represent an increase of only $5 for a single print (the price goes from $10 to $15 for a 7 x 7-inch print), the extra profit can really add up when you consider an album contains from 50 to 75 prints. If you add the extra amount you can charge for a 10 x 10 binding (as opposed to an 8 x 10), the profit rises even more.

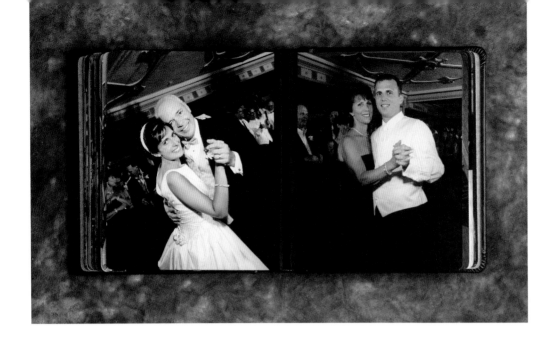

Square prints do not cost much more to produce than rectangular 5 x 7 or 8 x 10-inch prints, but you can sell the square format print for more. Plan ahead when you are thinking about album sales, and shoot with a two-page photo spread in mind, like this bride/father and groom/mother dancing combination.
© Jan Press Photomedia

Square prints are also an easy upgrade to sell for parent albums. The resulting 8 x 8 (or 7 x 7) parent album is more impressive than the traditional 5 x 7 parent album. If you decide to offer square prints and albums, take the shape into account when you compose the photograph. Although square prints are lucrative, in general the majority of the prints I sell are the "normal" rectangular sizes.

You can also adjust the format and print-size of your proofs to help increase profitability. While some photographers looking to sell square album prints offer square proofs, I have standardized on the slightly weird 3-1/2 x 5 proof size. I deliver 3-1/2 x 5-inch proofs to my customers for one simple reason: I often give my proofs away as incentives. Therefore, if they were sized at 4 x 5 inches, I would lose 4 x 5-inch print sales. I consider a 4 x 5 to be a finished print. By making my proofs 3-1/2 x 5, I can sell 4 x 5s as enlargements and therefore charge more for them.

More Per-Print Costs

As a pro, you can't just hand your client a stack of loose prints. Presentation is part of the game and adds value to a seemingly simple piece of paper. The cost of a folder for each 8 x 10 print can range between $0.50 (for a simple cardboard folder) and almost $2.00 (for a heavy stock, lightly textured, feather deckled edge, gold-embossed, cardboard Cadillac—which is my studio's choice). While these folder prices decrease with volume purchases, the price might go up (by about $0.10) if you decide to have your studio name and phone number imprinted on each folder. Spend some time with an album catalog to decide in which type of folder you would like to present your prints.

You also must include any print finishing costs in your calculations. These might include spotting, slight retouching (major retouching should be offered and billed separately), lacquer spraying, and texturing of your final prints. If you budget between $1 and $2 per print for this, you won't be far off. The bottom line for an 8 x 10 (in case you haven't been keeping up) is now over

$11, and that total reflects just materials, not labor. Therefore, you must consider how much time it will take you to locate the negative, order the print, drop off and pick up the print, examine the print, have the print finished, insert the print in a folder, and prepare it for delivery. It doesn't matter whether you or a staff member perform these tasks, nor does it matter whether completing these steps just means delivering the negative or print to an outside supplier. It still takes time, and as you now understand, time is money! Since you can prepare many images for the lab (or prints for the bindery or retoucher) at once, these procedures are not extremely labor-intensive, but all the steps together probably add up to handling each print for 5 or 10 minutes (or 1/6 hour). Add these labor costs to the $11+ you've already spent for materials.

Don't Forget Car Mileage

I can't even count the number of times a beginning photographer has told me that sending prints to a customer costs only the postage and the envelope. He never mentions (or even considers) that he lives five miles from the post office! It's sad but true, but every time the odometer on your car clicks to the next mile, your car is one step closer to needing a repair, one step closer to being replaced, and worth a few pennies less when you try to sell it. Every time the tires make one revolution they are one turn closer to needing replacement. Big companies understand this and calculate an expense of approximately $0.50 for every mile traveled

Important Hint

One way to insure success is to overestimate the amount of time involved to produce the job. That way, when something takes three hours instead of one, you already have a fudge factor built into your calculations! In fact it makes good business sense to overestimate all your production costs so you won't find yourself working for a very small profit when something unforeseen pops up.

by car. Why companies can understand this and photographers can't is beyond me.

Run a quick test. Pick a busy week (although a month or even a six-month trial would be better) and keep track of all the miles you put on your car while doing photographic legwork. Remember to include trips to the camera store, the lab, the post office, the bindery, prospective clients, other wedding suppliers, the cleaners to drop off and pick up your wedding outfit, and shooting assignments. Add up your totals and divide them by two. Your answer will be the number of dollars needed to operate your car for that time period. You'll be surprised at what your car actually costs to operate so that you can run your business. Now remember to include this figure in your expenses.

The Final Tally

With all these costs included, I can't see how any studio owner would charge less than $20 to $25 for an 8 x 10 print. However there are hundreds of studios that successfully operate and sell 8 x 10 prints for between $10 and $15. These studios either do a huge volume or operate at such a small profit that driving a cab (as mentioned in this book's introduction) becomes more profitable. How much you charge for an 8 x 10 is purely up to you, but to make an educated decision, you have to be aware of the costs I've outlined.

Setting a high price as a starting point for additional prints presents another advantage when you are selling your work. If your profit margin is strong enough, you can offer a slight discount if your customer is willing to guarantee a larger order at the time of booking.

Here's the scenario: You explain your prices and packages to the customer, and when the customer asks how much additional 8 x 10s are, you tell them $25 a piece. The customer goes crazy and says he or she

wouldn't pay $25 to have tea with the queen! Don't get flustered, but instead say, "I can offer you a 20% discount on the price of extra prints if you will guarantee me an order of 75 prints in the bridal album right now." This sometimes works and (forgive the cliché) a bird in hand is worth two in the bush. Once you agree to a set of terms, write it up in the contract. If you've built a good profit margin into your print price, you have room to negotiate. Some customers don't really care about the price, but they do care about getting some type of discount. With proper planning on your part, you can give those customers what they want and still make the profit you need to make a living.

Have a Contract

While some photographers consider a handshake as a way to seal a deal, I feel a written contract is a necessity. Any time you are selling services and products to a customer, it pays to have both parties' responsibilities written down and agreed upon. The contract you design should include much more than just a list of what the customer is going to receive and how much he or she is going to pay. Even if your contract is simple, here are some ideas on other things that should be included in it.

Include a Payment Schedule

Two thousand (or five thousand) dollars is a lot of money as one big sum. Therefore, your contract should break the total down into amounts that are manageable for the customer. You should require a retainer from your customer to reserve the date. This might be anywhere from 10 to 25% of the total amount. Note that I use the term retainer instead of deposit. While deposits are refundable, retainers aren't! If the client gives a retainer while you hold the date open for them, you and the client are exchanging something of value. Your contract should stipulate that if the customer cancels, the reservation retainer is refundable only if you can get another assignment for that day.

For your clients' protection as well as your own, it is necessary to have a written contract that precisely spells out the services, responsibilities, and prices that are involved in this two-way street. Among the many questions addressed by a contract: When are payments due, how long will you be at the reception, what happens if you lose the film? And don't forget, always collect a retainer to reserve a date for your client. © Freed Photography

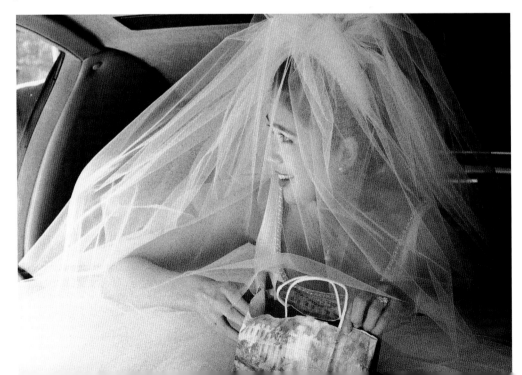

The second payment, after the retainer, should be required on or before the wedding day, and that payment plus the reservation retainer should equal between 75% and 80% of the total bill. Then, half of the remaining balance (with any extras included) should be required when the customer returns the proofs, and the final payment, due upon album delivery, should be by cash or certified check. Be very careful about making exceptions to these rules. Once you have delivered the final album you have no leverage left to insure payment, and the last thing you want to do is chase after a customer who bounces a final payment check!

Include Number of Shooting Hours and Charges for Overtime

Are you shooting pictures for two hours or twelve? Some customers expect you to be with them for the entire wedding day, regardless of when it starts and when it ends. Bands do not work that way. Caterers do not work that way. Why should you?

In my region, "standard coverage" (if there can be such a thing) consists of six hours of photographic time. Additional half-hours are billed to the customer at rates from $35 to $75 per person (remember you might have an assistant with you). When deciding upon an overtime rate, your charge must take into account not only the labor costs involved, but also the use and processing costs for materials. A reasonable estimate would be $36 to $48 per hour (approximately one picture every one-and-a-half minutes at about a $1 per picture).

Consider charging extra for twilight bookings during peak seasons. You could fit in two weddings on a Saturday in June if one is a morning ceremony followed by a luncheon and the second ceremony is at 4:00 PM followed by a dinner. However, a 2:00 ceremony with a 6:00 reception will eat up your entire day. Every caterer (at least in my

area) understands that they must maximize their profit given the limitations of their dining room facilities, and therefore they charge a premium if one party ties up their facilities for the entire day. If you are a lone photographer, you too must maximize your profit during the busy seasons. Whether or not you decide to follow these suggestions is up to you, but to make informed choices (and more money), you should consider all these options.

Include the Limits of Your Liability

What happens if there is a power failure at the lab while your customer's film is in the processor? What happens if the leaf shutter on your lens drops a blade while the bride is walking down the aisle? What if you lose one of your memory cards? What happens if the exposed film is stolen from you by a bullfrog with a machine gun? What happens?!

There may be a time, through no fault of your own, that the pictures you take at a wedding don't come out. What do you owe the bridal couple? Your contract should cover this eventuality (in the gentlest words possible), and your liability should be limited to the return of your customer's deposit(s). Professional labs understand this because every lab order form states that if there is a problem, they will give you an equal amount of unexposed film as compensation for your loss. If (or when) this type of catastrophe does occur, you should have a mechanism (your contract) that details what you are going to do about it. If you're dumb enough to get falling-down drunk at a wedding you've contracted to cover, no disclaimer on your contract will save you from a lawsuit (and you deserve it), but if there is a problem that is beyond your control and you've acted in good faith, your contract should protect you.

The paper a photograph is printed on is of little value— it is the image that is important. Your contract should state clearly that you own the rights to the images. © Jan Press Photomedia

Spell Out Who Owns Negatives and the Copyright to Images

This may be self-explanatory to you, but it should be covered by your contract. In the digital world, it is a simple process for a bride or groom to plop your photographs on the bed of a scanner and create copies for the entire family. Although this type of unauthorized use of your intellectual property (the pictures) is hard to police, your contract should state in plain terms that the images are yours. One photographer I knew pointed out to customers that the piece of paper on which the photograph was printed was worth only pennies. It was what he put on the paper that was of value! What you put on the piece of photographic paper is yours, and you are selling the bride and groom only the rights to look at and enjoy the images, not the right to make and distribute copies.

Include Price of additional Prints and Any Extra Charges

Most often, disagreements over wedding photography occur because something wasn't discussed beforehand, and when you bring it up later, the customer is distraught because you never mentioned it during your sales pitch. Therefore, everything that might add to the price should be listed in your contract, including your overtime rate and the charge for an additional set of proofs. No surprises . . . no arguments.

All of the legalese covered by your contract might make selling your wedding photography more difficult. It would be easier to gloss over the fine points as you use words to paint a beautiful picture during your sales pitch. However, covering all these points up-front can eliminate numerous problems later.

Consider getting legal help with this document (your contract). Laws are different from state to state and, because your contract is a legal document that might someday be needed in court to settle a dispute, it is important to dot your "i's" and cross your "t's." A local lawyer can help you with this better than I. Most importantly, the contract you design should favor you! It should be fair to your customer, but your goal in making a contract is to protect yourself.

The Whole Package

Some wedding studios offer package deals that typically include a bridal album, two parent albums, a large-sized portrait, and a dozen wallet-sized prints. Other studios, usually ones that are catering to an upscale clientele, believe in an à la carte policy that requires a minimum order (usually the bridal album) to reserve the date, and everything else costs extra, from parent albums to portraits. And yet other studios, again with upscale clientele, charge a creative fee for the shoot day and everything else (including the bridal album) is à la carte.

The type of pricing structure you choose will be based on the clientele and the competition in your area. You might want to work with a creative fee and an à la carte menu, but if all the local competition offers packages that include everything for one price, you might find it hard to attract and sign up customers. On the other hand, in a small studio operation, selling packages means that on any given "hot" date (i.e., a Saturday afternoon in June or September), you won't be committed to fulfilling a small order (such as a minimal bridal album), because the customer has already agreed to purchase the bridal album, parent albums, portraits, and other products.

Many of the non-photographic costs enumerated earlier change from one geographic area to another. While the photographic costs remain about the same, everything else (including your labor, due to the higher cost of living) is much more expensive in large metropolitan areas. Defining the prices for your area is your job, but I can give you an idea of the photographic expenses involved in producing two single-album wedding orders. I have used approximate figures, and my figures are based on six hours of coverage, working with one assistant, and shooting 6 x 6cm negatives on 220 film. The examples I'm citing, which include labor costs, are based on the New York metro area. First let me describe what the client receives for their money.

A Basic Starter Package

◆ One (1) 50-picture 8 x 10 leather-bound library album
◆ One (1) 11 x 14 portrait
◆ Twelve (12) wallet-sized pictures, maximum of 2 poses (6 of each)

SCENARIO A: PHOTOGRAPHIC AND LABOR COSTS

1. Twenty (20) rolls of 220 film @ $8/roll	$160	
2. Processing and numbered proofs @ $17/roll	$340	
3. Fifty (50) 8 x 10 prints @ $4/print	$200	
4. One (1) 8 x 10 leather binding @ $300	$300	
5. Lacquer spraying of album prints @ $0.80/print	$40	
6. Candidman—six hours @ $100/hour	$600	
7. Assistant—six hours @ $25/hour	$150	
8. One (1) 11 x14 print @ $12/print	$12	
9. Twelve (12) wallet photos @ $0.75/print	$9	

Total Cost of Labor and Materials $1,811

I'm certain that some reader is going to question my figures knowing that they can produce this for less. Some may feel that they can cover a wedding with ten rolls of film (instead of 20), and that change alone reduces the expenses (including processing) by $250. Others might offer a 24-print starter package (instead of my 50-print minimum—a difference of $104), or they might not lacquer-spray their prints (a savings of $40), or they may provide a less expensive,

plastic, slip-in binding. These photographers might be willing to work for $50 per hour and offer only three hours of coverage. Further they may be able to find an assistant that will help out for only $25 for the entire assignment.

All of these cost-saving procedures are valid. The customers and the competition in your region may demand these more thrifty choices, but I have found that I don't enjoy the end product of my labors as much when I start to cut corners. If your geographic area demands that you cater to customers on a small budget, so be it. But I find it is much more fulfilling (and profitable) to offer the best quality I can produce, and I look for customers with the same desire. In addition, because the number of days on which you can shoot a wedding is limited (we're back to time again), choosing to shoot the low-budget wedding cuts into the time you have available for high-end assignments.

If you expect customers to hire you based solely on your rock-bottom prices, you must realize that whatever you charge, some other photographer will be willing to do the same thing for less. If you get your price down to one measly buck, some other photographer will offer the same job for 99 cents. The question becomes this: Do you even want the lowest-paying, least-profitable assignments?

Setting aside my distaste for low-budget coverage (in fact, I don't even offer it!), let's total the minimalist approach just to see what the bottom-line expenses are.

SCENARIO B: PHOTOGRAPHIC AND LABOR COSTS—MINIMAL COVERAGE

1.	Six (6) rolls of 220 film @ $8/roll	$48
2.	Processing and numbered proofs @ $17/roll	$102
3.	Twenty-four (24) 8 x 10 prints @ $4/print	$96
4.	One (1) 8 x 10 plastic slip-in binding	$50
5.	Lacquer spraying— eliminated	$0
6.	Candidman—three hours @ $50/hour	$150
7.	Assistant—three hours, flat fee	$25
8.	One (1) 11 x 14 print @ $12/print	$12
9.	Twelve (12) wallet photos @ $0.75/print	$9

Total Cost of Labor and Materials $492

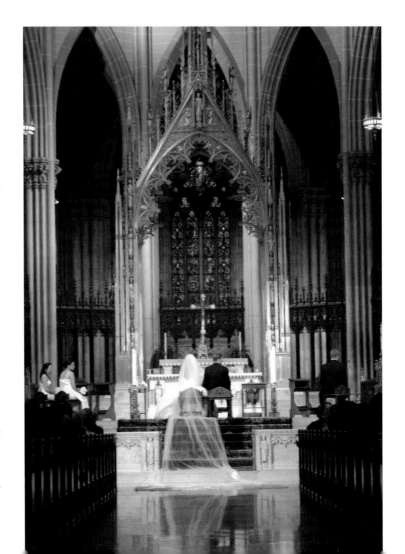

You can always find ways to shave costs, especially if that's the norm in your geographic area or if that is what your client is asking from you. But remember, if you want to make money, you'll make more profit from higher-budget assignments. © Jan Press Photomedia

Working with High-Road Figures

As you can see, there are many ways to cut a corner, but let's return to Scenario A for a moment. Even accepting my desire to produce the best-quality product possible, some reader is going to look at the first set of figures and decide that because he (or she) is making $600 for the shooting time on this hypothetical assignment, he therefore can charge the customer $1,811 and still do just fine. In his mind, he is considering his shooting time to be profit, but it is not. These figures are your costs. You should never price either of these jobs, Scenario A or Scenario B, at their bottom-line cost. It wouldn't make any sense. Remember, cost is not profit.

Keep Yourself and Your Studio Separate

A mistake many beginning photographers make is not separating themselves from their studio. The two are separate entities, and both must make a profit. You, as a candidman, work for the studio, and deserve a reasonable wage for the work you do. As a candidman, you must supply camera and flash equipment (including spares and maintenance), a reliable car, insurance on equipment and car, liability insurance, a clean tuxedo, and your time to shoot a wedding. Therefore, you (wearing the candidman hat) must make a profit. The studio must book and produce the job; carry the expense of staffing and advertising; carry liability insurance; pay rent; have phone, fax, and answering systems; pay phone bills; print stationery; make samples; and so on. But the studio must also make a profit.

Let me give you an example: Imagine that you have booked two weddings for one hot Saturday in June. You hire a second photographer and assistant and pay their wage for covering the second wedding. If you use Scenario A and charge the client only your cost of $1,811, you make nothing for a lot of work! This is not success, no matter how many weddings you book!

If you are the sole owner of the wedding studio, you must make a profit as a candidman (working for your own studio) and your studio must also make a profit. This will help carry you through those lean months when you have no weddings to shoot. It might be hard for a new photographer facing the pressures of competition and finding new customers to follow these guidelines, but wedding photography is a business. If you want to photograph for fun (a noble pastime), go shoot scenics or whatever else interests you. But when a bride is in front of your camera, you must be a businessperson, a creative one, for sure, but a businessperson nonetheless.

Let's return, for a minute, to the price you charge for an 8 x 10 print and relate that to the idea of charging $1,811 for the entire assignment. If you decide to price an 8 x 10 print at $20, and you deliver fifty 8 x 10s in an album, the price you are charging for the prints alone (50 x $20 = $1,000) not counting the binding would equal more than half what you are charging for the entire assignment ($1,811)! If the customer takes out a calculator and does some simple math, they will realize that you are including all the rest (film, proofs, binding, and both photographic and production labor) for a mere $811! Anyone would agree this is not good business! Your choice is simple: Either lower your print prices or raise your package price. Without a doubt, a higher package price is the way to go! If you look at the cost figures for Scenario A and decide on a package price between $2,500 and $3,000, you are on the right track. This represents cost ($1,811) plus profit ($689 to $1,211).

Offer Incentives

Consider offering several packages with different prices, and offer your customers incentives for selecting the more expensive options. If the customer signs a contract with you for a 50-picture bridal album, you might normally charge an additional $200 to include the entire set of proofs in a slip album (your cost for the proof album might be an additional $20). However, if the customer orders two additional parent albums (24 5 x 7 pictures in a leather-bound album @ $400 each), you might offer to include the proof album for free. It's an incentive. Get the idea?

Some studios form a relationship with local videographers and offer videotaping as well as still photography services. If you can get a reduced rate from the video studio (i.e., reduced to the trade), you can sell a video service and offer your customer free photo thank-you cards if they use your videographer. Just make sure that the video profit is more than the profit on the thank-you cards and you'll be on the road to more success. Other advantages to using your videographer (from a customer's point of view) are one-stop shopping and the confidence that both the still photographer and videographer are working as a team, ensuring that things go more smoothly. Some studios even have arrangements with florists, tuxedo rental shops, invitation printers, and favor providers with further incentives to the bridal couple for using the studio's whole package.

Some of these ideas may seem like pie in the sky to the photographer begging for his or her first wedding assignment. But the idea of this chapter is to get your mind working in a business mode that can lead to the application of some of the ideas I've suggested. I cannot tell you exactly what to charge because the market and the clientele in every region are different. It never hurts to check with the local association of retired businesspersons in your area for more ideas on what it takes to be successful. Also, taking local college courses on small business administration might be as important as further honing your skills as a creative photographer. Investigate joining a professional photographers' organization such as PPA (Professional Photographers of America) or WPPI (Wedding and Portrait Photographers International). Your preproduction planning should also include finding an accountant and a lawyer to help you start out on the right foot.

Finally, you must realize that you are in control of your own destiny. No one but yourself can make you take an assignment that is unprofitable. Now, go find an assignment, make beautiful pictures, and make money!

A Sample Repertoire

What follows is a list of the types of photographs described in Chapter 2, The Wedding Repertoire. Feel free to make copies of this list to use on your own assignments. But don't think of this just as a checklist; it can be much more useful.

- Make it your own. Use this list as a framework for building your own repertoire. Add creative shot ideas, and expand the list as your photographic style changes.

- During a sales presentation, show this list to customers to clarify all the events you will cover and photos you will take on their wedding day. Ask your prospective clients what other types of pictures they might want and add them to the list while you are talking with them to illustrate your personalized service.

- Use this list to coordinate the job with your assistant. This will prepare your assistant and put his or her "mind in gear." Have your assistant check off the photos as you take them. Also keep track of the photos yourself—doing the job well is ultimately your responsibility.

- When working with another photographer, use this list to divide the labor and designate who will take particular shots. A repertoire is like a game plan. Working off a list is essential when you're shooting as a team.

- If you hire a photographer to shoot for you, the photographs he or she takes should be in your style. Give the photographer this list annotated with your stylistic guidelines, to ensure he or she delivers the product your client was promised.

THE BRIDE'S HOME

The Dressing Room

1. The Invitation and Possibly the Ring Bearer's Pillow with the Bridal Bouquet

2. Mirror Photos

 a. Bride Using Comb and Brush

 b. Bride with Compact

 c. Bride Applying Lipstick

 d. Bride's Hands Holding Parents' Wedding Photo, with Her Reflection in the Mirror Behind

 e. Bride's Hands Holding Invitation with Her Reflection in the Mirror Behind

 f. Bride's Hand Holding Engagement Ring, with Her Reflection in the Mirror Behind

 g. Bride and Mirror Together

3. Mom Adjusting Bride's Veil

4. Bride and Maid of Honor

The Living Room or Yard

1. Bride and Dad: Formal

2. Bride and Dad: Kissing Him on the Cheek or Hugging Him

3. Bride and Her Parents: Two Images

 a. Bride and Her Parents: Selective Focus

4. Bride's Parents Alone: Two Images

5. Bride and Mom: Regular and Soft Focus

6. Three Generations: Bride's Side

7. Bride and Sisters (and optional, Bride with Each Sister or Bride with All Siblings)

8. Bride and Brothers (and optional, Bride with Each Brother)

9. Bride and Bridesmaids (and optional, Bride with Each Maid)

 a. Bride and Flower Girl

10. Bride Alone: Three to Four Close?up Poses, Two to Three Images per Pose

 a. By Window Light: At Least Two

11. Bride Alone: Three to Four Full?Lengths

12. First Half of a Double Exposure

Leaving the House

1. Bride, Parents, and Bridesmaids in Front of House

2. Dad Helping Bride into Limousine

THE CEREMONY

Arriving at the Ceremony

1. Dad Helping Bride out of Limousine (or variations)

2. Groom and Best Man: Two Frames (possibly the second as a gag shot)

The Processional

1. Mother of Bride and Mother of Groom Being Escorted Down the Aisle

2. Each Bridesmaid Walking Down the Aisle

3. Maid of Honor Walking Down the Aisle

4. Flower Girl and Ring Bearer

5. Bride and Dad Walking Down the Aisle: At Least Two Shots

6. Dad's Kiss Good-Bye

Readings or Music

Second Half of a Double Exposure

Long Exposures from the Rear

Rings Two Times

Candle Lighting

Special Traditions

1. Mass

2. Couple Kissing at the Sign of Peace

3. Bride and Groom Kissing Parents at the Sign of Peace

4. Drinking Wine and/or Receiving the Host

5. Presenting Flowers to the Church

6. Other Religious Traditions

The Recessional

1. Bride and Groom: At Least Two Images

2. Bride and Groom: Kissing in the Aisle at Rear of Church

Receiving Line: Three to Twelve Candids

Bride and Groom with Each Set of Parents

1. Possible Pictures of the Couple with Their Grandparents

Leaving the Church

1. Bride and Groom: Silhouette in Church Door

2. Bride and Groom with Bridal Party on Church Steps and the Rice Throw

Getting into the Limousine

1. Shooting through the Far Door, Looking in at the Bride and Groom

2. Bride and Groom Looking out Limousine Window

3. From Front Seat Looking into Back of Car

4. Bride and Groom Toasting

5. Bride and Groom Facing Camera and Facing Each Other

6. Bride and Groom Kissing

FORMAL PORTRAITS

Entire Bridal Party: Two Different Poses—Three or Four Shots of Each

Groom and Ushers (and Optional, Groom with Each Usher)

Bride and Bridesmaids

Bride, Groom, Maid of Honor, and Best Man

Bride and Maid of Honor

Groom and Best Man

Groom Alone: Four to Six Poses— Two to Three Full-Length and Two to Three Portraits

Bride and Groom: Three to Four Different Poses

Variations on the Bride and Groom Portraits

1. Close-up of Rings on Hands

2. A Scenic Image

3. Bride and Groom: Selective Focus

If There is Time...

1. A Few Additional Full-Lengths and Close-ups of the Bride

2. Any Bridal Party Couples

3. Groom with His Siblings in the Bridal Party

4. Relaxed Group Picture of the Bridal Party around the Limos

FAMILY PHOTOS

Groom and His Dad

Groom and His Mom

Groom and His Parents: with or without Selective Focus

Groom's Parents Alone: Two Frames

Groom and His Siblings

Three Generations: Groom's Side

Bride and Groom with Groom's Parents: Two Shots

Bride and Groom with Groom's Family: withand without Grandparents

Bride and Groom with Groom's Siblings

Bride and Groom with Groom's Grandparents

Bride and Groom with Bride's Family

Bride's Family Miscellany

Grandparents Alone or as Couples

Extended Family

THE RECEPTION

The Entrance
1. Siblings

2. Best Man and Maid of Honor

3. Flower Girl and Ring Bearer

4. Bride and Groom: Two Images

The First Dance
1. Bride and Groom: Two to Three Full Lengths and Possibly a Close-up

2. Bridal Party Couples (especially married ones)
3. Parents

4. Grandparents

The Toast
1. Best Man Toasting

2. Bride and Groom with Best Man and Toasting Glasses, If Possible

3. Bride and Groom Toasting Each Other

Table Pictures
1. The Tables for Each Set of Parents

Candids: 24 To 48 Photos of Bridal Party and Guests Dancing
1. Two-Up Dancing Photos: Faces toward the Camera

2. Three- and Four-Up Groups Dancing: Facing the Camera

3. Large, Impromptu Groups of the Couple's Friends

4. Totally Candid Tight Shots (Close-ups) of the Bride and Groom

Bride and Dad Dancing

Groom and Mom Dancing

Romantic Interlude: 10 or 12 Photos
1. Double Exposures

2. Candlelight Photos

3. Good-Bye Shots or Gag Shots

4. Available-Light Night Scenes Including Reception Hall Scenery

The Cake
1. Bride and Groom Cutting Cake: Two Images Bride and Groom Looking at the Camera and then Looking at the Cake

2. Bride Feeding Groom

3. Groom Feeding Bride

4. Bride and Groom's Hands over Cake, Showing Rings

5. Bride and Groom Kissing Each Other with Cake in Composition

Boquet and Garter Toss
1. Tossing Bouquet

2. Removing Garter

3. Tossing Garter

4. Putting Garter on Bouquet Catcher's Leg

PHOTO EQUIPMENT AND SUPPLIES

CAMERA MANUFACTURERS

CANON
www.canon.com

EASTMAN KODAK COMPANY
www.kodak.com

FUJI PHOTO FILM
home.fujifilm.com

HASSELBLAD
www.hasselblad.se

KONICA MINOLTA
konicaminolta.com

LECIA
www.leica-camera.com

MAMIYA
www.mamiya.com

NIKON
www.nikon.com

OLYMPUS
www.olympus-global.com

PENTAX
www.pentax.com

ROLLEI FOTOTECHNIC
www.rollei.de

BATTERY POWERED FLASH

LUMEDYNE
www.lumedyne.com

METZ
www.metz.de

NORMAN
www.photo-control.com

QUANTUM INSTRUMENTS
www.qtm.com

SUNPAK
www.sunpak.jp

VIVITAR
www.vivitar.com

BATTERY PACKS

CANON
www.canon.com

LUMEDYNE
www.lumedyne.com

NIKON
www.nikon.com

QUANTUM INSTRUMENTS
www.qtm.com

SUNPAK
www.sunpak.jp

AC POWERED FLASH

ALIEN BEES
www.alienbees.com

BOWENS
www.bowensinternational.com

BRONCOLOR
www.bron.ch

DYNA-LITE
www.dynalite.com

ELINCHROM
www.elinchrom.com

NORMAN
www.photo-control.com

NOVATRON ELECTRONIC LIGHTING SYSTEMS
www.novatron.com

PHOTOGENIC PROFESSIONAL LIGHTING
www.photogenicpro.com

PROFOTO
www.profoto.com

SPEEDOTRON
www.speedotron.com

WHITE LIGHTING
www.white-lightning.com

LIGHT MODIFIERS

CHIMERA LIGHTING
www.chimeralighting.com

LUMIQUEST
www.lumiquest.com

PHOTOFLEX PRODUCTS
www.photoflex.com

PROFOTO
www.profoto.com

RED WING
www.redwingphoto.com

SLAVES & REMOTE CONTROLLERS

BOWENS
www.bowensinternational.com

POCKET WIZARD
www.pocketwizard.com

QUANTUM INSTRUMENTS
www.qtm.com

WEIN
www.weinproducts.com

EXPOSURE METERS

BRONCOLOR
www.bron.ch

GOSSEN
www.gossen-photo.de/deutsch

KONICA MINOLTA
konicaminolta.com

NOVATRON
www.novatron.com

PATERSON PHOTOGRAPHIC
www.patersonphotographic.com

SEKONIC
www.sekonic.com

SHEPARD/POLARIS
www.omegasatter.com

VISATEC
www.bron.ch

WEIN
www.weinproducts.com

FILTERS, FILTER SYSTEMS, VIGNETTERS, AND SHADES

COKIN
www.cokin.com

HELIOPAN
www.heliopan.de

HITECH
www.visualdepartures.com

HOYA
www.thkphoto.com

KENKO
www.kenko-tokina.co.jp

KODAK WRATTEN
www.kodak.com/US/en/motion/
products/wratten1.shtml

LEE FILTERS
www.leefilters.com/home.asp

LECIA CAMERA
www.leica-camera.com

LINDAHL
www.photo-control.com

NIKON
www.nikon.com

OPTIFLEX
www.visualdepartures.com

SCHNEIDER OPTICS
www.schneideroptics.com

SINGH-RAY
www.singh-ray.com

TIFFEN
www.tiffen.com

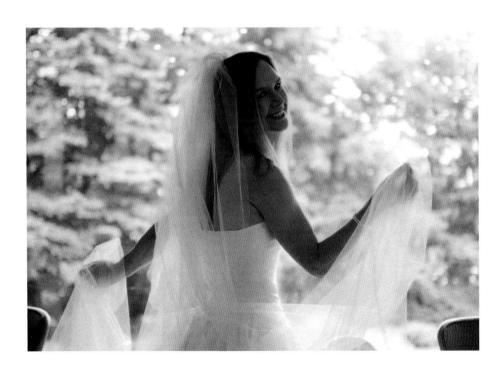

TRIPODS AND LIGHTSTANDS

Benbo
www.patersonphotographic.com

Cullmann
www.cullmann-foto.de

Davis & Sanford
www.tiffen.com

Gitzo
www.gitzo.com

Hakuba
www.hakubaphoto.co.jp

Lowel-Light Manufacturing
www.lowel.com

Manfrotto
www.manfrotto.com

Slik
www.slik.com

Sunpak
www.sunpak.jp

Velbon
www.velbon.com

BRACKETS

Lindahl
www.photo-control.com

Newton Camera Brackets
newtoncamerabrackets.com

Stroboframe
www.tiffen.com

BACKGROUNDS

Backdrop-Alley
www.dennymfg.com

Lastolite
www.lastolite.com

Off The Wall Productions Ltd.
www.otwp.com

Photoflex Products
www.photoflex.com

Reflecmedia
www.reflecmedia.com

Studio Dynamics
www.studiodynamics.com

F.J. Wescott
www.fjwestcott.com

Won Background Mfg.
www.artwon.co.kr

UMBRELLAS

BRONCOLOR
www.bron.ch

**DENNY MANUFACTURING
COMPANY**
www.dennymfg.com

DYNA-LITE
www.dynalite.com

ELINCHROM
www.elinchrom.com

HENSEL
www.hensel-studiotechnik.de

LASTOLITE
www.lastolite.com

LOWEL-LIGHT MANUFACTURING
www.lowel.com

NORMAN
www.photo-control.com

**NOVATRON ELETRONIC LIGHTING
SYSTEMS**
www.novatron.com

PATERSON PHOTOGRAPHIC
www.patersonphotographic.com

PHOTEK
www.photekusa.com

PHOTOFLEX PRODUCTS
www.photoflex.com

**PHOTOGENIC PROFESSIONAL
LIGHTING**
www.photogenicpro.com

PROFOTO
www.profoto.com

F.J. WESCOTT
www.fjwestcott.com

POUCHES, CASES AND CARRIERS

ALUMINUM CASE COMPANY
www.aluminumcase.thomasregister.com

DELSEY
www.delsey.com

HAKUBA
www.hakubaphoto.co.jp

KART-A-BAG
www.kart-a-bag.com

LIGHTWARE
www.lightwareinc.com

LOWEPRO
www.lowepro.com

PELICAN PRODUCTS
www.pelican.com

PERFECTED PHOTO PRODUCTS
(818) 885-1315

PORTER CASE
www.portercase.com

ROADWIRED
www.roadwired.com

TAMRAC
www.tamrac.com

TENBA
www.tenbagear.com

LADDERS

WING ENTERPRISES
www.littlegiantladders.com

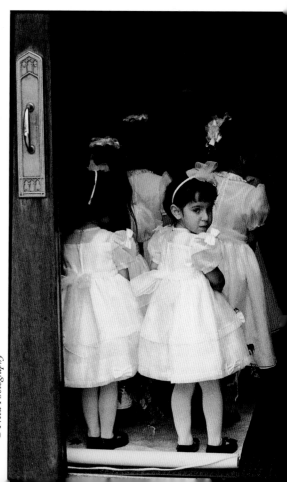

© Freed Photography

ALBUMS AND FINISHING

Traditional Style Matted Albums

ALBUMS INC.
(800) 662-1000
www.albumsinc.com

ALBUMS UNLIMITED
2012 Hartog Drive
San Jose, CA 95131
(800) 625-2867
www.albumsunlimited.com

ART LEATHER
Elmhurst, NY 11373
(888) 252-5286
www.artleather.com

GENERAL PRODUCTS LLC
4045 North Rockwell Street
Chicago, IL 60618
(800) 888-1934
www.gpalbums.com

KAMBARA USA INC.
PO Box 747
Tualatin, OR 97062
(800) 662-6650
www.kambara.com

RENAISSANCE ALBUMS
AlbumX Corp.
www.renaissancealbums.com

SANDIS LEATHER ALBUM MFG. CO.
289 Bridgeland Avenue Unit #105
Toronto ON
Canada M6A 1Z6
www.sandisalbum.com

Library Bound Mounted Albums

CAPRI ALBUM COMPANY
510 South Fulton Avenue
Mt. Vernon, NY 10550
(800) 666-6653
www.caprialbum.com

CLASSIC ALBUMS
343 Lorimer Street
Brooklyn, NY 11206
(800) 779-1931
www.classicalbum.com

LEATHER CRAFTSMEN
51 Carolyn Blvd.
Farmingdale, NY 11735
(800) 275-2463
www.leathercraftsmen.com

QUEENSBERRY LEATHER LTD.
PO Box 20-314
Auckland 1007, New Zealand
(800) 4778-7149
www.queensberry.com

WHITE GLOVE BOOKS
8092 Warner Avenue
Huntington Beach, CA
(714) 841-6900
www.wgbooks.com

ZOOKBINDERS
151-K S. Pfingsten Road
Deerfield, IL 60015
(800) 810-5745
www.zookbinders.com

Scrapbook Style and Alternative Albums

ARTZ
(800) 789-6503
www.artzproducts.com

CYPRESS ALBUMS
1001 E. 1st Street, Suite 17
Los Angeles, CA 90012
www.cypressalbums.com

RAG & BONE BINDERY
1088 Main Street
Pawtucket, RI 02860
(888) 338-8128
www.ragandbone.com

WATERHOUSE BOOKS
158 Rt. 154
Chester, CT 06412
(860) 526-1296
www.waterhousebooks.com

Digital Montage Albums

DIGICRAFT
www.digicraftonline.com

WHITE GLOVE BOOKS
8092 Warner Avenue
Huntington Beach, CA
(714) 841-6900
www.wgbooks.com

PROFESSIONAL AND EDUCATIONAL ORGANIZATIONS

AMERICAN SOCIETY OF
MEDIA PHOTOGRAPHERS
www.asmp.org

BLUE PIXEL
www.bluepixel.net

EDITORIAL PHOTOGRAPHERS
www.editorialphoto.com

INTERNATIONAL MUSEUM OF PHOTOGRAPHY
George Eastman House
www.eastmanhouse.org

THE KNOT
www.theknot.com

MAINE PHOTOGRAPHIC WORKSHOPS
www.theworkshops.com

PHOTO MARKETING ASSOCIATION (PMA)
www.pmai.og

PROFESSIONAL PHOTOGRAPHERS OF
AMERICA (PPA)
www.ppa.com

WEDDING AND PORTRAIT PHOTOGRAPHERS
INTERNATIONAL
www.wppinow.com

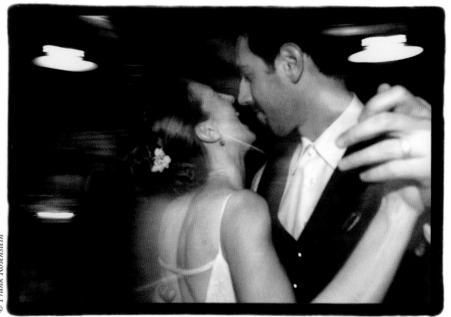

© Frank Rosenstein

Index